THE ART OF SEEING 2

the best of Reuters photography

REUTERS

Published by **Pearson Education**

London • New York • San Francisco • Toronto • Sydney • Tokyo • Singapore
Hong Kong • Cape Town • Madrid • Amsterdam • Munich • Paris • Milan

PEARSON EDUCATION LIMITED

Head Office:
Edinburgh Gate
Harlow CM20 2JE
Tel: +44 (0)1279 623623
Fax: +44 (0)1279 431059

Second edition published in Great Britain in 2003

© Reuters 2003

The right of Reuters to be identified as author of this work has been asserted by
them in accordance with the Copyright, Designs and Patents Act 1988.

ISBN 1 903 68437 4

First edition 2000 © Reuters

British Library Cataloguing in Publication Data
A CIP catalogue record for this book can be obtained from the British Library

10 9 8 7 6 5 4 3 2

Designed by Ian Roberts and Maggie Wells
Typeset by Pantek Arts Ltd, Maidstone, Kent.
Printed and bound by Bath Press

The Publishers' policy is to use paper manufactured from sustainable forests.

The images in this book were taken in the course of news gathering and or
journalistic activities for or by Reuters. None of the subjects within any of the
images sponsors or endorses the book in any way.

FOREWORD

It can happen in an instant. Yet it has the power to change everything. The events that shape history are captured everyday at Reuters through the lenses of some of the most talented photographers in the world.

In 1985, Reuters entered the news pictures business. From its black-and-white origins, the Reuters News Pictures Service has become the world's preferred source for up-to-the minute news photographs.

A pessimist might presume that in this high-tech age, with such pressure for rapid response and precise logistics to get to where the story is – and back again – photojournalists might have lost some of their creative flair. In editing this book, we were reminded once again that nothing could be further from the truth. Their work presents some of the most spectacular, disturbing and significant moments you will ever see.

In the **Art of Seeing**, we present a collection of the most stunning images that have been taken by Reuters photographers in the course of covering the news. As if holding a mirror to the world we live in, this book is an inspiring reminder of the colour and beauty of life that too often passes us by unnoticed as we rush through our days.

These are the images that have lived beyond their immediate news value. So, what sets them apart? In selecting the pictures, we had one simple criteria: the raw power of the image, either because of the subject matter, the situation in which it was taken or the surrounding circumstances, or just because it is an incredibly beautiful image.

Technology has no doubt helped Reuters become the great news agency it is now, but it is the real vision and talent of our photographers that makes their work so much more than just a record of what happened. Here we see the fruits of their curiosity, persistence, patience and precision.

Often taking personal risks, our photographers have sometimes paid a high price to get the best angle and the truly newsworthy photo.

We are proud of the recognition given to them by the public and our peers for their work, winning 17 awards in 2003. Without their collective vision and drive it would not have been possible to produce such a compelling book.

Monique Villa and Stephen Crisp

Damir Sagolj

24 May 2001

An Iranian boy sits among women during morning prayers in a Tehran mosque.

THE ART OF SEEING

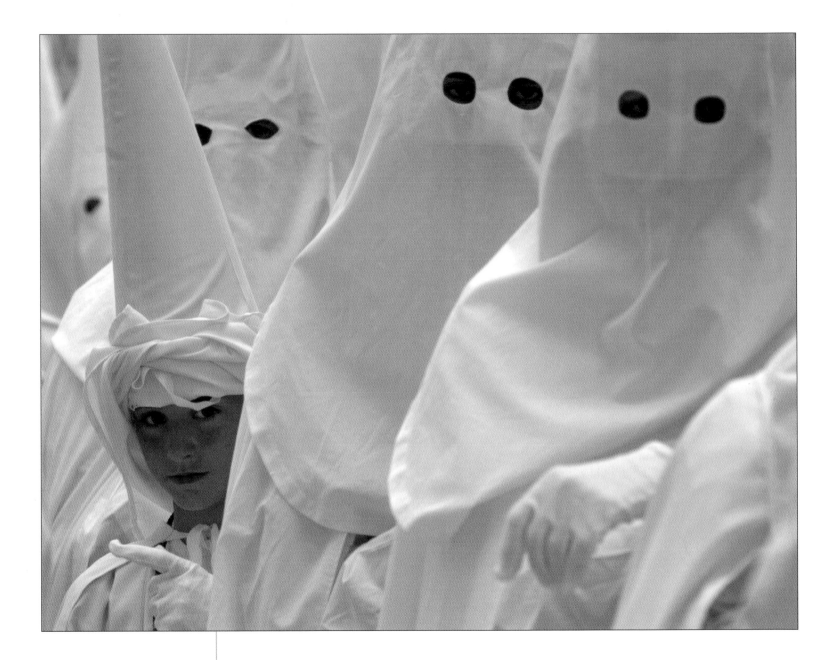

■ **Marcelo del Pozo**
13 April 2003

Hooded penitents prepare to join one of the many Holy Week processions in Seville, southern Spain.

Andrea Comas
30 March 2002

A penitent wearing traditional costume prepares to take part in a Holy Week procession in Madrid.

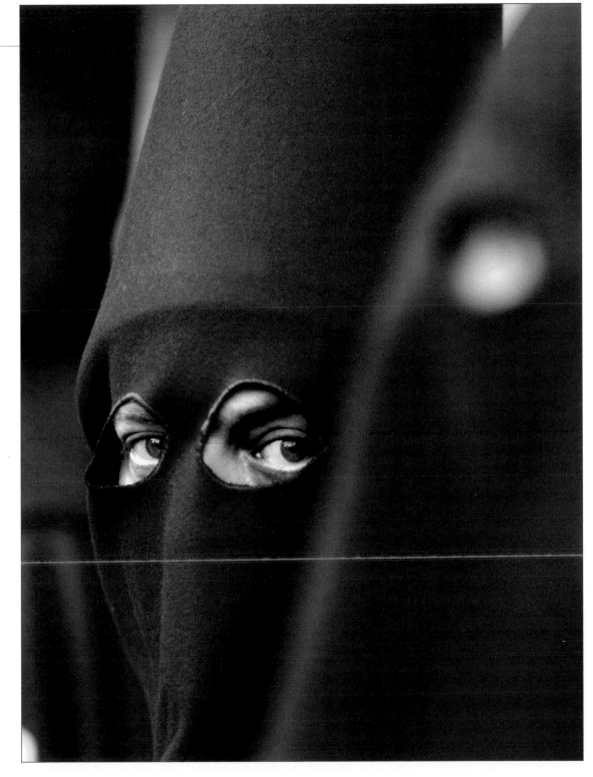

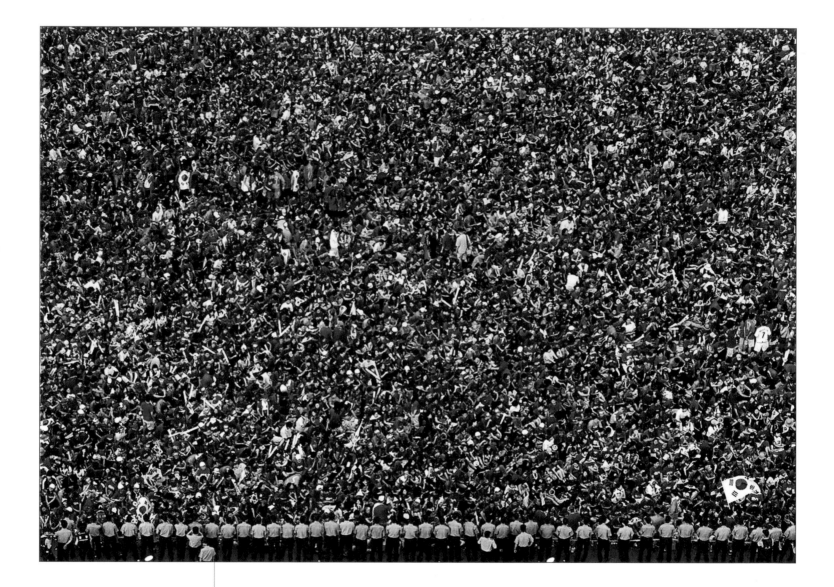

■ **Noh Soon-taek**
14 June 2002

South Korean soccer fans form a sea of red and white as they watch their country play Portugal in the World Cup on an outdoor screen in central Seoul.

■ Sucheta Das
2 June 2002

An Indian woman dries thousands of chilli peppers ready for sale in Namkhana, a village in northeast India.

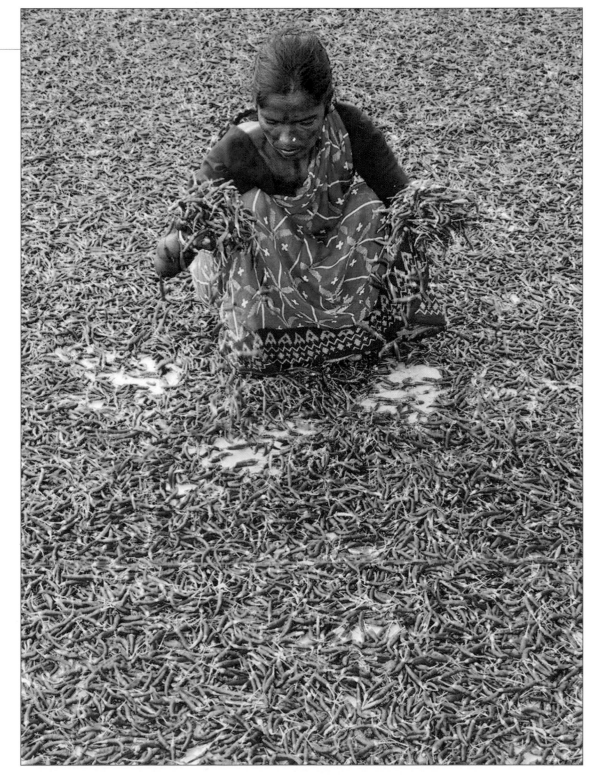

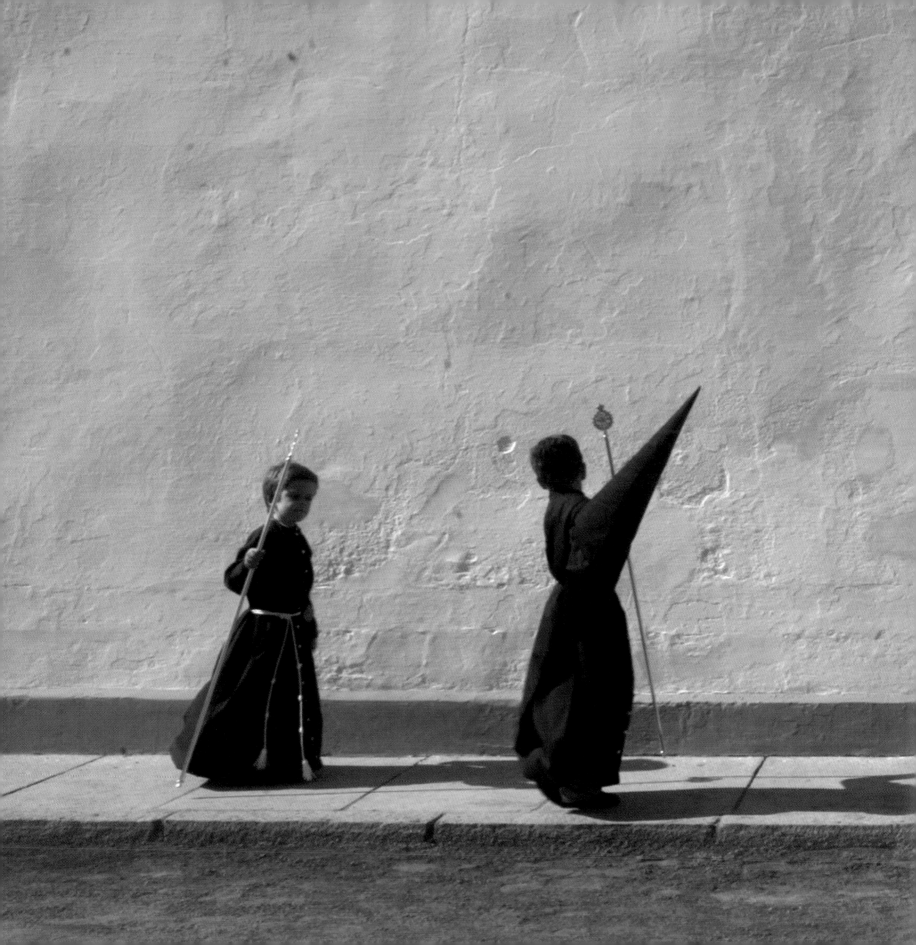

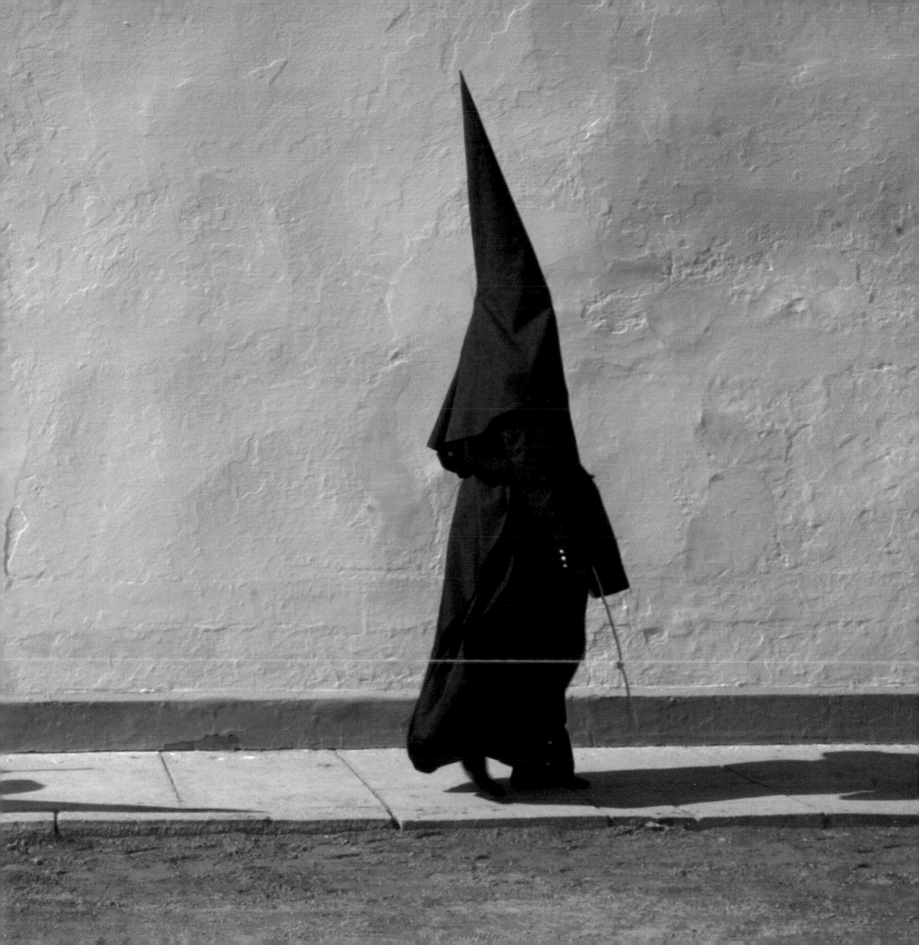

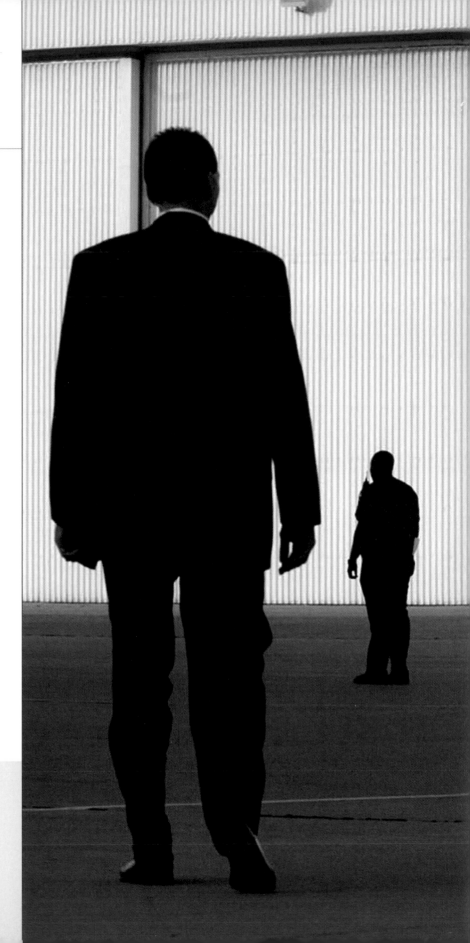

■ **Larry Downing**
7 August 2002

United States Secret Service agents patrol an airport in Waco, Texas, before the arrival of President George W. Bush for a Republican Party fundraiser.

The black-suited agents provide 24-hour protection for the first family, scanning crowds for potential threats, running alongside presidential motorcades and speaking to each other through mouthpieces discreetly hidden in their sleeves.

Agents arrive before the president on every official visit to check security, set up a command post and find evacuation routes in case of an attack. While they blend into the crowd once the ceremonies are under way, they can have an eerie presence in the quiet moments before the president – and the public – arrive at a location.

Previous page
■ **Marcelo del Pozo**
16 April 2003

Penitents walk to church to begin an Easter procession during the Holy Week celebrations in Seville.

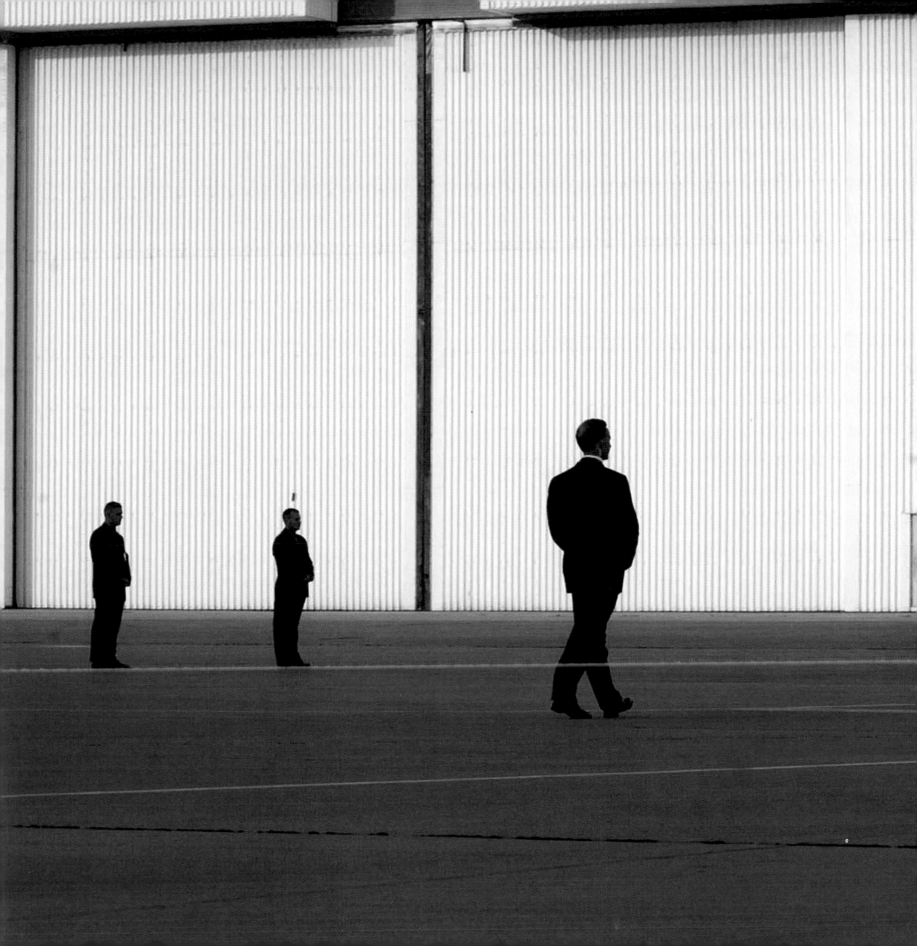

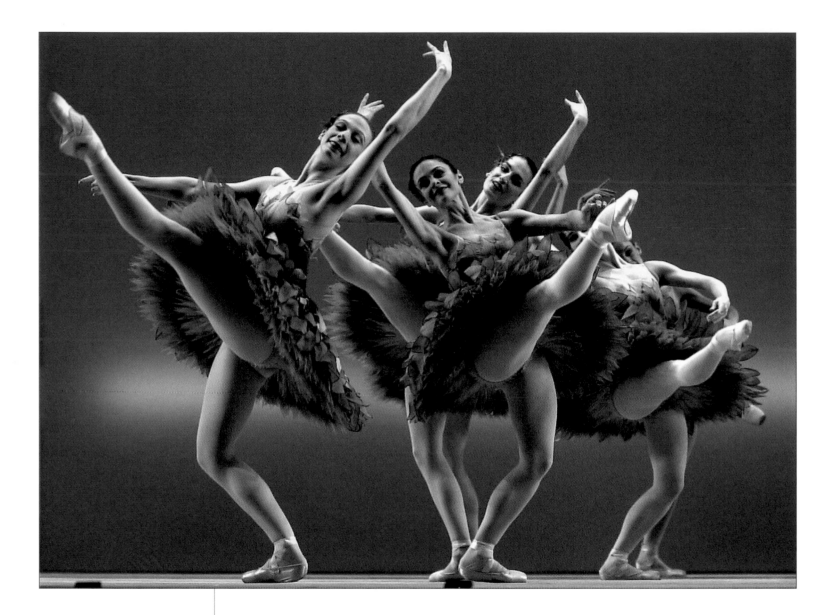

Natasha-Marie Brown
20 May 2003

The Royal Ballet perform David Bintley's 'Les Saisons' at the
Royal Opera House, Covent Garden, London.

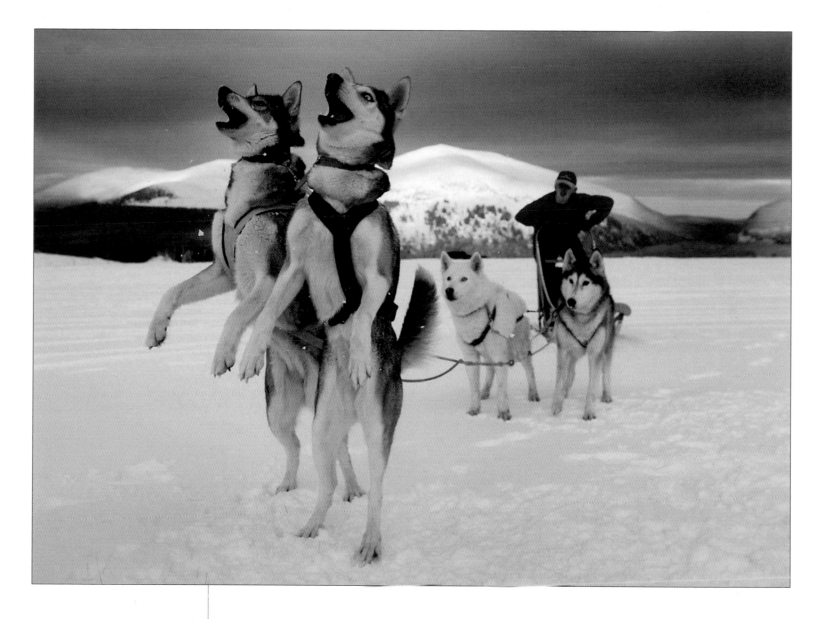

■ **Jeff J Mitchell**
23 January 2003

A team of huskies arrive to take part in the Royal Canin Sled Dog
Rally, near Aviemore, Scotland.

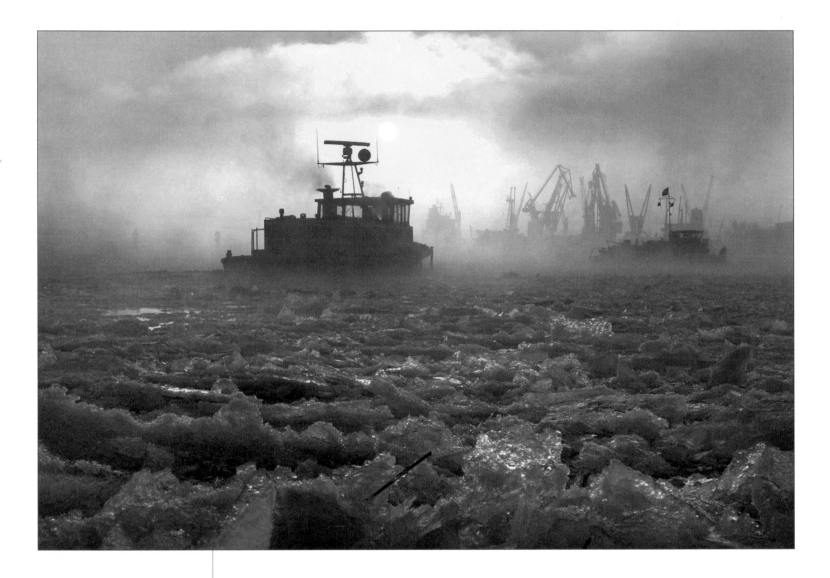

■ **Christian Charisius**
9 January 2003

Ships crash through Hamburg's frozen harbour during a cold snap in northern Germany.

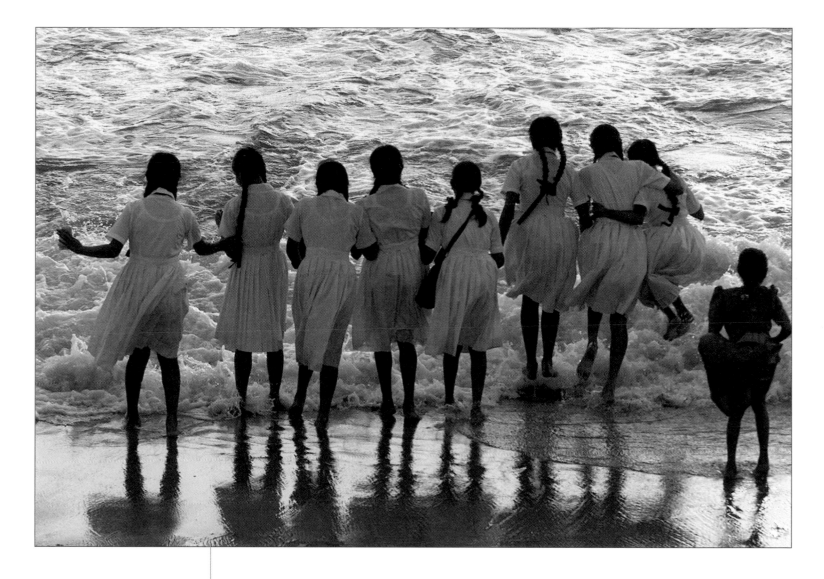

■ **Anuruddha Lokuhapuarachchi**
18 February 2003

Sri Lankan schoolgirls play in the surf on a beach in the capital Colombo.

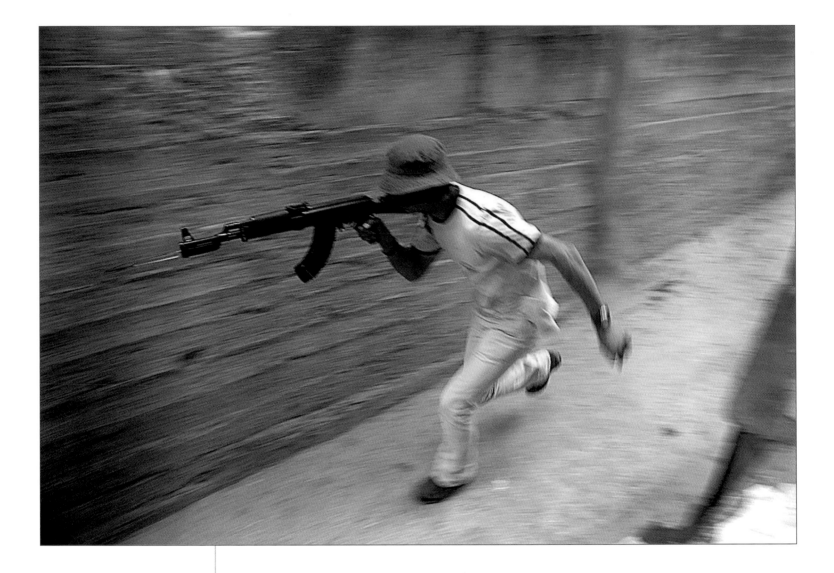

■ **Goran Tomasevic**
5 June 2002

A Palestinian gunman takes up a position in the Jenin refugee camp in the West Bank just before Israeli troops enter the town. A Palestinian suicide attacker earlier exploded a car bomb next to an Israeli bus, drawing condemnation from U.S. President George W. Bush and damaging the peace process.

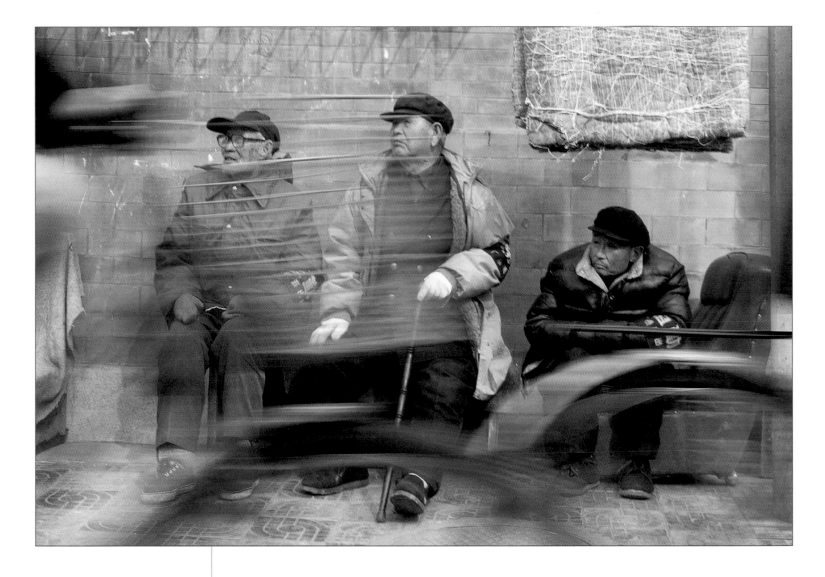

■ Guang Niu
27 February 2003

Chinese cyclists flash past elderly men taking part in a
neighbourhood watch campaign in central Beijing.

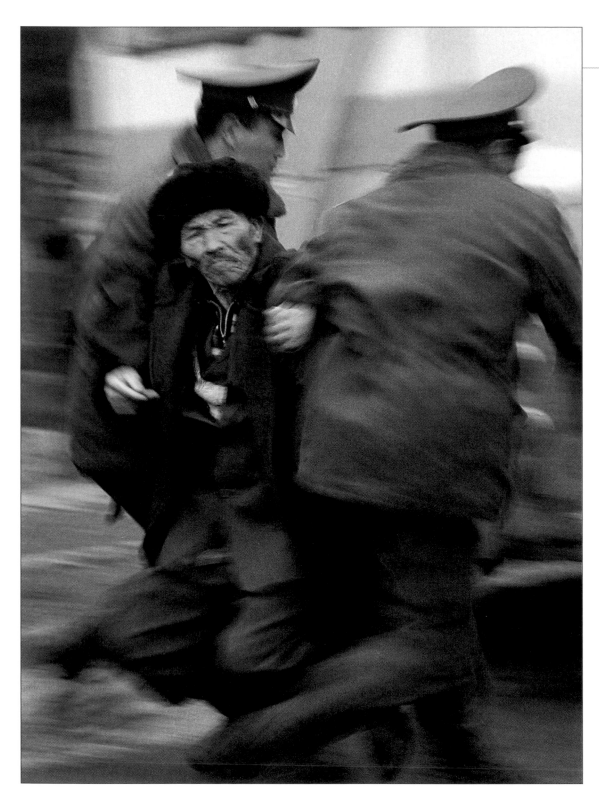

■ **Vladimir Pirogov**
16 November 2002

Police drag away a protester during demonstrations against the president in Kyrgyzstan, the former Soviet republic.

■ **Damir Sagolj**
14 May 2002

Muslim refugee Suljic Salih looks through the door of a ruined house after returning to a village near Srebrenica, the Muslim enclave where Bosnian Serbs killed thousands in 1995.

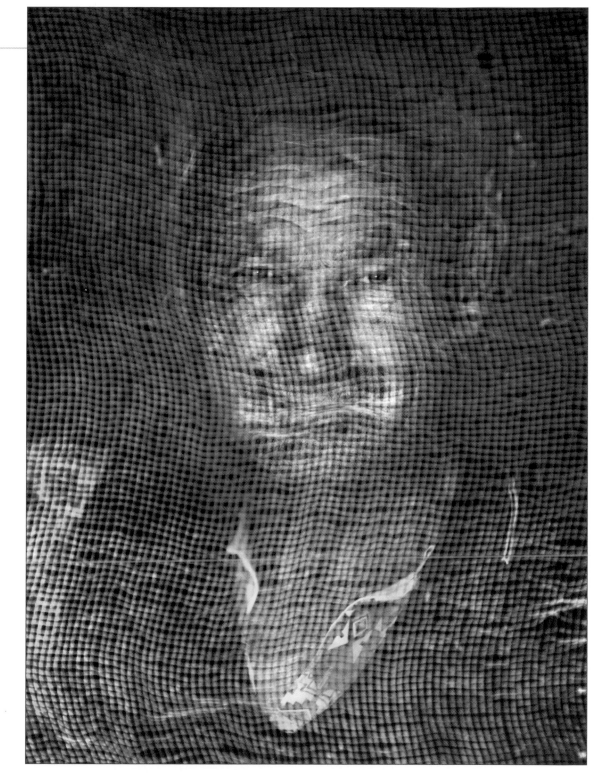

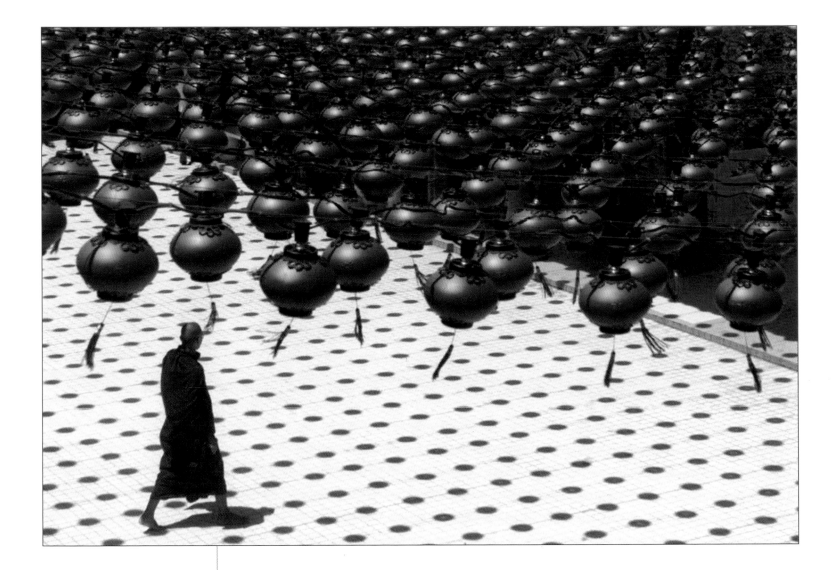

■ **Zainal Abd Halim**
31 January 2000

A monk walks beneath a sea of red lanterns hung at a temple in Kuala Lumpur to welcome in the Chinese New Year.

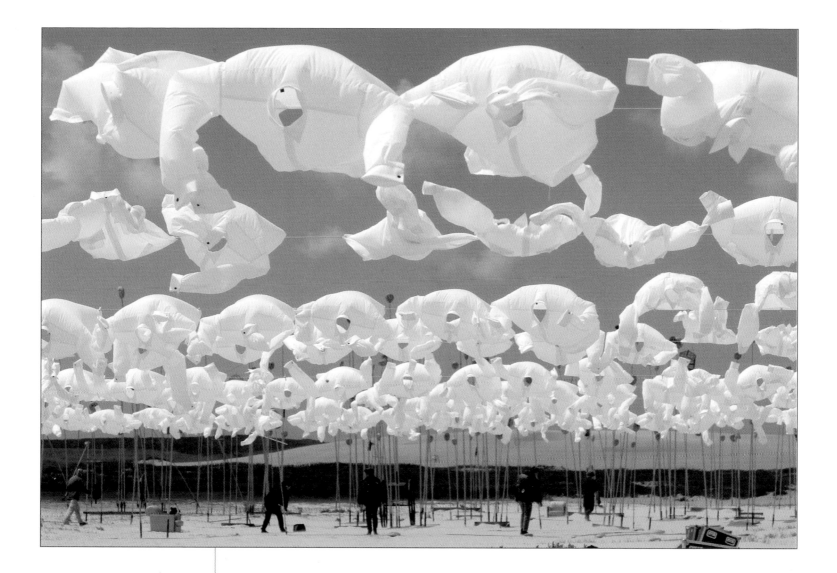

■ **Michael Kooren**
15 June 2002

Hundreds of white shirts billow in the wind in an art installation created by a group of European artists on the Dutch island of Terschelling.

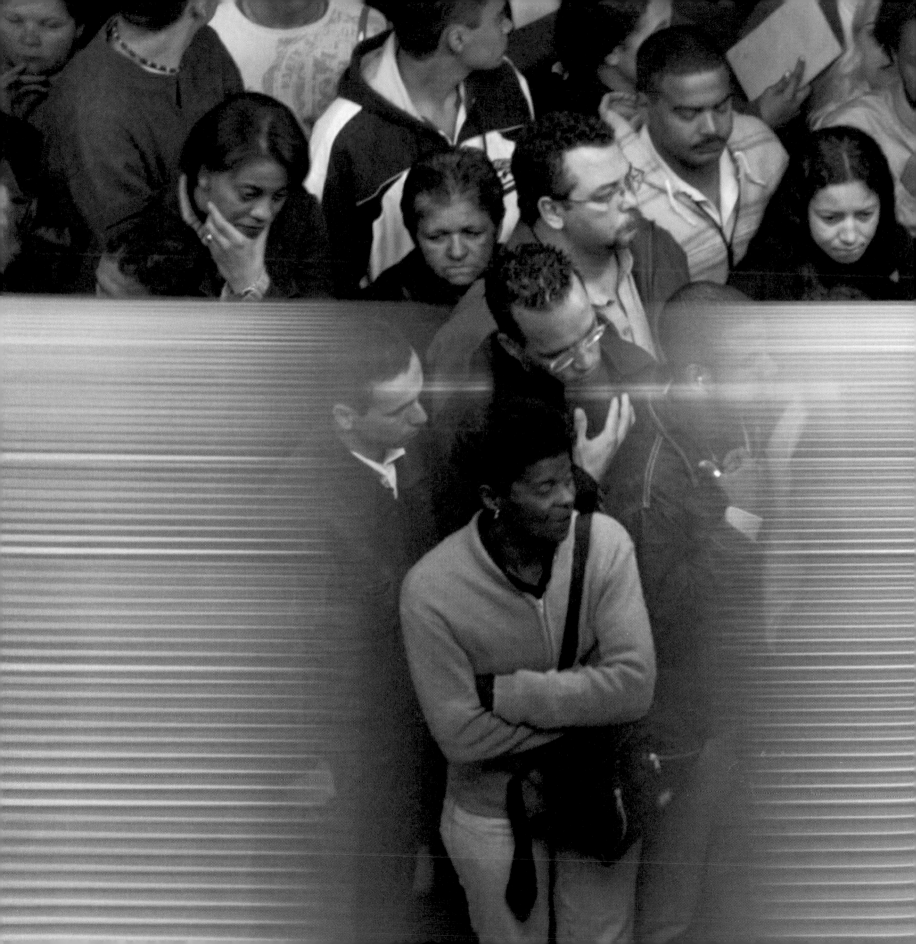

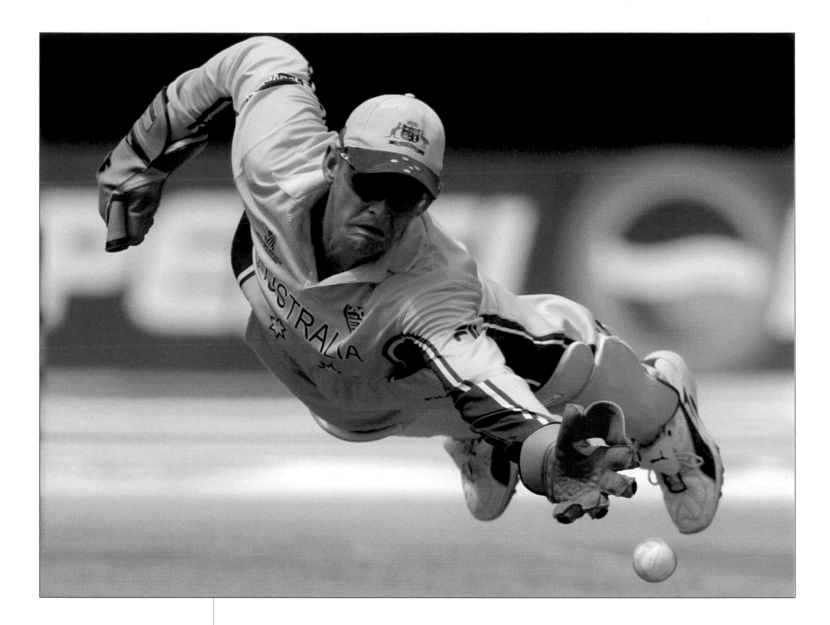

■ **David Gray**
29 September 2000

Australia's wicketkeeper Adam Gilchrist dives for a catch during a World Cup match against England in Port Elizabeth, South Africa.

Previous page
■ **Paulo Whitaker**
12 August 2003

Hundreds of commuters pack the Sé central subway station in São Paulo, Brazil, during rush hour.

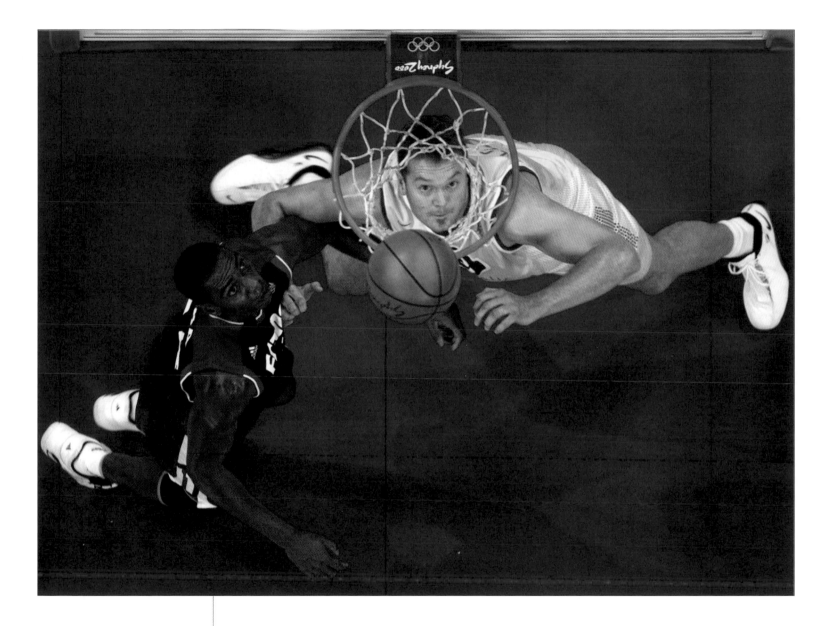

■ **Paul Hanna**
29 September 2000

Australia's Luc Longley (R) and French captain Jim Bilba jostle for the ball in the men's basketball semifinal at the Sydney Olympics.

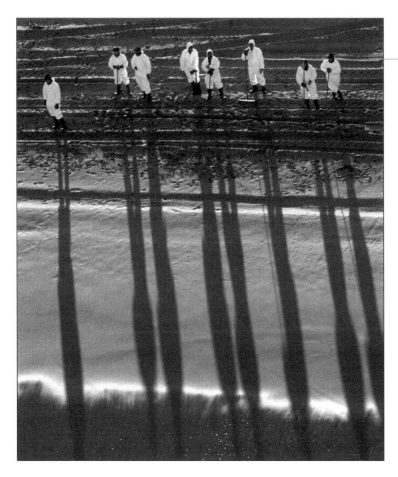

■ **Miguel Vidal (right)**
26 January 2003

Months after the Prestige oil tanker sank off northern Spain in November 2002, workers (L) still clean the oil from a beach in northern Spain. Volunteers (R), some of them newspaper readers drawn by Reuters photos, help clean beaches. The oil spill prompted a fishing ban along the coastline, killed and polluted hundreds of seabirds and endangered the area's rich shellfish resources vital to the region's economy. Up to half a million people joined a Madrid protest against government handling of the spill. Spain blamed the state of the ship, a 26-year-old single hull tanker, for the spill and urged other European Union countries to ban this type of vessel from carrying heavy fuel oil.

■ **Victor Fraile (above)**
8 February 2003

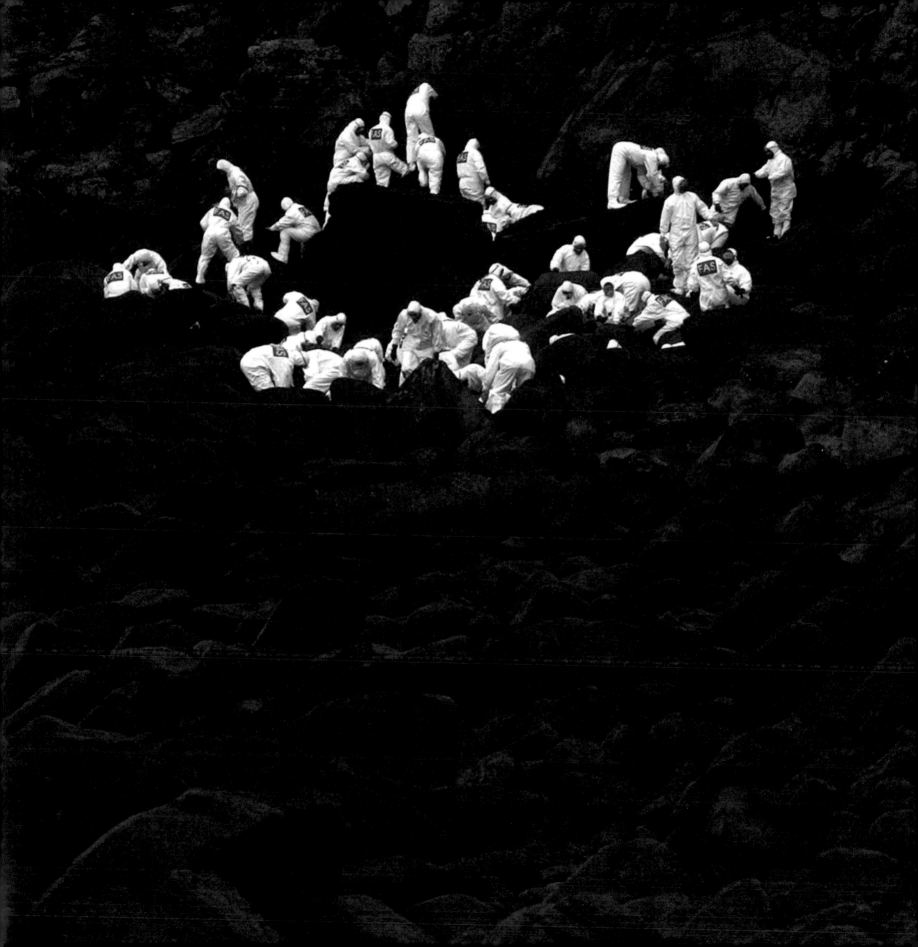

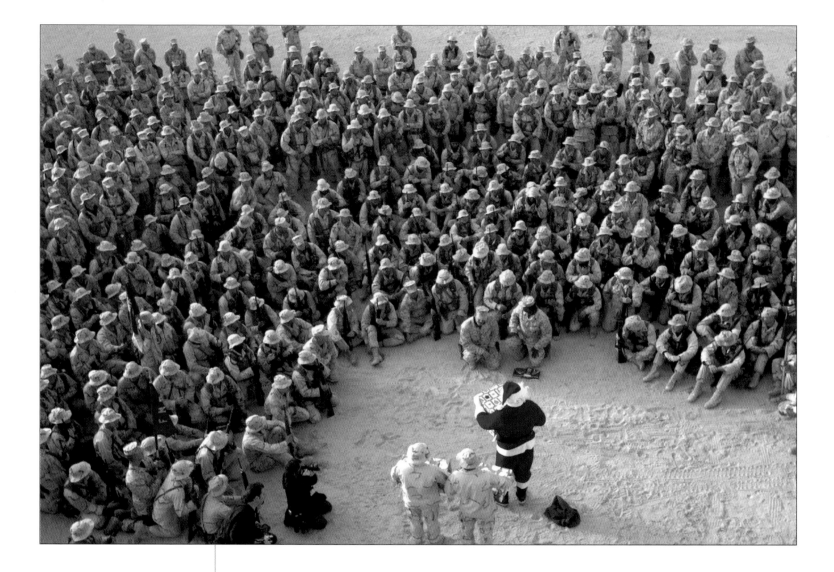

▪ Chris Helgren
28 December 2002

Santa Claus visits U.S. Marines at their camp in the Kuwait
desert on Christmas Eve.

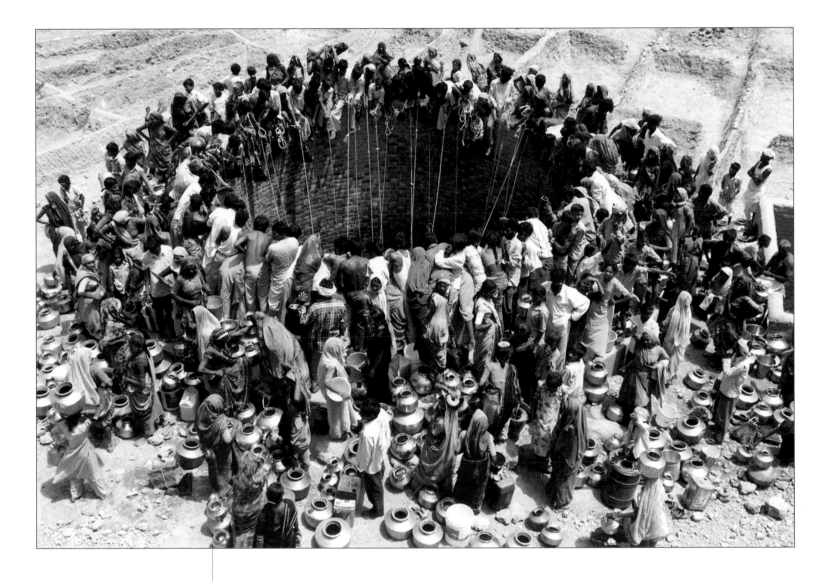

Amit Dave
24 December 2002

Villagers queue for water at a huge well during the worst drought in a decade in the western Indian state of Gujarat.

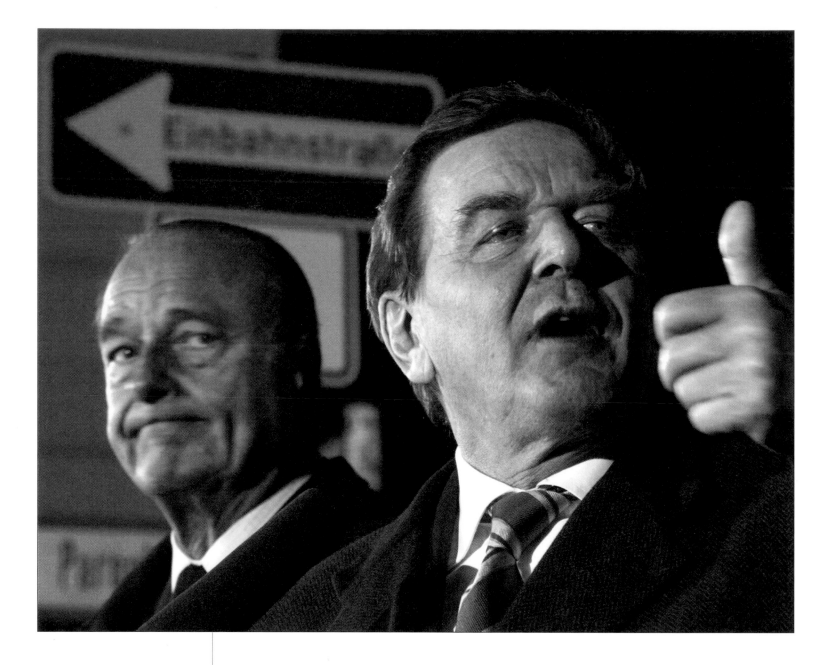

Damir Sagolj
28 May 2003

German Chancellor Gerhard Schroeder (R) addresses the media together with French President Jacques Chirac after a dinner in front of a sign reading 'One way' in Berlin. The two European leaders opposed the U.S.- and British-led invasion of Iraq two months earlier.

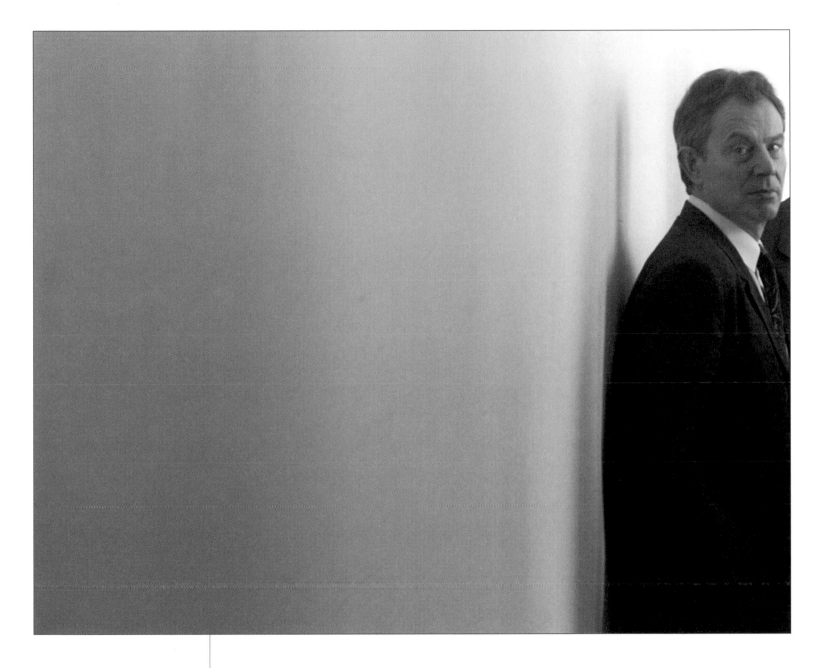

Toby Melville
21 March 2003

British Prime Minister Tony Blair waits to start talks with European Union heads of state split over the war in Iraq on the day he learned of Britain's first casualties in the conflict.

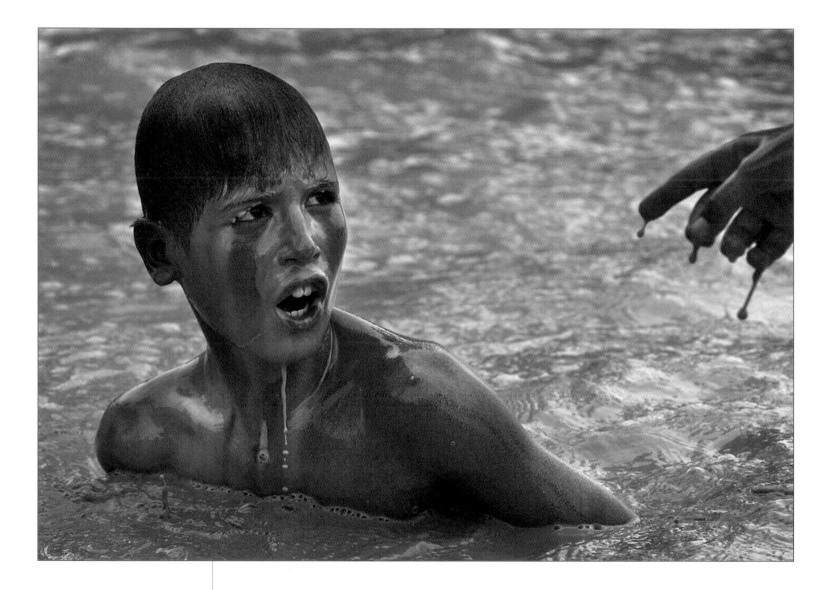

■ Fabrizio Bensch
24 February 2003

Iraqi teenagers swim in wastewater from the nearby Tuwaitha nuclear facility near Baghdad. Iraqis consumed contaminated water unaware of the dangerous pollutants that could cause severe ill health.

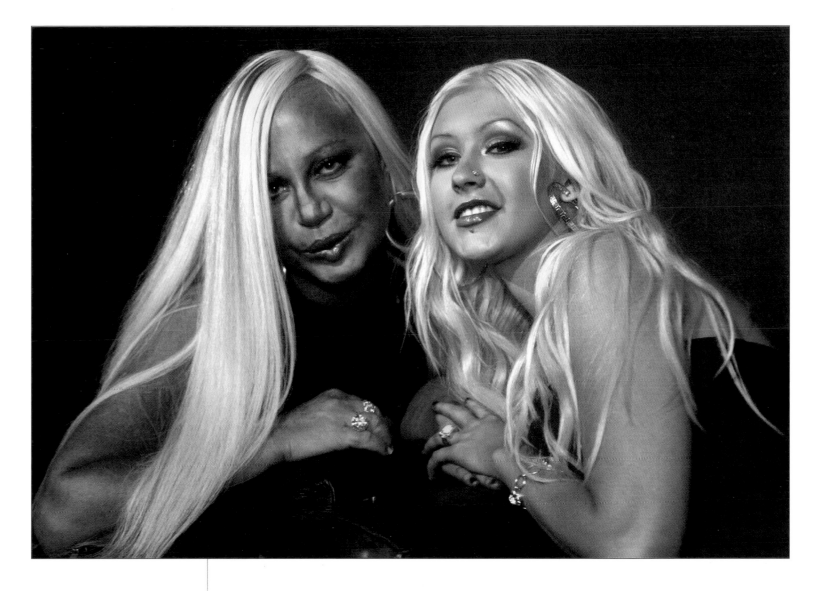

■ **Stefano Rellandini**
4 March 2003

U.S. pop singer Christina Aguilera (R) poses with Italian
designer Donatella Versace during Milan fashion week.

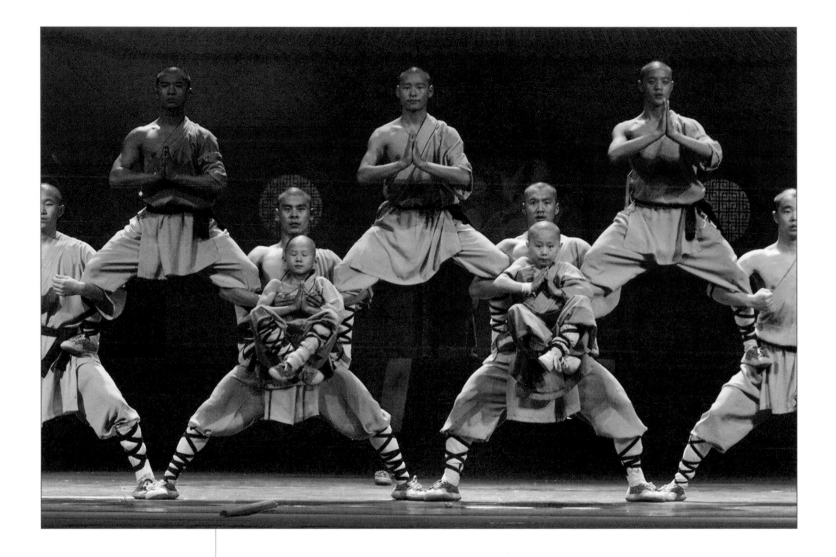

■ **Claro Cortes IV**
4 September 2002

Shaolin monks show their strength during a performance of
martial arts and spiritual rituals in Shanghai.

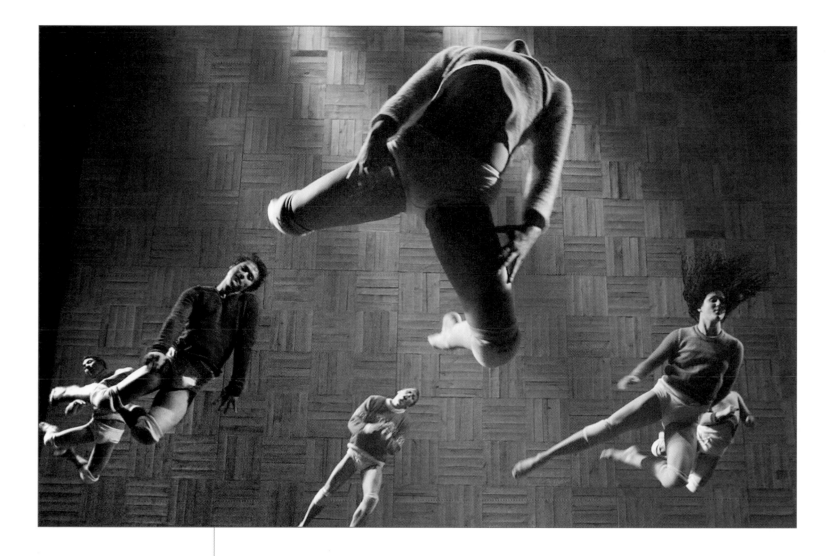

■ **David Gray**
26 June 2002

Australian dancers leap during rehearsals of 'The Age of
Beauty' at the Sydney Opera House.

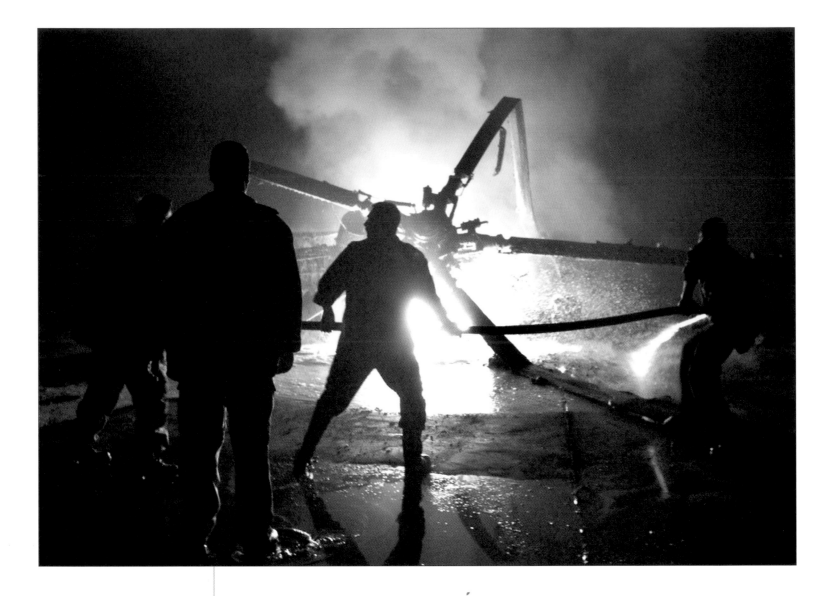

Suhaib Salem
3 December 2001

Palestinians battle to extinguish a blaze on Palestinian President Yasser Arafat's helicopter, destroyed by Israeli missiles in Gaza.

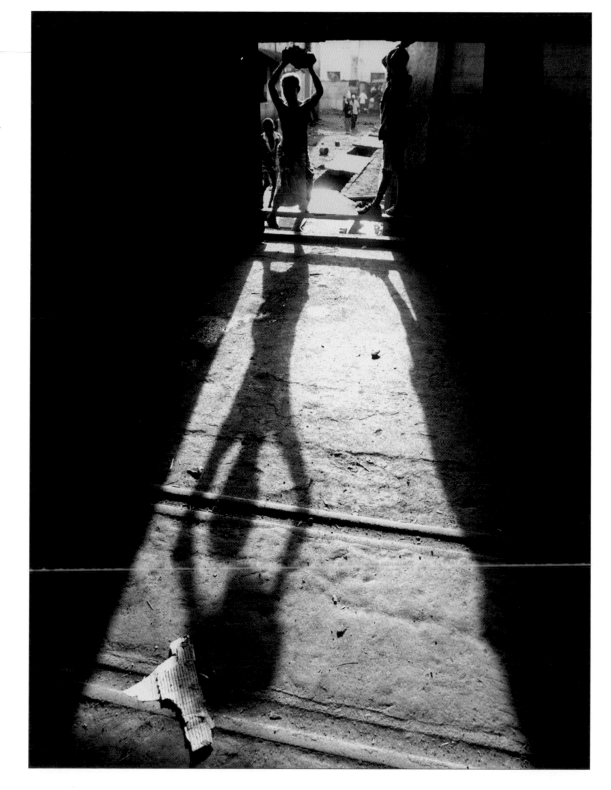

Yannis Behrakis
12 May 2000

A Sierra Leonean carries
wood into a Freetown
refugee camp packed with
people fleeing rebel attacks.

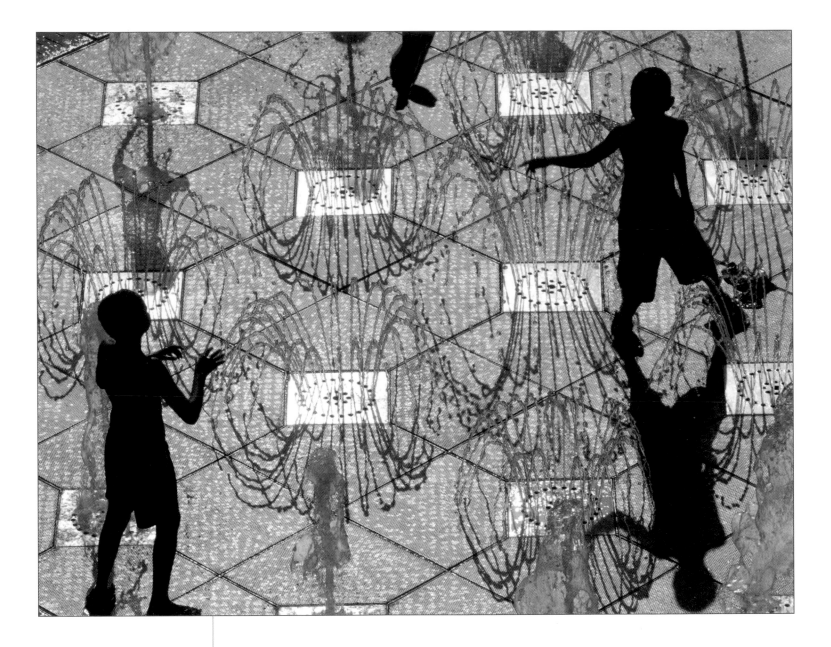

■ **Albert Gea**
20 August 2003

Boys play among water sculptures during a heatwave in Barcelona.

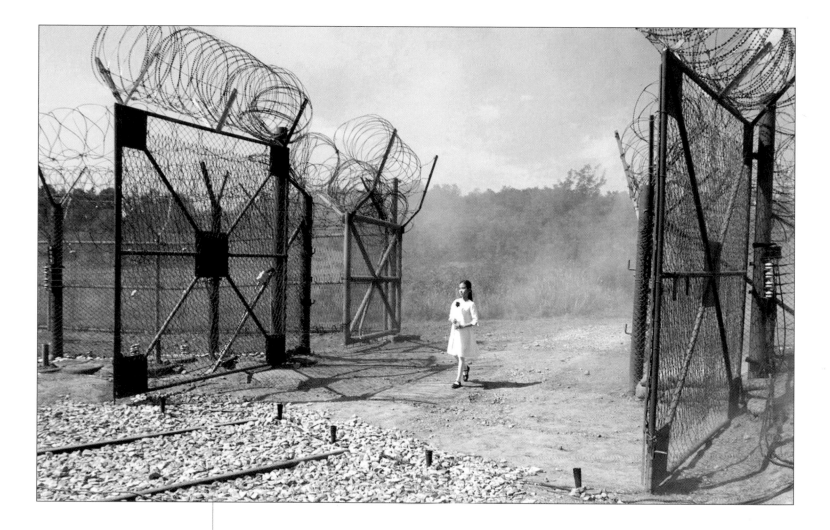

■ **Lee Jae-Won**
18 September 2002

A South Korean girl holding a flower takes a poignant step across the demilitarized zone separating the two Koreas in a landmark event which symbolically pierced the world's last Cold War frontier.

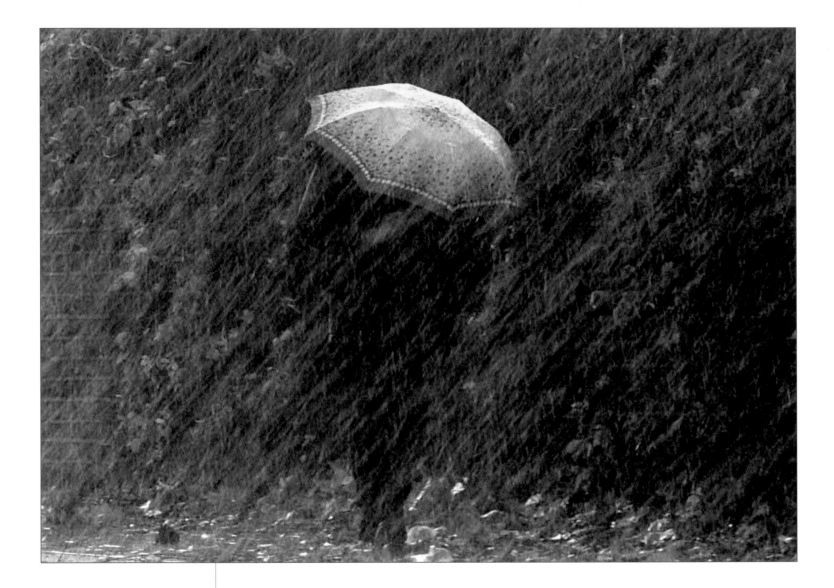

Russell Boyce
30 October 2000

A woman struggles through torrential rain and gale force winds during a storm in east London.

■ **Damir Sagolj**
11 July 2001

A Bosnian Muslim woman stares from a bus as she arrives in Srebrenica for the sixth anniversary of the massacre in the enclave.

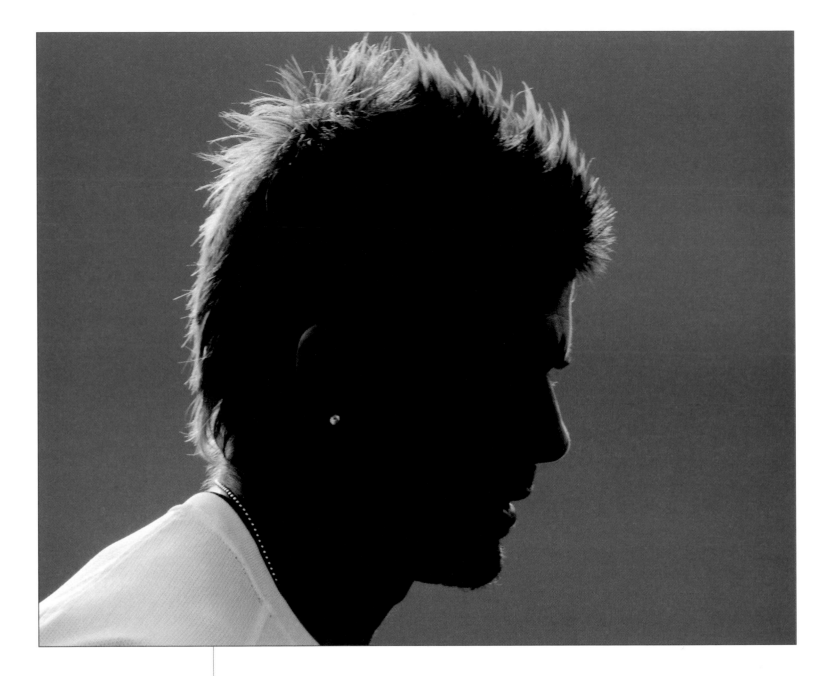

■ Dan Chung
3 June 2002

The sun catches England soccer captain David Beckham's 'Mohican' haircut during training for the World Cup in Japan.

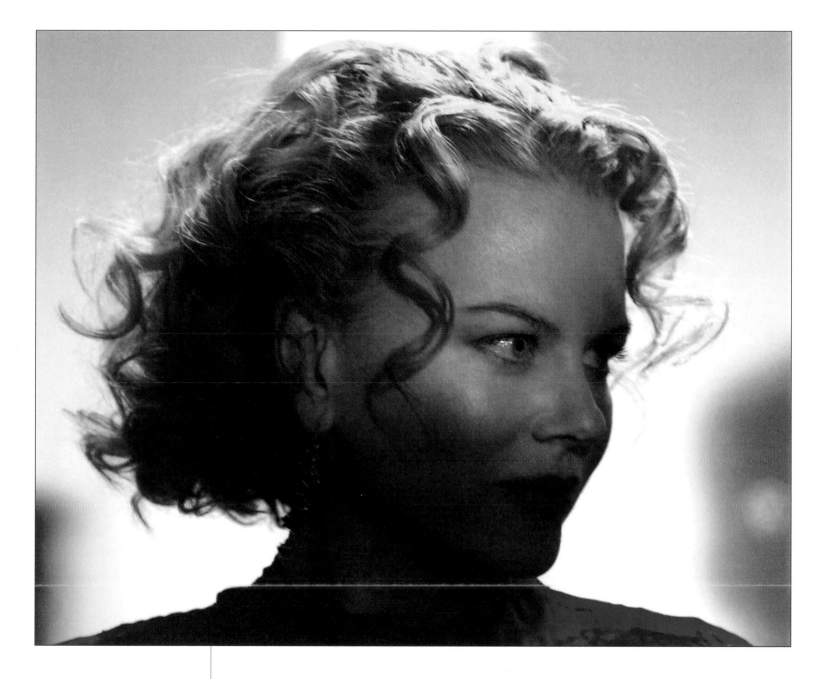

Christian Charisius
9 February 2003

Australian actress Nicole Kidman promotes the Oscar-winning
film **The Hours** at a Berlin news conference.

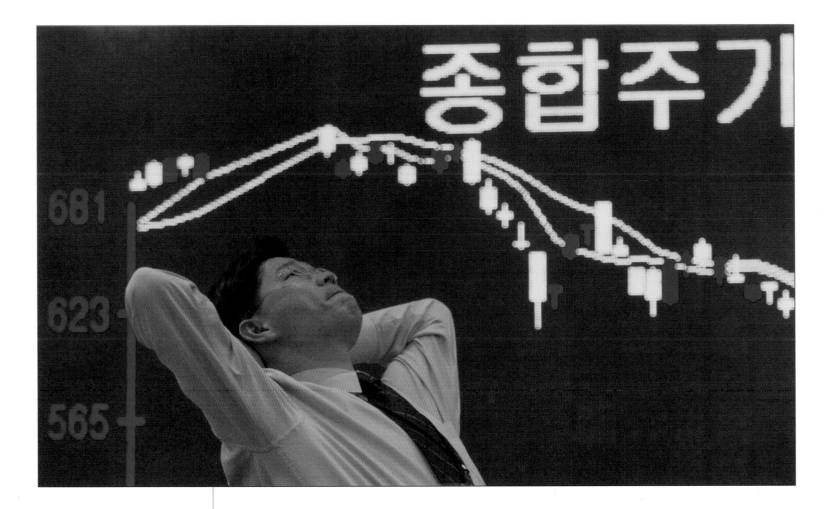

■ **Kim Kyung-Hoon**
11 March 2003

A South Korean financier grimaces after shares fell for a sixth straight day. The fallout from the Iraq war and the SARS outbreak hit Asian economies as they recovered from a 1997–98 financial crisis.

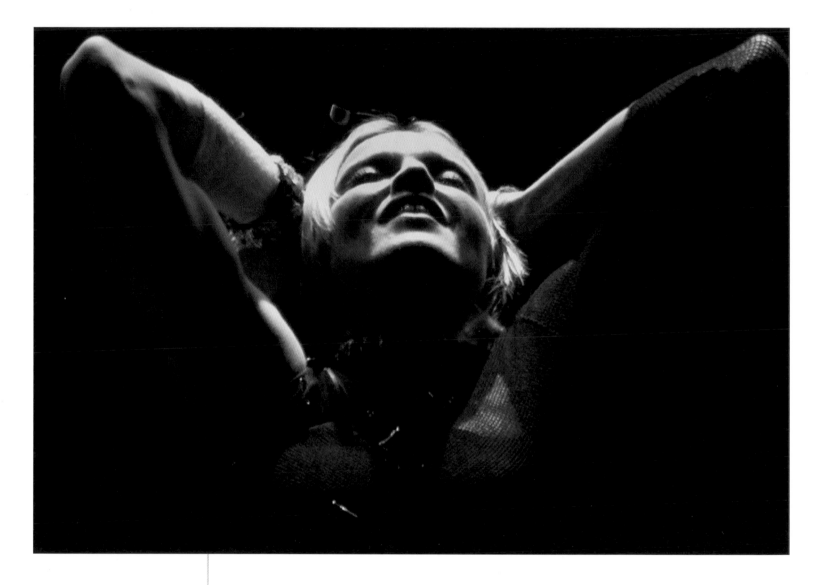

Alexandra Winkler
19 June 2001

U.S. pop star Madonna performs in Berlin during a European tour.

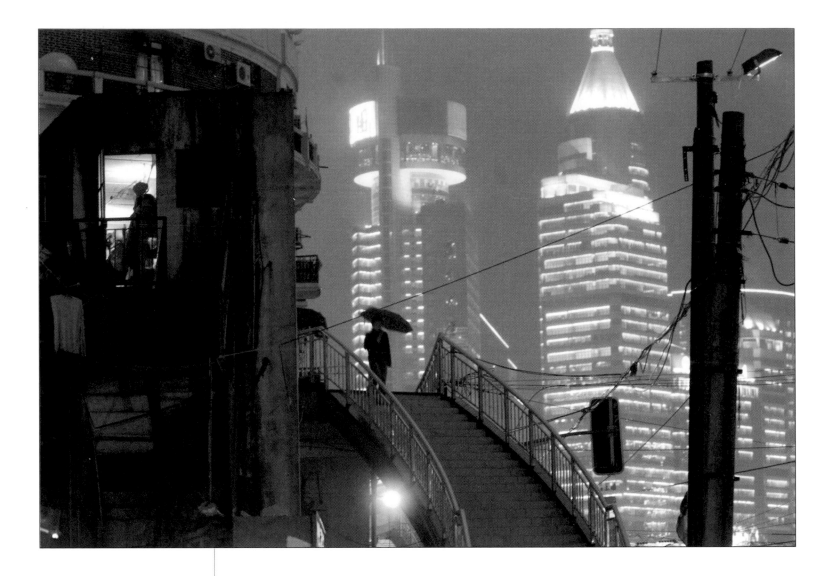

■ Guang Niu
31 October 2002

A Chinese woman walks between the old and new districts of Shanghai.

The photographer recalls, 'It was a rainy evening as I walked out to find a night picture that really captured the city. In China's modern history a "Shanghai Night" is always romantic and mysterious and has held a special place in the heart of the Chinese since the 1930s when the city was called "the Paris of the Orient". The beautiful financial centre used to be lit with neon lights and was famous for its nightlife until the Communist Party took over in 1949.

'But after the economic reforms over the last two decades, Shanghai has regained its glory and become China's most modern and important financial city once again.'

Niu's image captures the old and the reborn spirit of Shanghai.

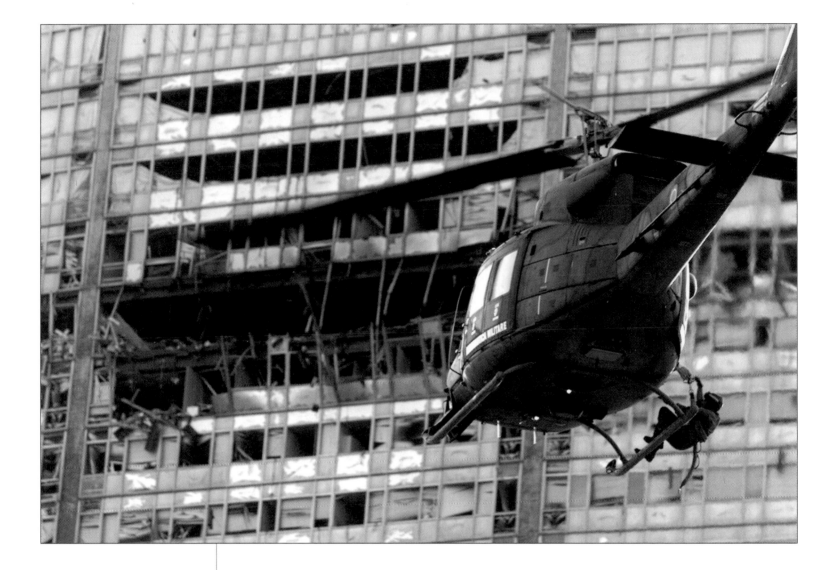

■ Stefano Rellandini
18 April 2002

A military helicopter flies close to a Milan tower block after a light aircraft crashed into it. The plane hit the 30-storey Pirelli Tower, Italy's highest building, killing the pilot and two women who worked inside, briefly raising fears of a September 11-style attack. Investigators concluded it was an accident.

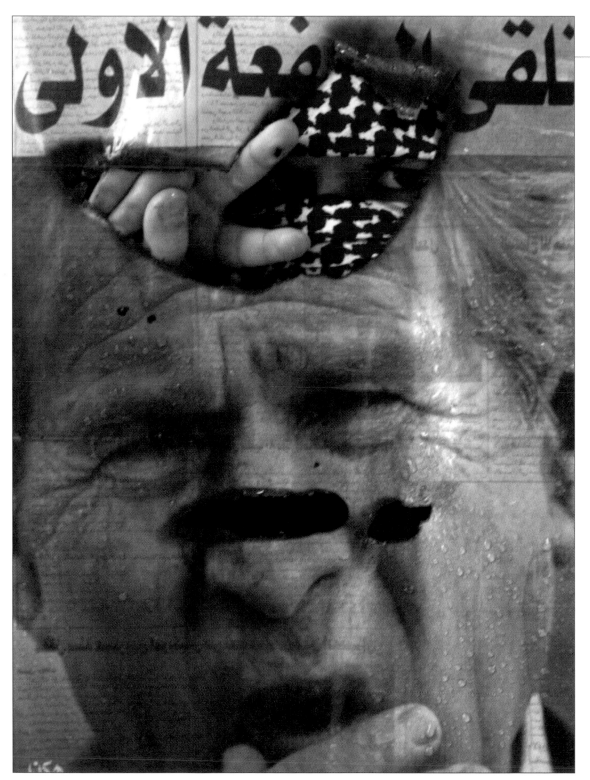

■ **Ali Jarekji**
26 March 2003

A Jordanian peers through an Islamic newspaper bearing a picture of U.S. President George W. Bush during a march in Amman against the U.S.-led war on Iraq.

■ **Ali Jarekji**
28 September 2002

A Jordanian protester stares through a charred photograph of an Israeli flag carrying the image of Israeli Prime Minister Ariel Sharon during a demonstration in Amman.

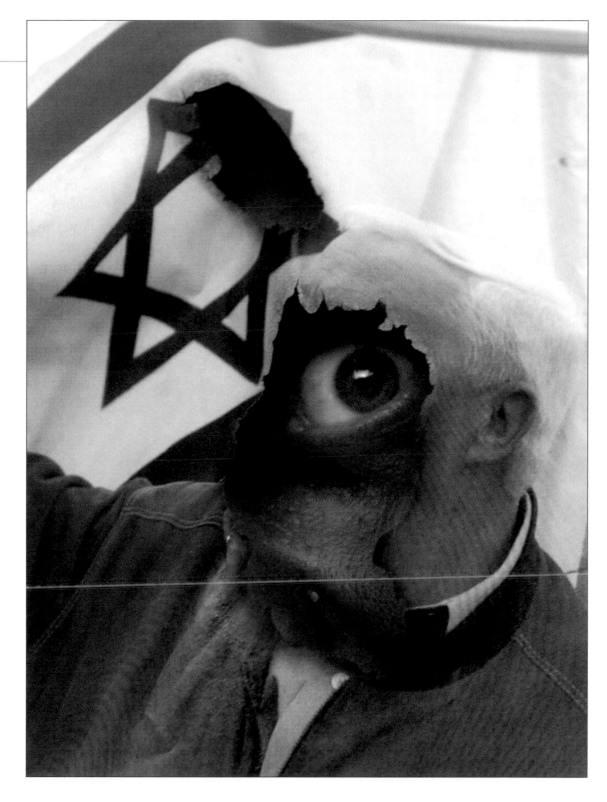

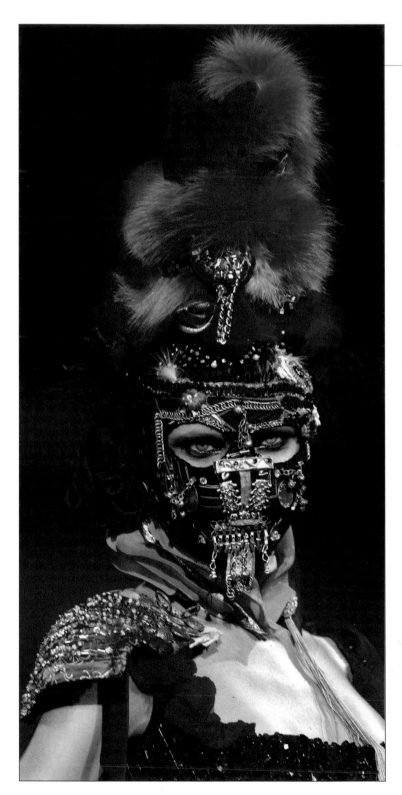

■ Philippe Wojazer
9 July 2002

A model wears a blood-red head-dress and jewel-covered mask during French designer Christian Lacroix's show in Paris.

Shooting fashion show pictures is as exciting as it is stressful. 'From my point of view,' explains Philippe Wojazer, 'great fashion show pictures require a couple of things – being in the line of the catwalk, trying to catch the model's look, knowing what the "tendance" is and not being frightened by your proximity to colleagues.

'This last factor means you have to be at the show hours before it starts as the platform where photographers stand is quite small and there are many photographers and television crews who also want the best spot. Some shows attract so many of them that it can be very hard to "squeeze" your camera into this wall of lenses. After you spend hours trying to defend your territory, you may, sometimes, witness colourful, creative collections.

'When Yves Saint Laurent was presenting his haute-couture show, it was always at 11 a.m. on a Wednesday in the very same, very luxurious Parisian hotel. My colleague and I always met at 7 a.m. to take our spots for the show, which was the most popular of the season and would never start before 12:30 p.m. So we had a long wait to "protect" our spot, which we had marked by a stepladder. After a couple of years, we decided to have our breakfast at the hotel bar. To make sure our stepladder was not removed, we screwed it into the wooden platform, and I must say it worked quite well.'

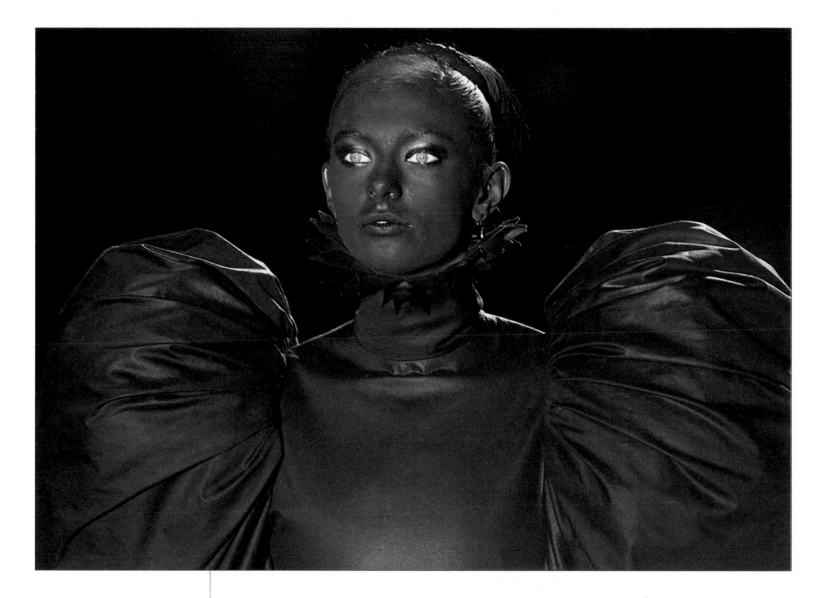

■ **Jacky Naegelen**
10 March 2001

A model painted with theatrical black make-up wears an evening dress by Dutch designers Viktor and Rolf in their 'Black Hole' show at Paris fashion week.

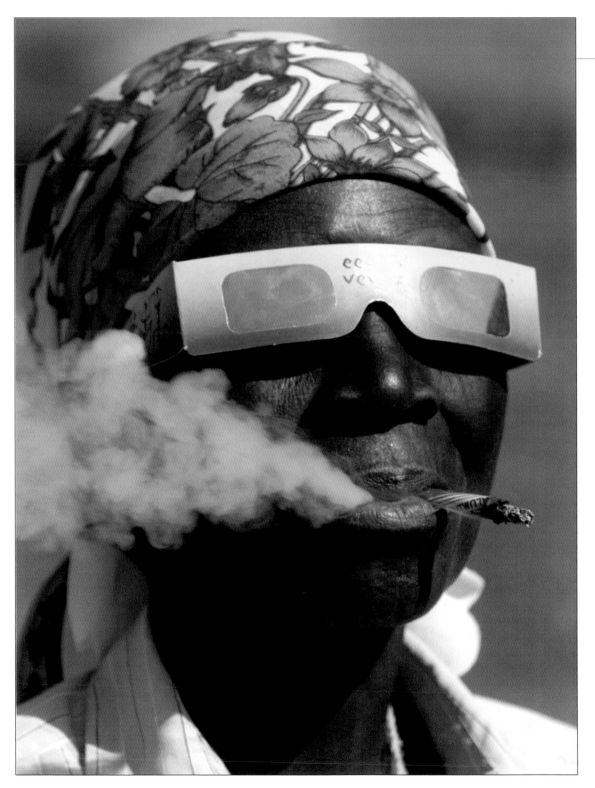

■ Howard Burditt
21 June 2002

An elderly Zimbabwean woman smokes as she watches a solar eclipse north of the capital, Harare.

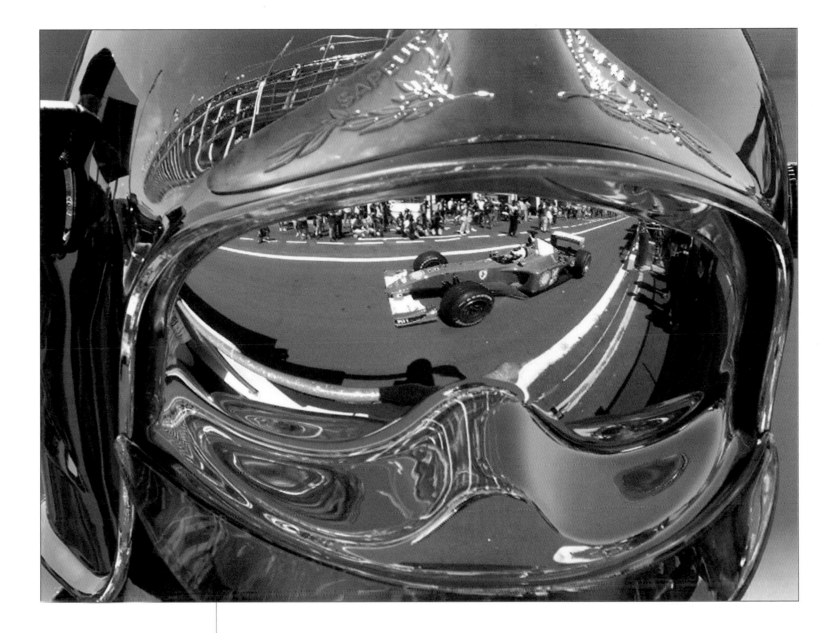

■ **Yves Herman**
29 June 2001

The Ferrari of Rubens Barrichello is reflected in a fireman's helmet at the French Grand Prix in Magny-Cours.

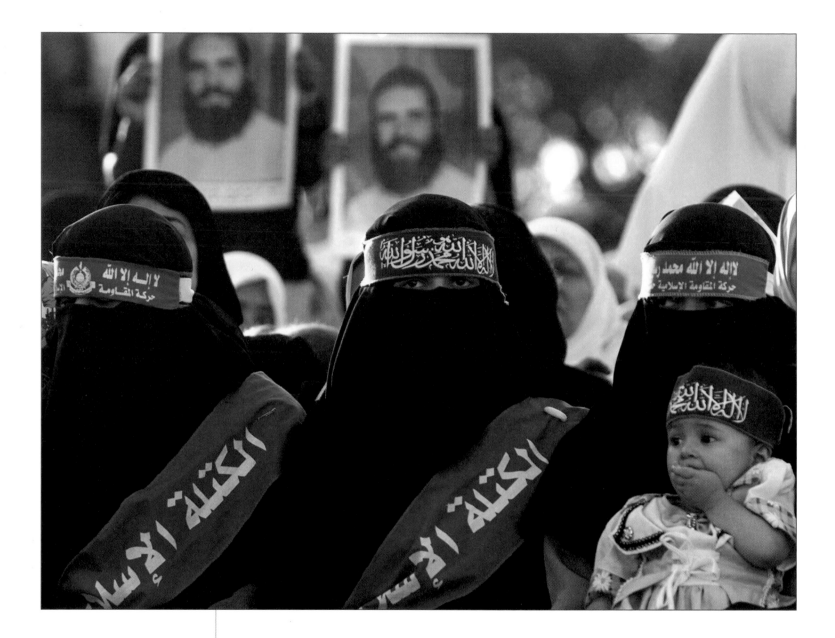

■ **Ahmed Jadallah**
29 August 2002

Hamas supporters rally in Gaza City to mark the 33rd
anniversary of an arson attack on Jerusalem's al-Aqsa mosque.

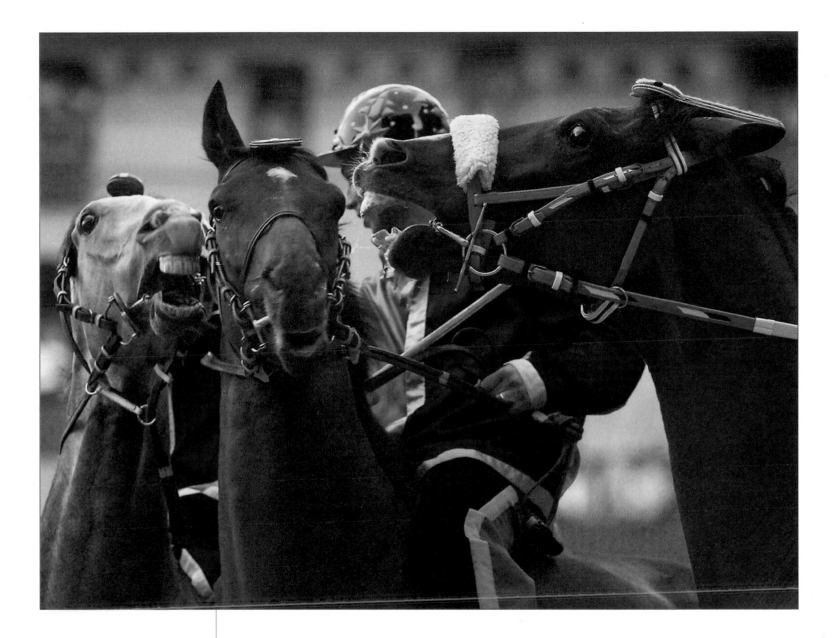

Dylan Martinez
16 August 2002

Horses rear up at the start of Siena's Palio, one of the world's
most thrilling horse races.

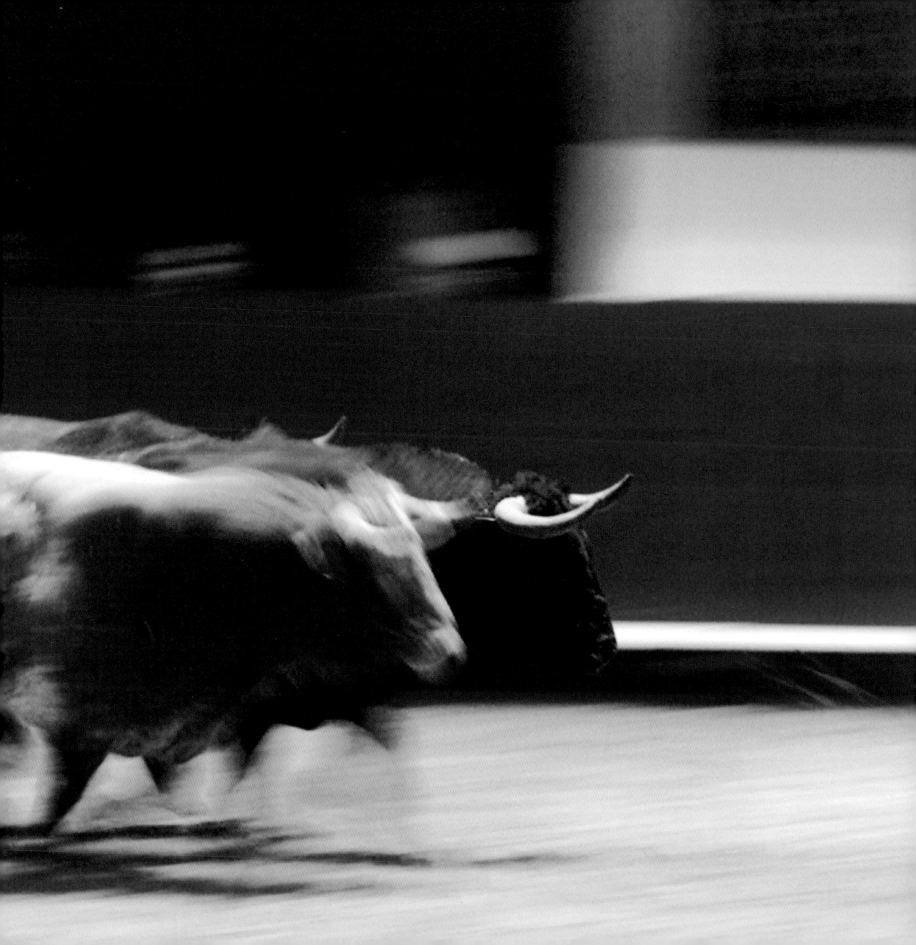

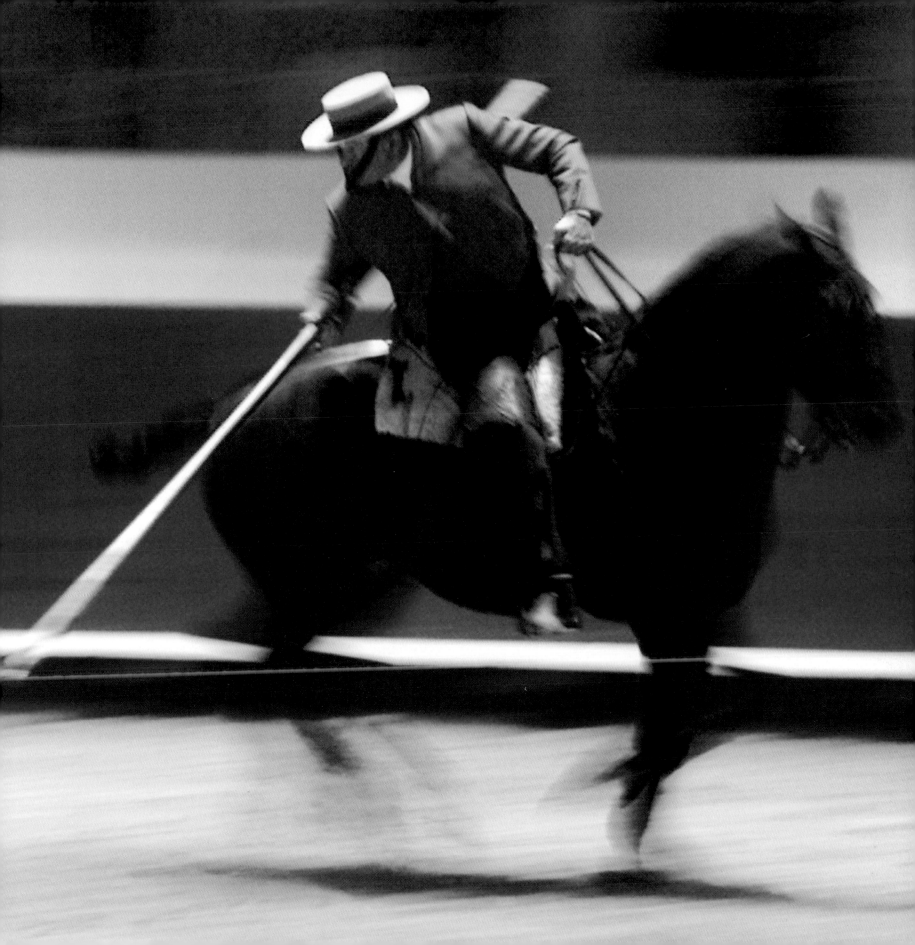

■ **Marcelo del Pozo**
25 April 2003

Spanish matador Davila Miura prepares to take on a bull, whose shadow is cast on his muleta, or red cape.

Previous page
■ **Marcelo del Pozo**
7 February 2001

A rider leads a pack of charging bulls at the World Bull Fair in Seville.

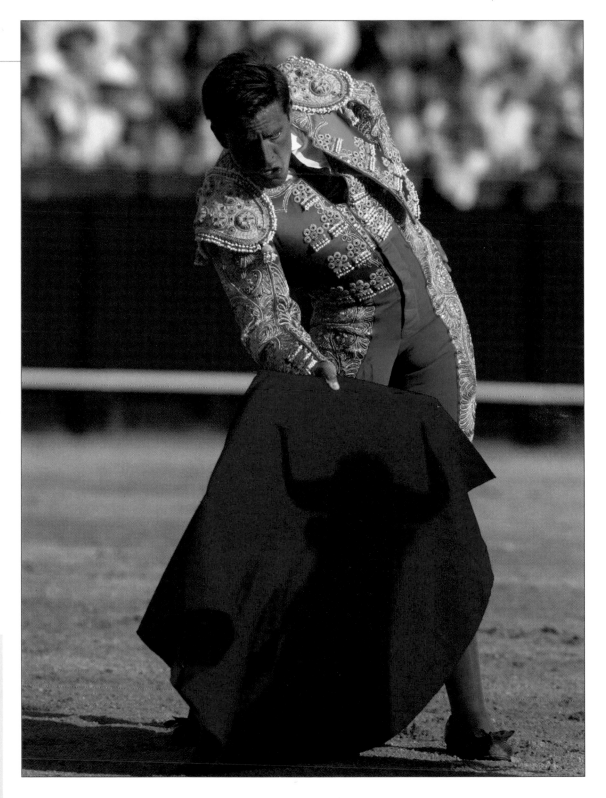

Toby Melville
20 February 2003

U.S. singer Justin Timberlake and Australian Kylie Minogue perform their scene-stealing routine at The Brits, the British music industry's annual Oscar-style ceremony.

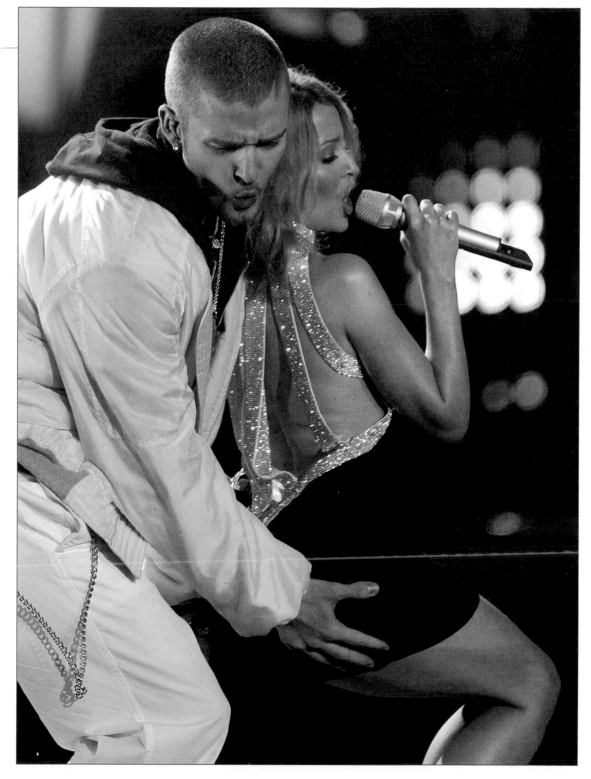

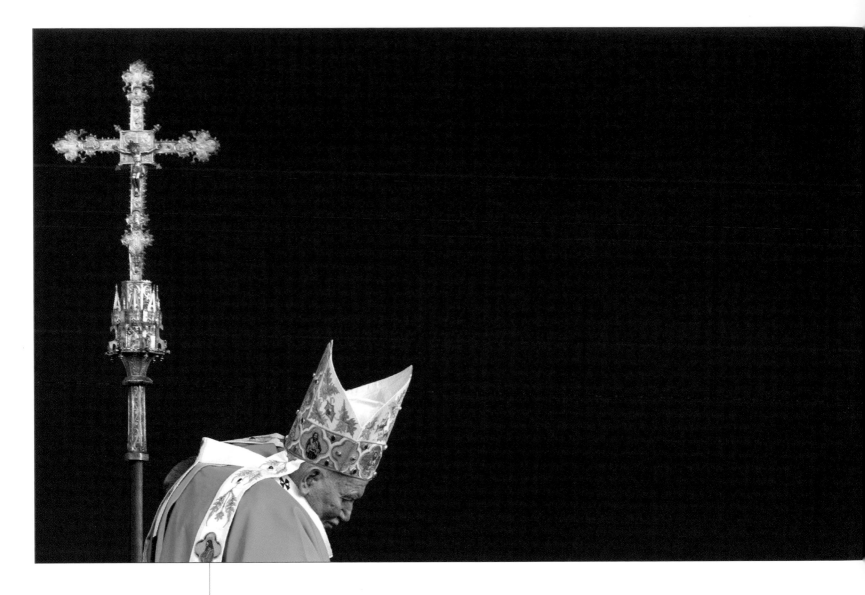

■ **Vincenzo Pinto**
18 August 2002

Pope John Paul II celebrates mass in Krakow's Blonia park during his ninth trip home to Poland. This marked the largest Mass in Polish history.

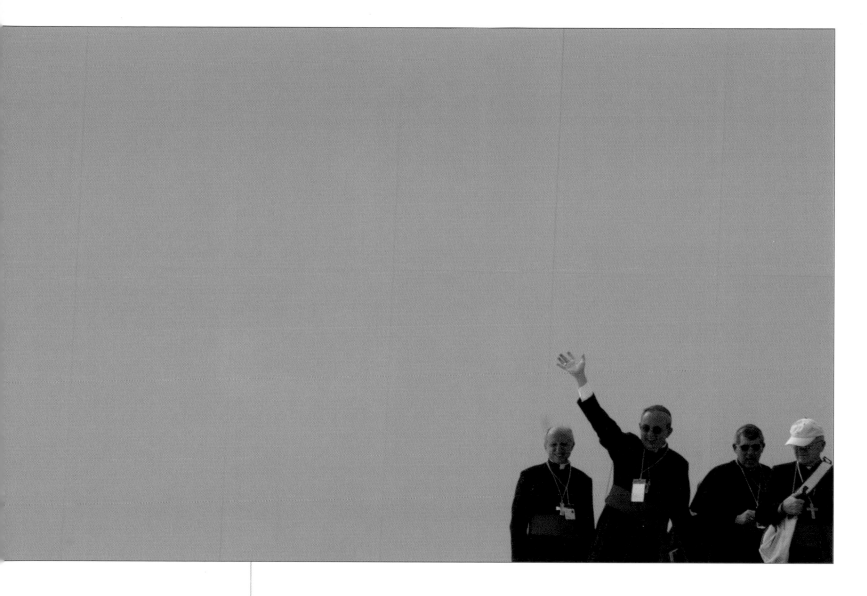

Marcelo del Pozo
3 May 2003

Cardinals wave from the stage as they await Pope John Paul II
at an airbase near Madrid.

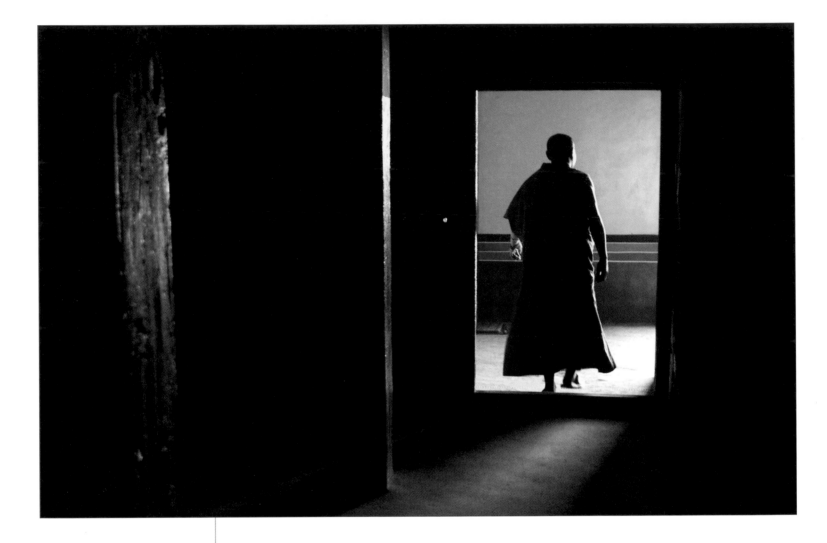

■ **Claro Cortes IV**
11 August 2002

A Tibetan Buddhist monk walks through a temple in Lhasse, the capital of Tibet, where the Dalai Lama's throne has been empty since 1959.

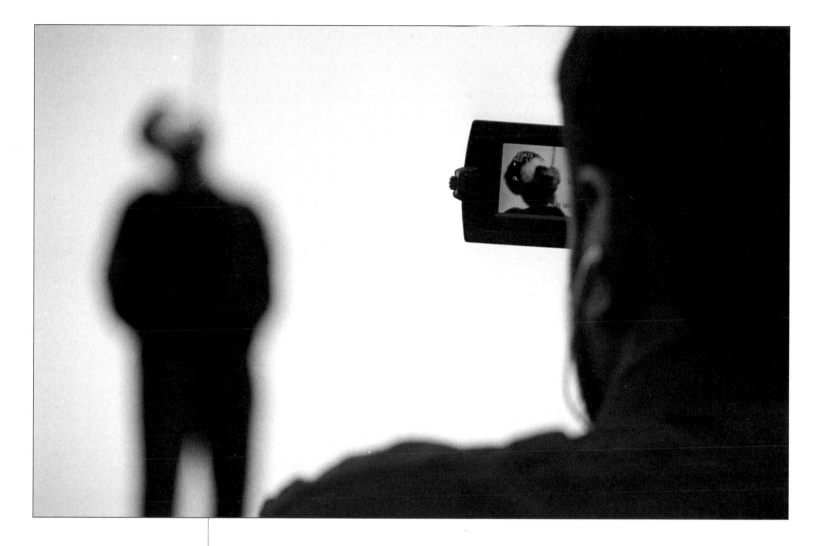

Morteza Nikoubazl
27 October 2002

An Iranian police cameraman films the hanging of convicted murderer Hashem Auharniya in Tehran.

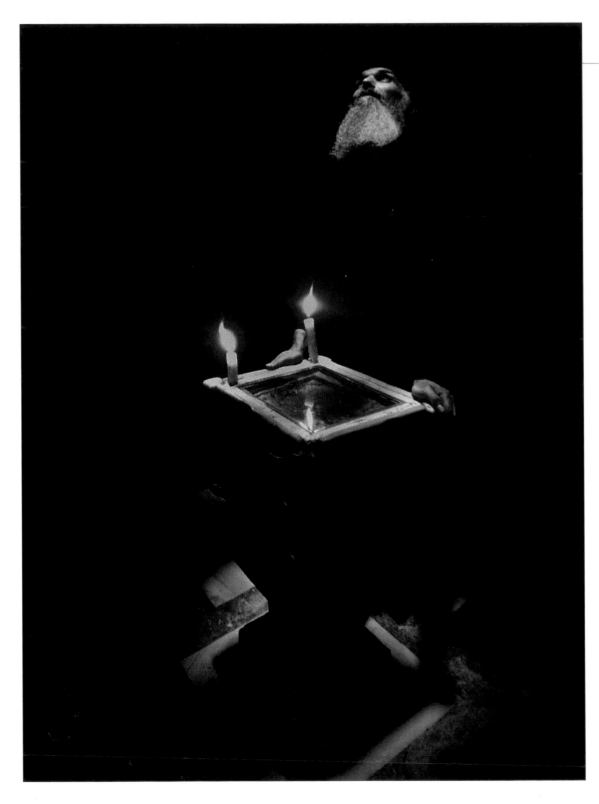

■ **Yannis Behrakis**
17 June 2002

A Greek Orthodox monk stares through a hole inside Christ's tomb in the Church of the Holy Sepulchre in east Jerusalem.

■ Ian Waldie

4 August 2001

Britain's Queen Elizabeth is seen beyond the gates of Clarence House, during celebrations to mark her mother's 101st birthday.

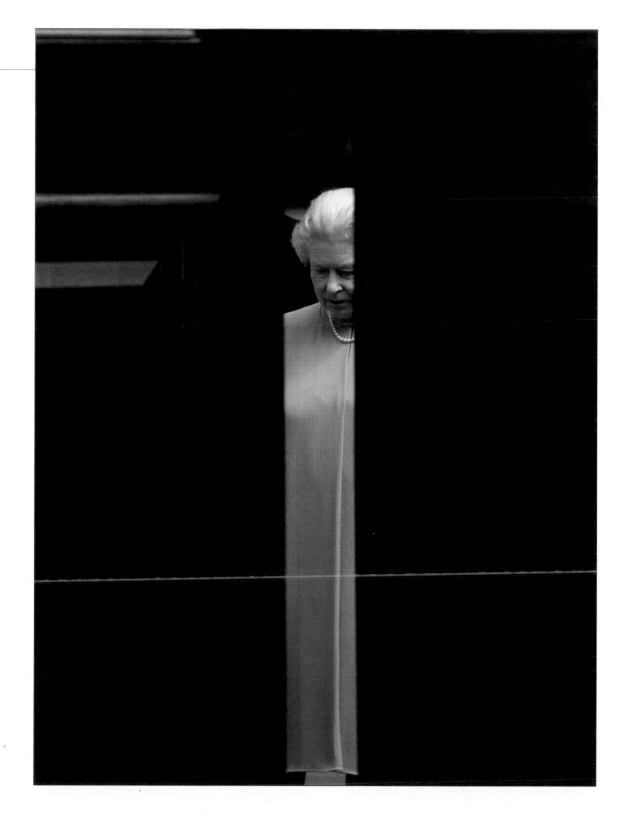

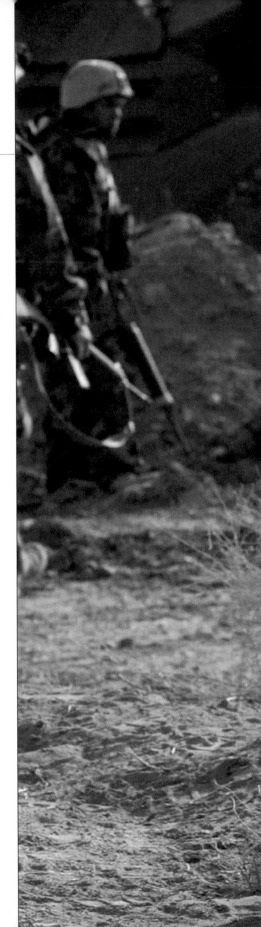

■ Damir Sagolj
29 March 2003

A U.S. Marine doctor holds an Iraqi girl caught in frontline crossfire which killed her mother in central Iraq. The photographer recalls:

'This was one of these absurd war scenes that can occur where there is no exact front line between sides and the positions of the troops are changing quickly.

'I was camping with the Kilo company of the 1st Marines Division, just before a hostile village on their way from the southern city of Nassiriya to Baghdad.

'The Marines knew that some of Saddam's fighters were in the village – the situation was tense. There had been sporadic fire all day, but just as we were beginning to think we had had a reasonably easy day, we heard machine-gun fire just 50 metres from where we were standing.

'A few minutes of chaos followed, with everybody shooting heavily, helicopters in the air, and tanks and troops moving to defend and attack. There were too many things happening at the same time and I was struggling to stay cool in such a "saturated" situation.

'When the heavy shooting stopped, we realized that the vehicle approaching our checkpoint was a civilian family with children. There was a military truck behind it. All of a sudden it had opened fire at the family's car – or at the Marines' position.

'A few gunmen were killed, some wounded, but the family in the car was caught in crossfire and needed help. Men were waving with their white shirts and screaming for help. Although the site was still very dangerous and some of the gunmen had escaped, several Marines were sent to help the family and bring them to safety.

'Though I understood very few Arabic words, I understood enough to realize that two of the young girls being attended to by the Marine Medics were screaming for their mother, killed in the shooting, and for their wounded father.

'Moments later, behind an army vehicle and somehow separated from the chaos of the scene, Wilson Barnett, a Marine medic, was sitting on the ground holding one of the girls in his arms, clearly moved. Despite his comrades running around trying to organize evacuation of the injured and arresting or treating for wounds other Iraqis involved in the incident, Barnett was just sitting there, holding the girl. I would, normally, go close to them and use my wide angle lens, but the scene was strong and I did not want to interfere. Instead I chose a long lens and few pictures. A few minutes later helicopters were in the air and the family was evacuated. The body of the mother was left behind in the middle of the road. There was just enough time to save the wounded and send them for better medical treatment.'

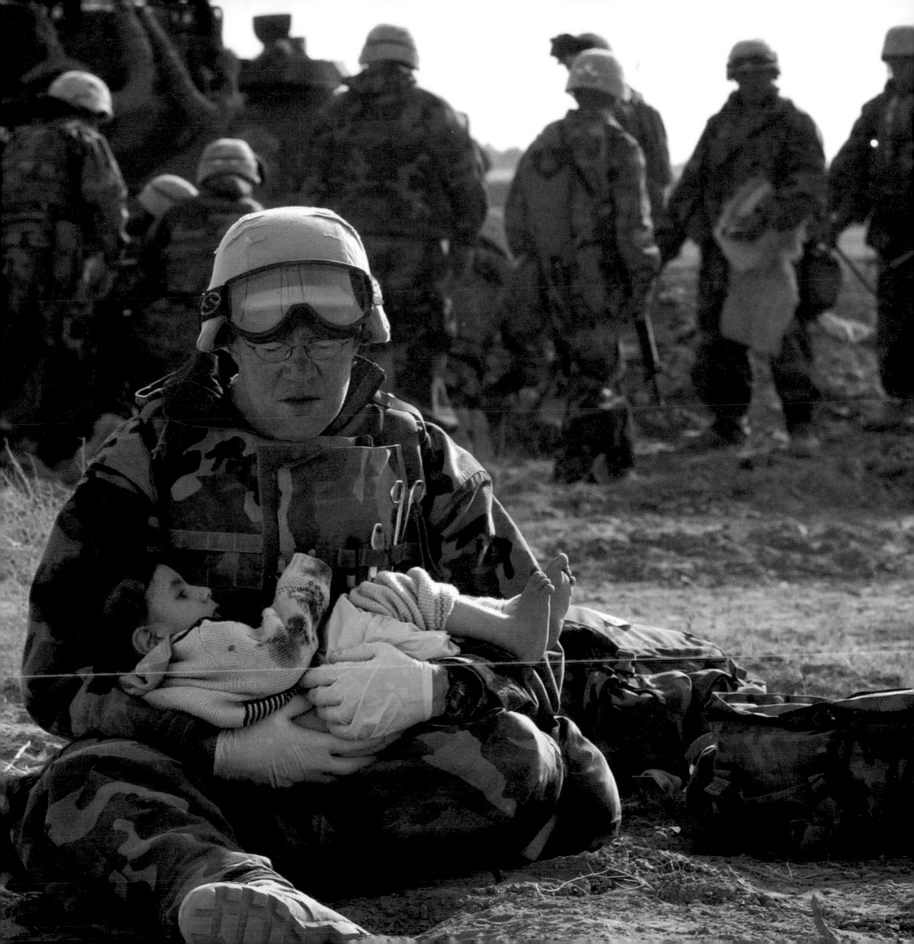

■ **Tobias Schwarz**
19 November 2002

Michael Jackson dangles his baby son out of a Berlin hotel window as stunned fans watch below in an incident which sparked international outrage. The U.S. pop star appeared to lose his grip on his third child, Prince Michael II, before bundling him back inside. Jackson later described the incident as a terrible mistake after he drew fire from child welfare groups around the world.

Reuters photographer, Tobias Schwarz, who captured the image exclusively in 2002, recalls, 'When Jackson arrived in the German capital, where he was due to pick up a Bambi 2002 media award for his lifetime achievement in music, I was waiting for him at the main entrance of the hotel with around 50 other media representatives. Eventually he turned up and ghosted past us up to his room amid a seething scrum of security guards, ecstatic fans and media. No sooner had he arrived than he was gone, holed up inside his suite – and the lobby was left looking like a battlefield.

'I decided to stay for a while with the fans at the hotel and after hours of waiting, he emerged silhouetted at his window blind. Spurred on by the chants of his fans he finally presented his two children at the open window. For about three seconds he held the youngest of the children out the window. "That's a weird thing to do with your kid," I thought. Then he disappeared.

'Only later that evening did I realize the impact the photos would have. From that moment on, all the news agencies had their photographers on standby at the window night and day lest anything else occur. But it was not to be – nobody else was to have my luck.'

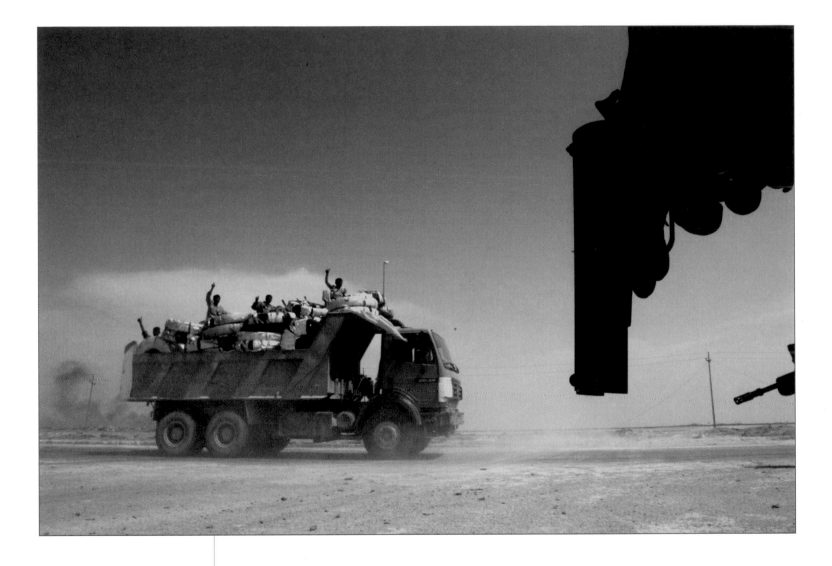

■ **Yannis Behrakis**
6 April 2003

A British army officer with a cocked handgun stands guard as Iraqi civilians flee fighting in Basra, southern Iraq.

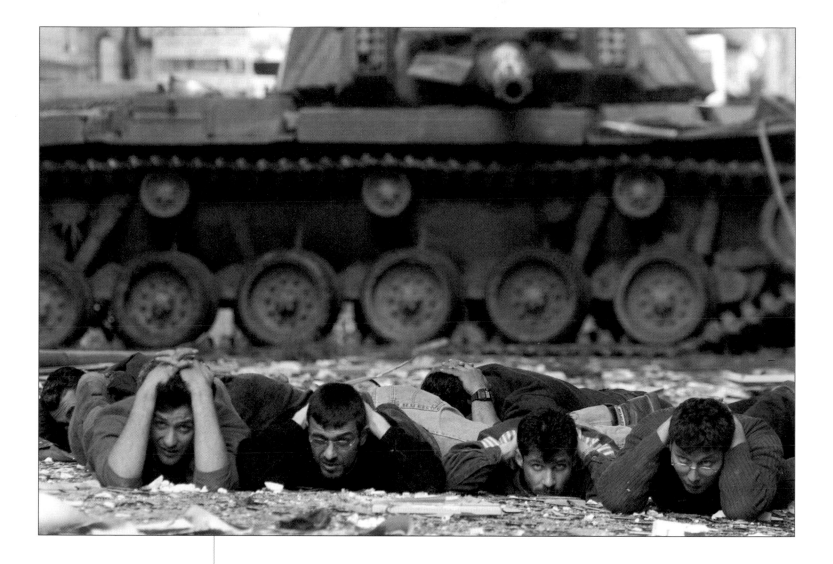

Laszlo Balogh
30 March 2002

Palestinians lie in front of an Israeli tank after their arrest during
an Israeli operation in the West Bank city of Ramallah.

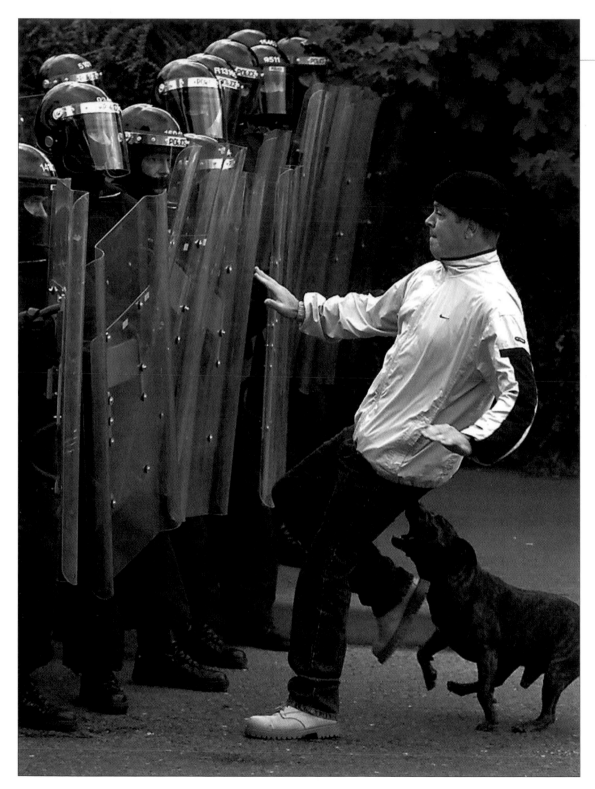

Jeff J Mitchell
30 June 2001

A nationalist protester in Belfast confronts police during Northern Ireland's volatile 'marching season' when pro-British loyalists mark Protestant King William of Orange's victory over Catholic King James at the Battle of the Boyne in 1690.

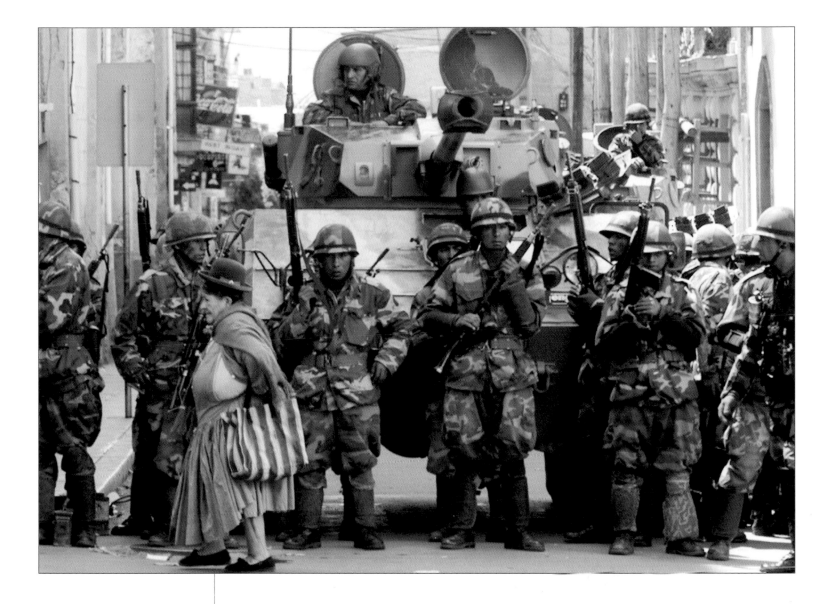

■ **David Mercado**
13 February 2003

A Bolivian woman passes soldiers in the capital, La Paz, after two days of protests against unpopular tax measures.

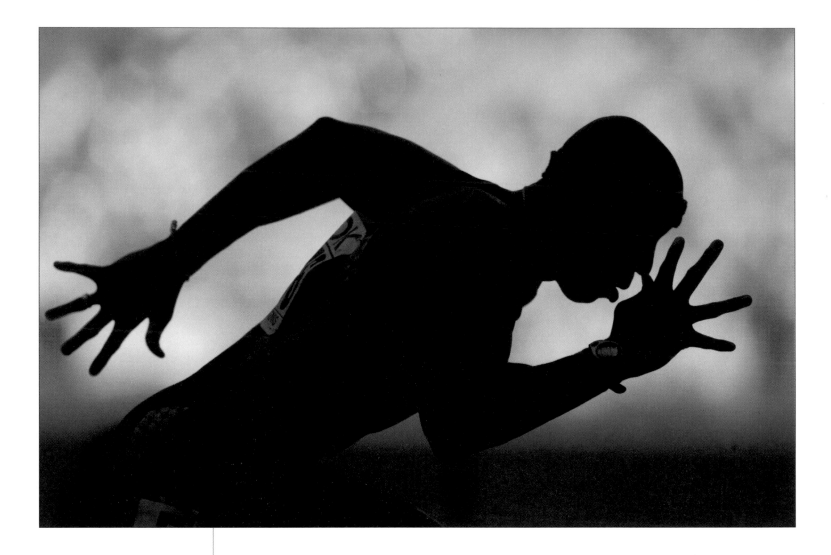

Gary Hershorn
24 August 2003

Tyree Washington of the United States runs a semi-final of the men's 400 metres at the 9th World Athletics Championships in the Stade de France.

■ **Laszlo Balogh**
25 May 2003

Kayakers in the women's K4 200m final leave the start line at the
Canoe World Cup in Szeged, Hungary.

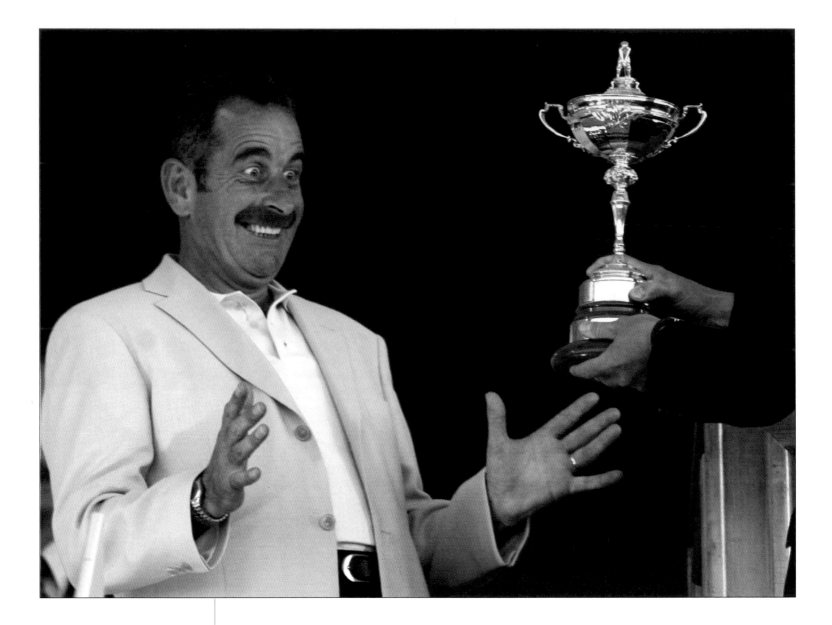

■ Win McNamee
29 September 2002

Golfer Sam Torrance accepts the Ryder Cup as captain of the European team at the Belfry, England, after beating the U.S. team.

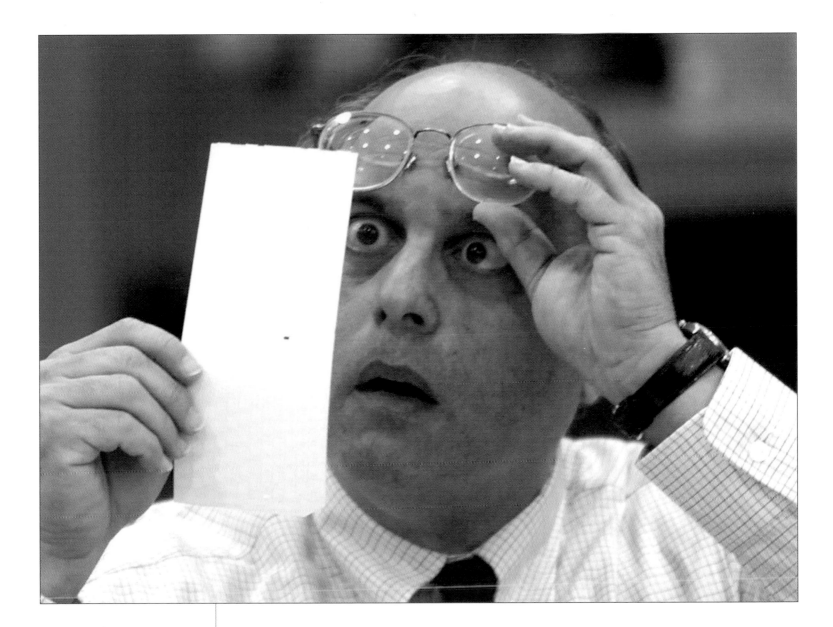

■ **Colin Braley**
23 November 2000

Judge Robert Rosenberg scrutinizes a ballot paper in Florida's Broward County, a key area which helped decide the cliffhanger U.S. presidential election in 2000. Counters painstakingly checked ballot papers for 'hanging chads', tiny pieces of paper that voters were supposed to have punched out on ballot papers. Machines rejected thousands of papers because they were not fully punched, leading to a manual recount.

■ Kevin Lamarque
19 November 2001

A turkey called Liberty takes President George W. Bush by surprise during a Thanksgiving ceremony at the White House.

'I thought this was going to be the usual photo opportunity,' recalls the photographer, 'turkey pardoning at Thanksgiving. When I looked at the image I had just shot, I broke out in laughter. I thought that European media might find the image amusing; in fact it was on many front pages. Needless to say, the following year, the turkey was kept at a greater distance from the president.'

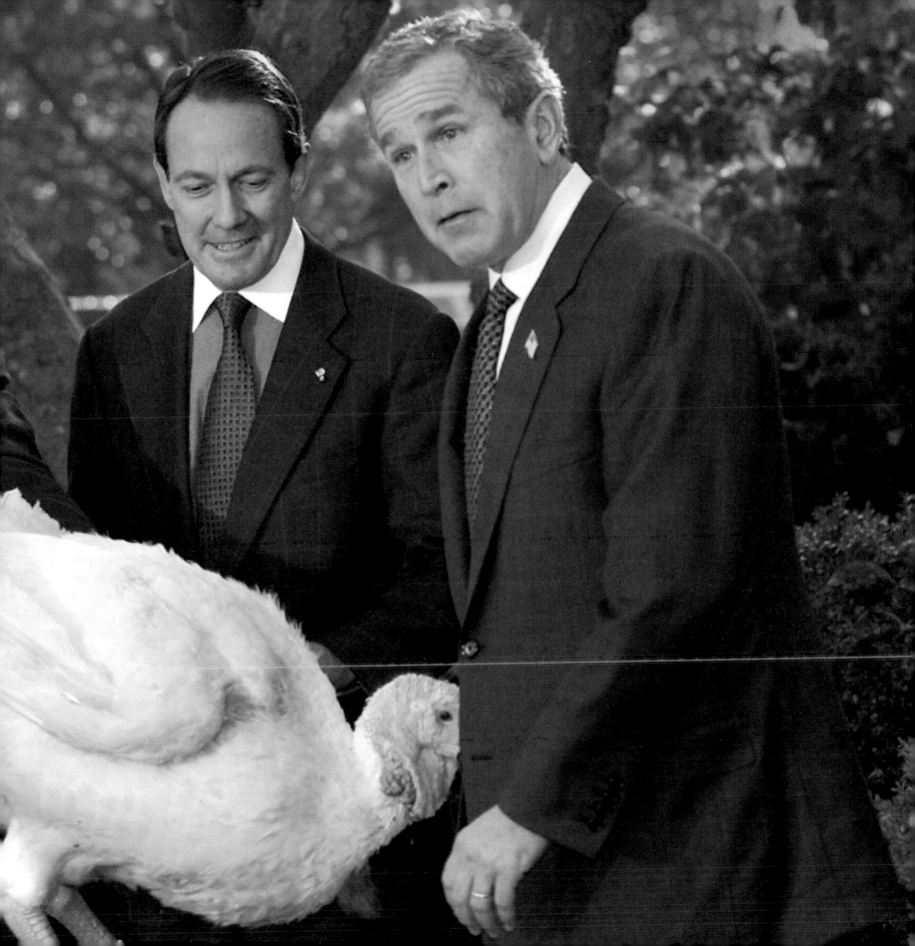

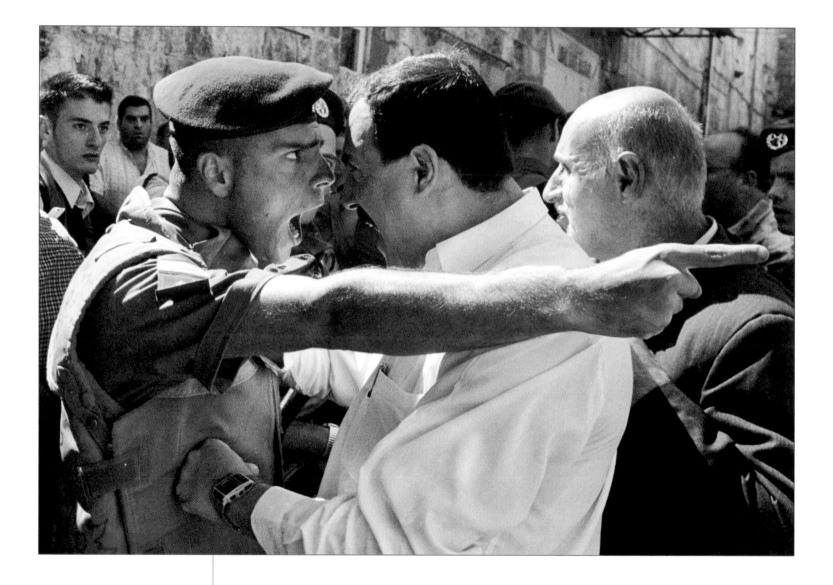

■ Amit Shabi
13 October 2000

An Israeli border guard and a Palestinian go head to head after security forces blocked thousands of people from entering al-Aqsa mosque during heightened tensions in Jerusalem.

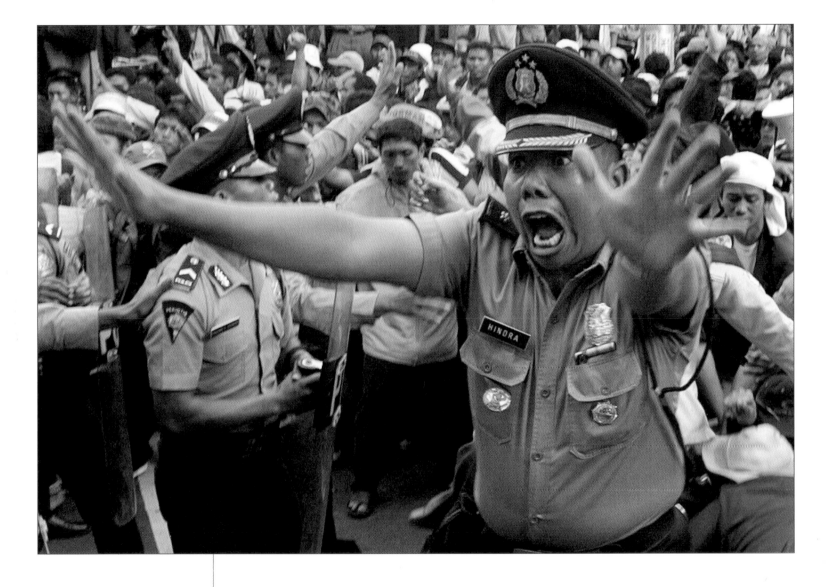

■ **Darren Whiteside**
6 February 2003

An Indonesian policeman shouts during a clash with anti-government protesters in Jakarta.

■ Desmond Boylan
7 July 2002

A fighting bull slips on the wet streets as it charges through central Pamplona during the first run of the San Fermin Festival.

The image of the bull, already bearing a T-shirt trophy on one of its horns, ran in the world's press and sparked a flood of concern about the photographer's fate.

One German newspaper ran the photo with a headline asking, 'How well is the photographer?' while a Scandinavian picture agency rang Reuters to inquire if Boylan had been killed.

But although thousands regularly join the beasts for the annual running of the bulls during the week-long festival, Boylan remained safely behind the barriers set up along the route.

Armed with a remote control, Boylan said he wrapped his camera in wads of bubble wrap leaving just the lens poking out and slid it out under the barrier on to the road. 'It was pandemonium. I saw the bulls coming – it was the biggest rush of adrenaline,' said Boylan, who snapped off two frames just as one beast came crashing towards the barrier.

Each year several people are gored or trampled by the bulls as they run through the streets of the Spanish town. Since records began in 1924, a total of 13 runners have been killed and hundreds more injured by the bulls.

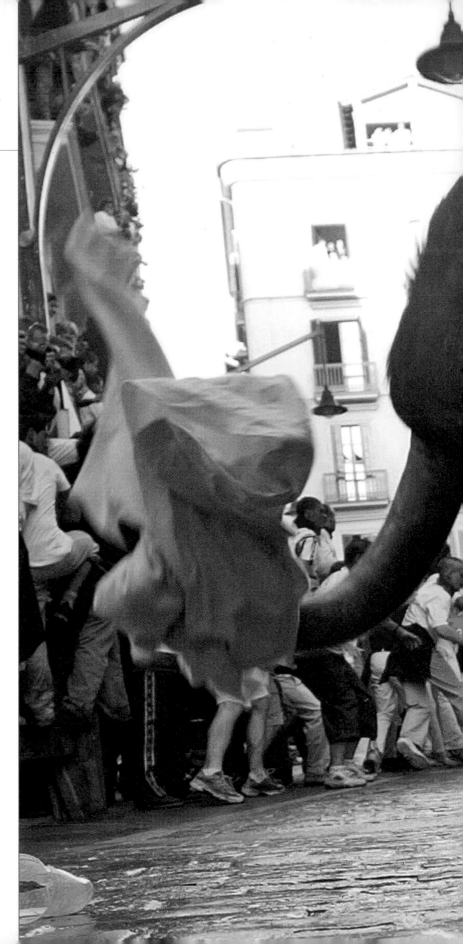

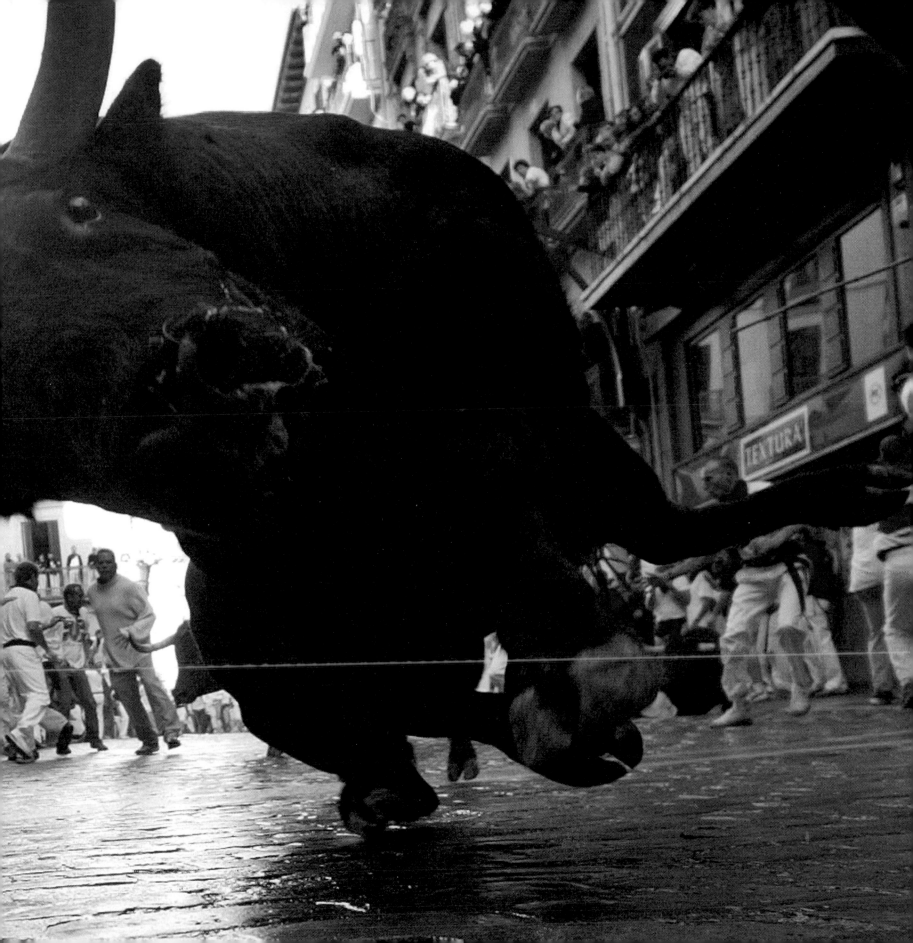

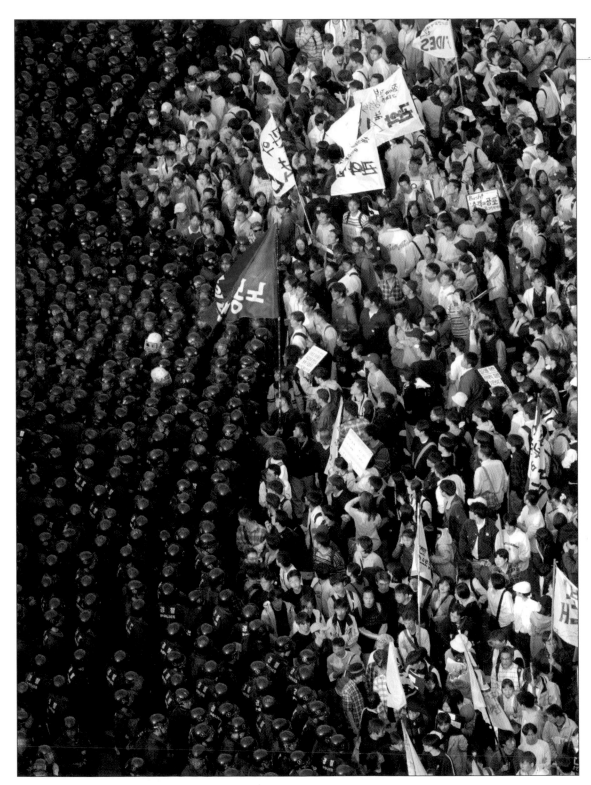

■ **Kim Kyung-Hoon**
2 April 2003

South Korean riot police block protesters trying to march to the National Assembly in Seoul as parliament votes to send non-combat troops to Iraq.

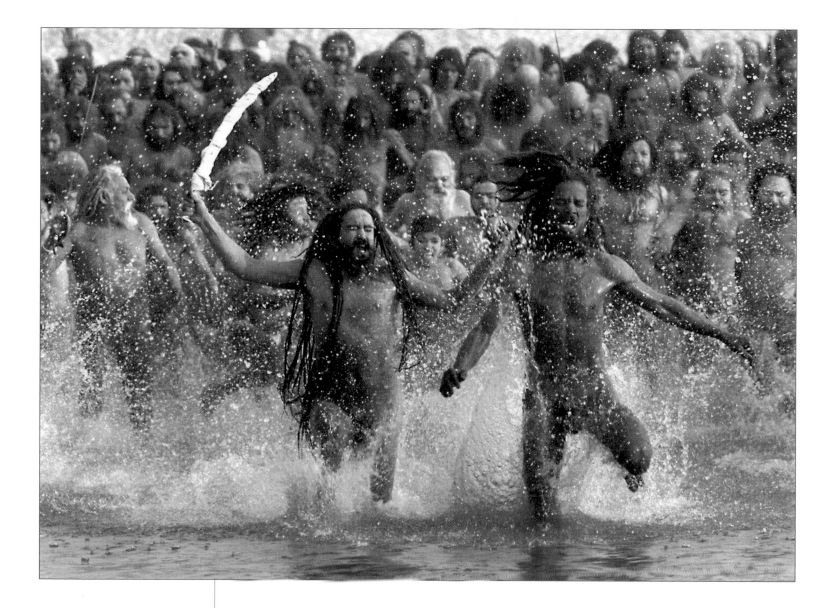

Pawel Kopczynski
14 January 2001

Hindu holy men charge into India's holiest river, the Ganges, for a sin-cleansing dip during 'Maha Kumbh Mela', or the Great Pitcher Festival, in the northern Indian city of Allahabad.

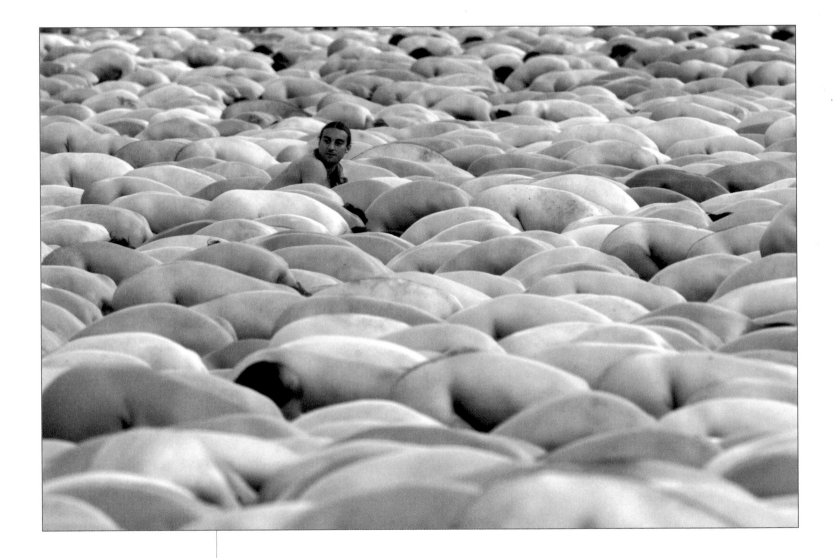

■ **Albert Gea**
8 June 2003

Volunteers pose nude in Barcelona for New York artist Spencer Tunick's installation.

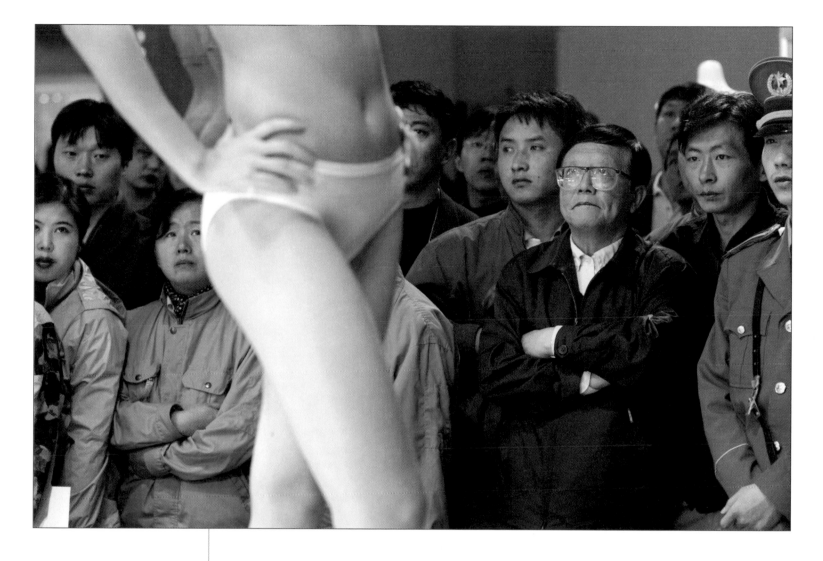

■ **Guang Niu**
18 October 2002

Crowds watch a model on the catwalk at a fashion show in Beijing.

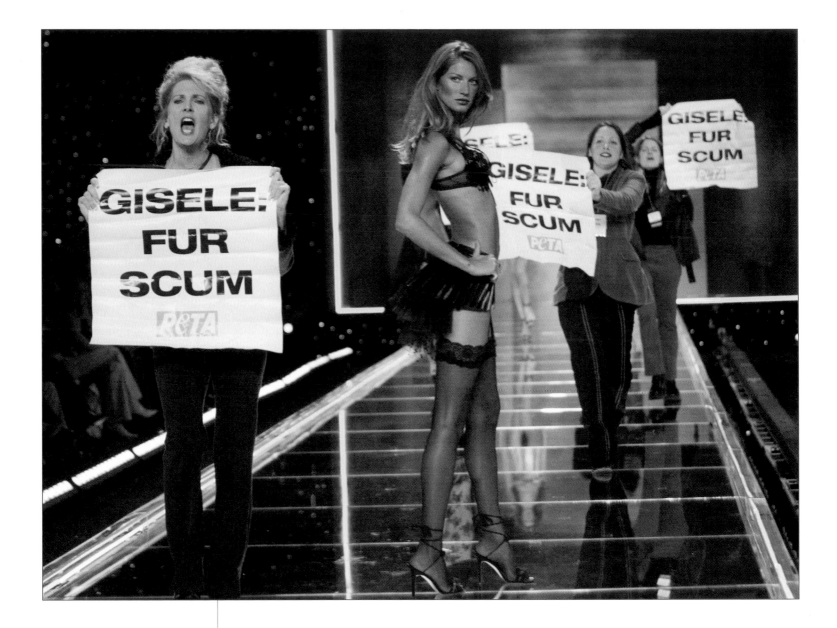

■ **Mike Segar**
14 November 2002

Animal welfare protesters surround Brazilian supermodel Gisele
Bundchen during a fashion show in New York.

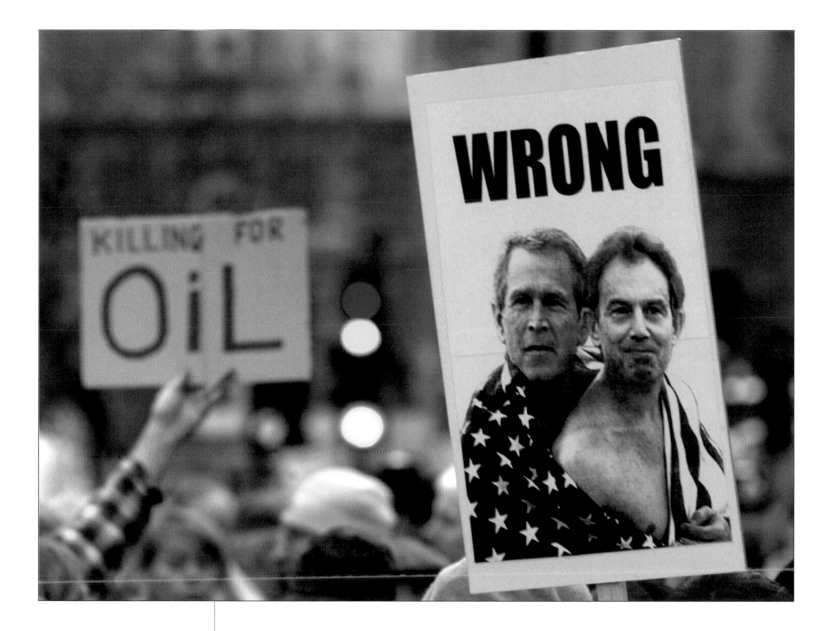

■ Stephen Hird
21 January 2003

Demonstrators protest against Britain sending troops to Iraq outside the Houses of Parliament in London. Millions took part in a wave of anti-war protests across the world.

■ **Joachim Herrmann**
11 June 2003

Beachgoers, with their territory marked by small walls of sand at the beach of Travemuende outside the northern German city of Luebeck.

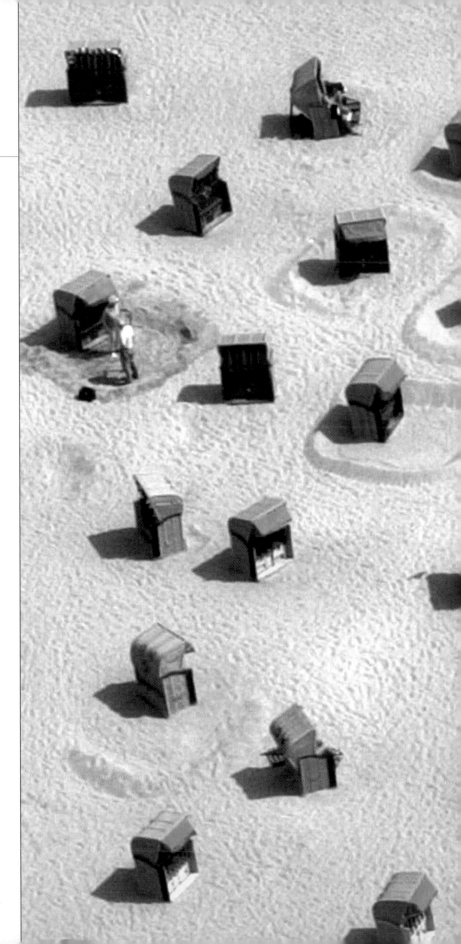

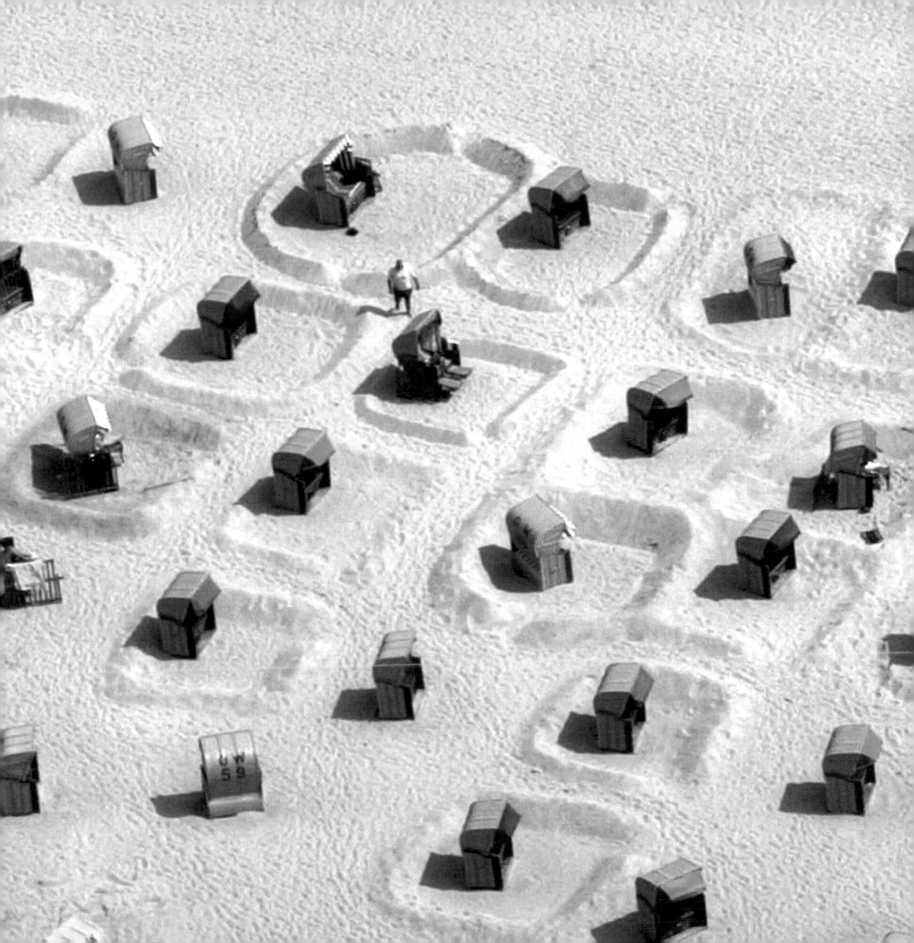

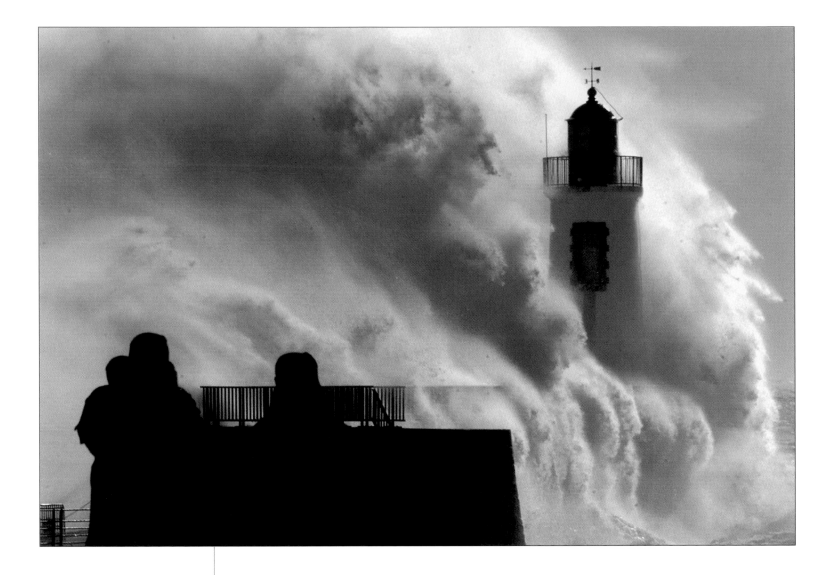

■ **Charles Platiau**
6 November 2000

A huge wave batters a lighthouse on France's Atlantic coast after bad weather delayed the start of the fourth Vendeé Globe round-the-world yacht race.

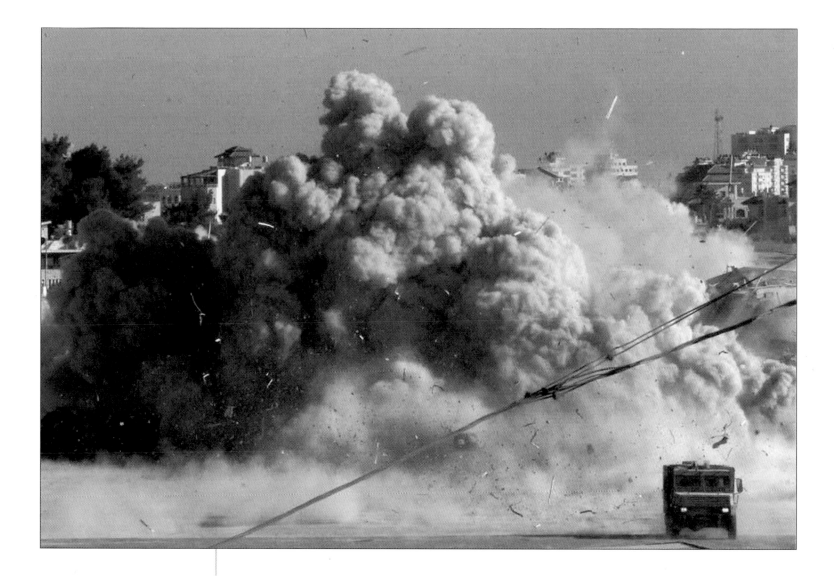

■ **Ammar Awad**
20 September 2002

The Israeli army blows up part of Palestinian President Yasser Arafat's Ramallah compound after a suicide bomber killed six people on an Israeli bus.

■ Nadezhda Breshkovskaya
21 March 2001

Young seals are trapped in a net after being caught on the ice of the White Sea, northern Russia.

■ **Dan Chung**
16 January 2001

Hounds wait to be unloaded from their van at the start of a day's fox hunting in Northumberland, northern England.

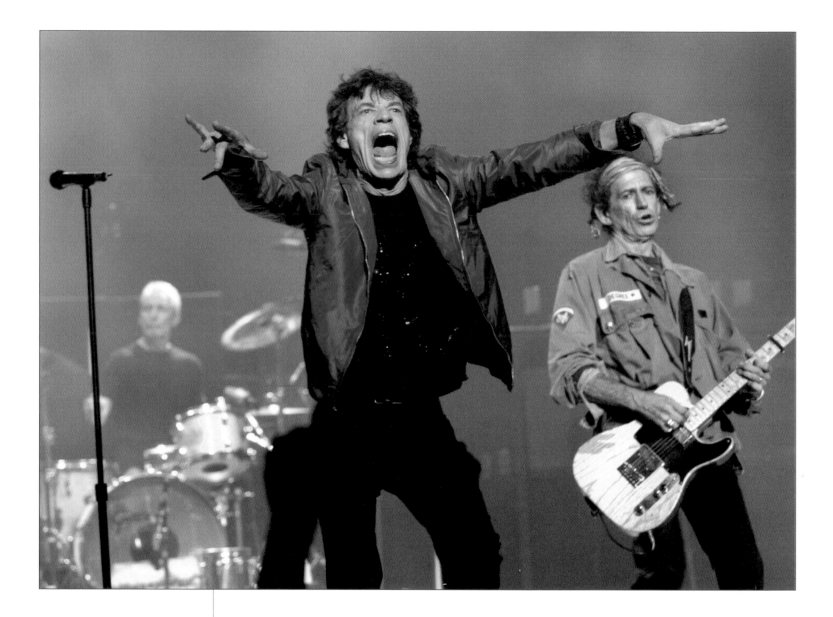

■ **Robert Galbraith**
4 November 2002

Rolling Stones singer Mick Jagger and guitarist Keith Richards perform 'Jumpin' Jack Flash' in Los Angeles.

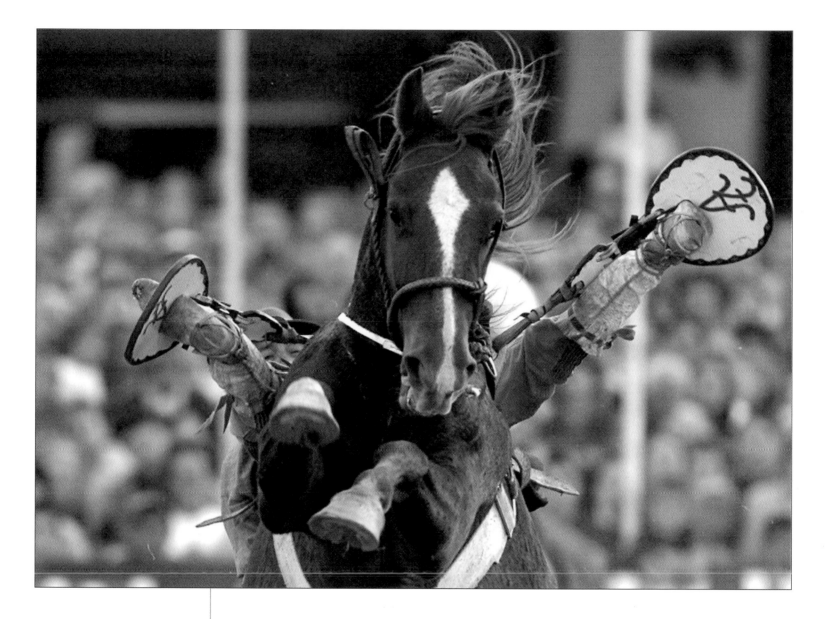

Andres Stapff
14 April 2003

A Uruguayan gaucho rides a wild horse during an annual
competition for South American cowboys.

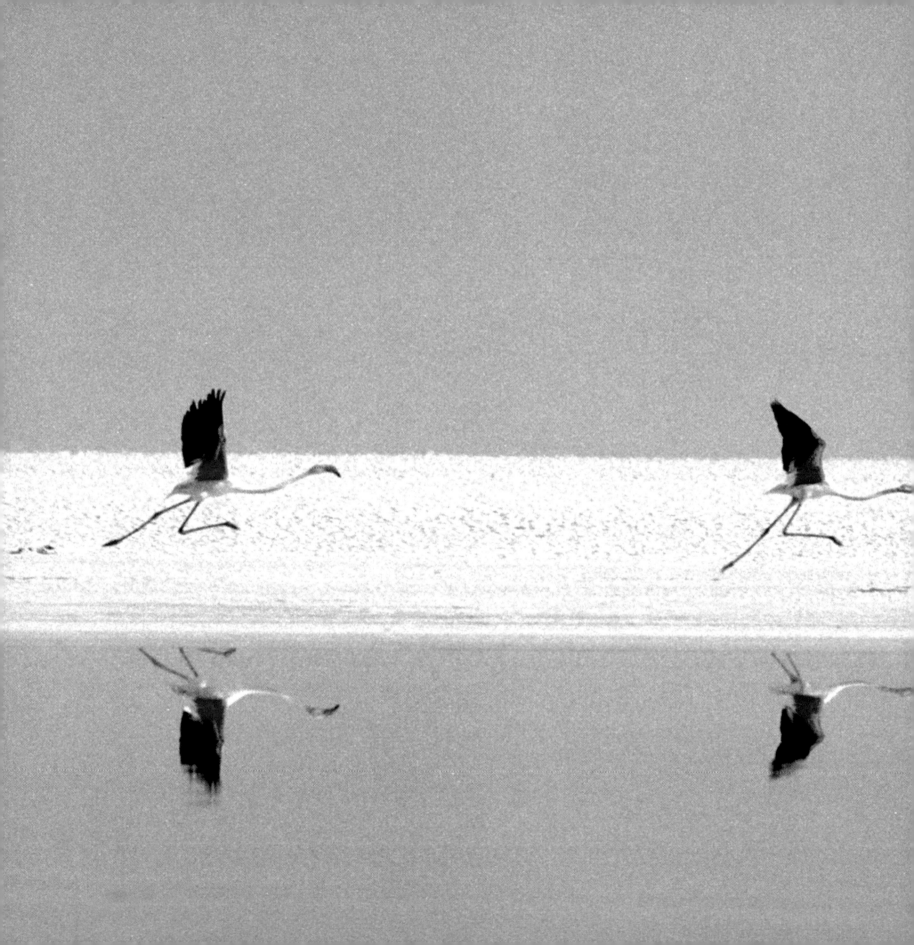

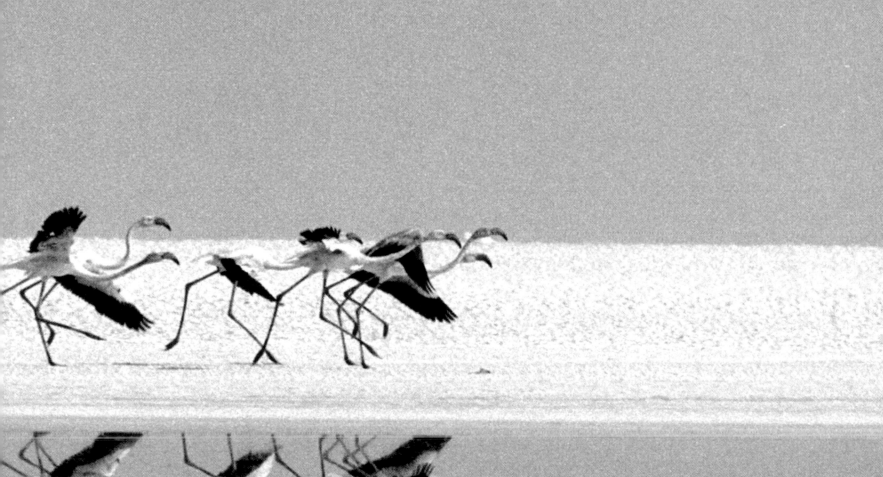

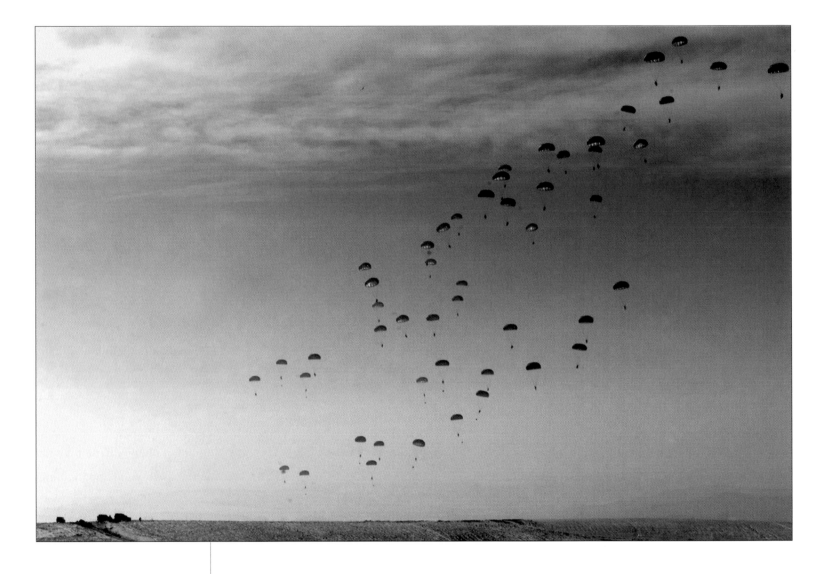

■ **Hazir Reka**
15 January 2003

U.S. army parachutists drop during an exercise west of
Kosovo's capital, Pristina.

Previous page
■ **Caren Firouz**
22 July 2001

Flamingos run across a dried-up salt lake in
southern Iran.

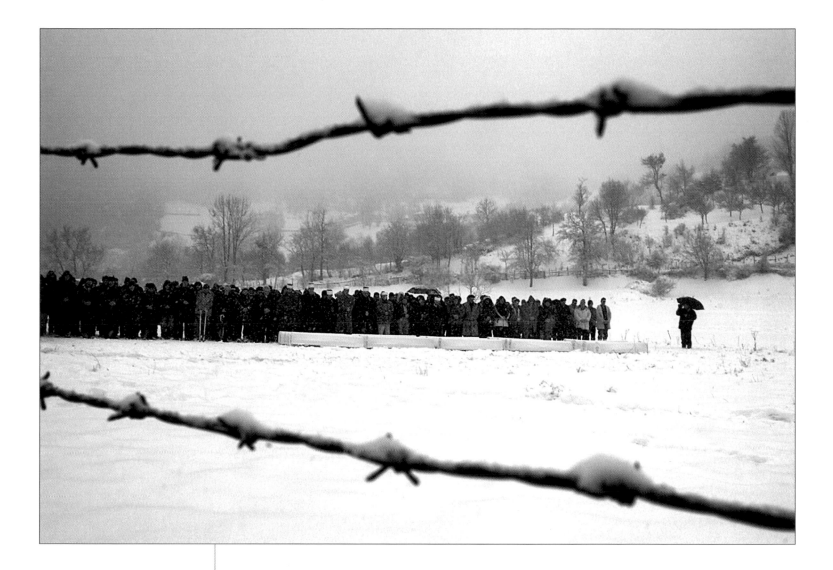

■ **Damir Sagolj**
13 January 2001

Bosnian Muslims brave the snow to attend the funerals of relatives and friends killed in the country's war and those found in mass graves near Foca, southeast of Sarajevo.

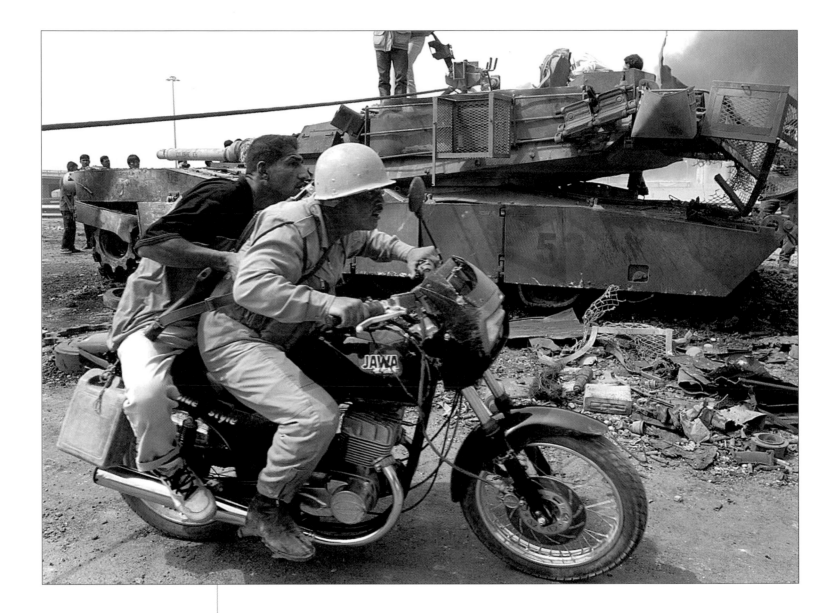

■ Goran Tomasevic
6 April 2003

An Iraqi soldier rides past a destroyed U.S. tank in Baghdad.

■ **Chris Helgren**
28 March 2003

A family runs for cover after a mortar attack on British army positions in Basra, southern Iraq.

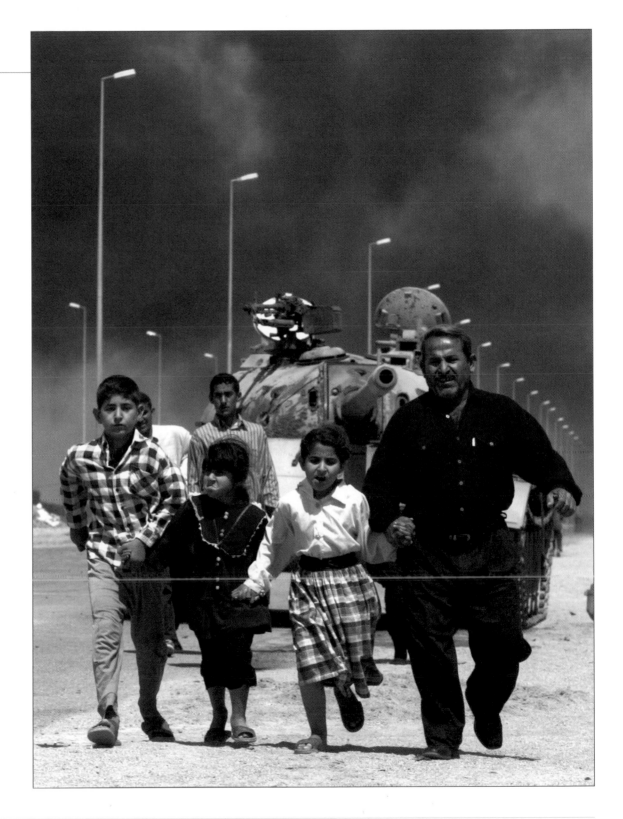

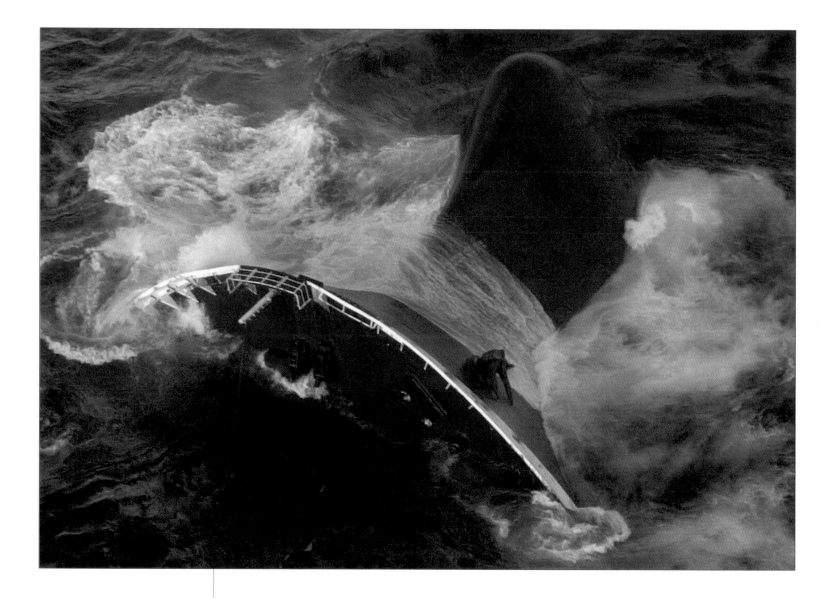

Paul Hanna
19 November 2002

The bow of the Prestige oil tanker sinks off northwestern
Spain, sparking an environmental disaster.

■ **Anton Meres**
8 October 2002

Coast guards rescue an illegal immigrant off southern Spain after a boat carrying scores of people from Africa overturned.

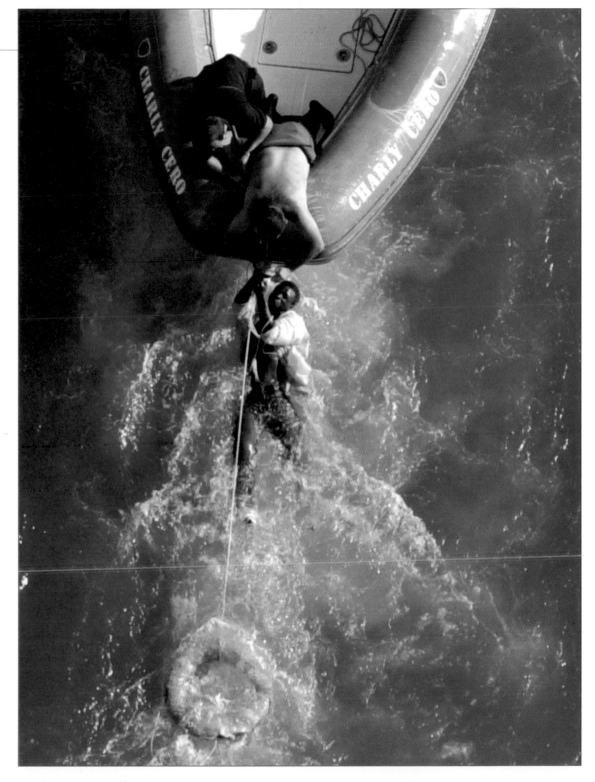

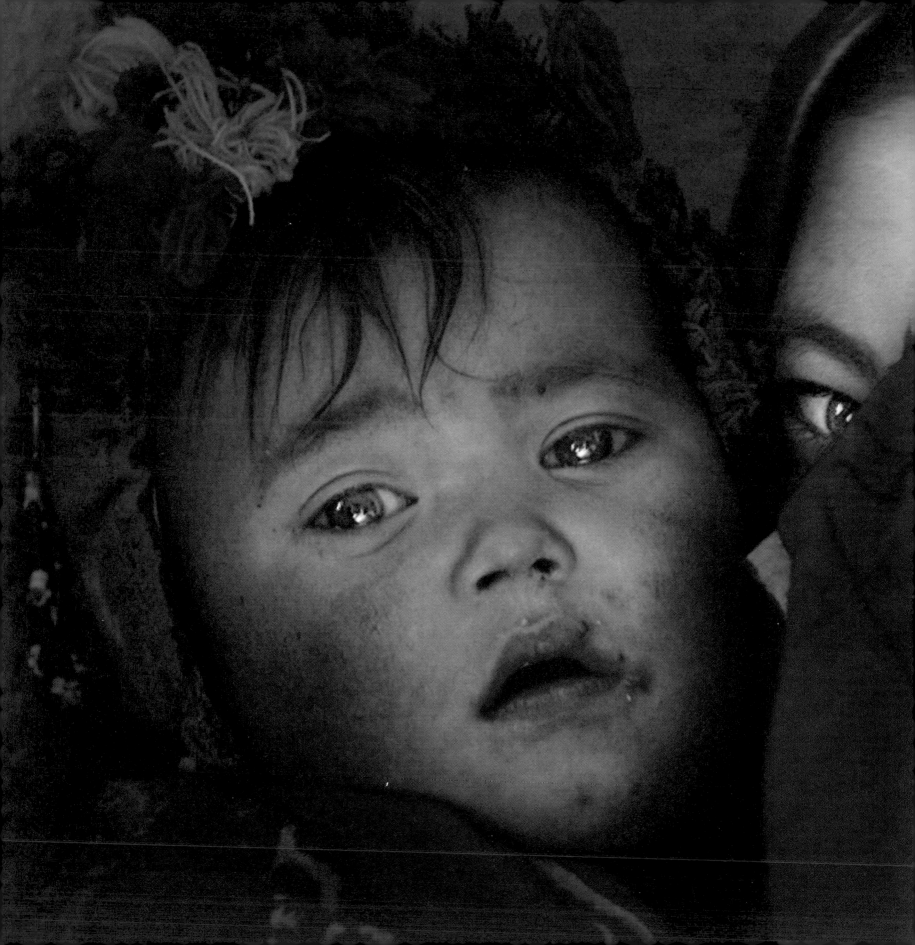

■ **Peter Andrews**
15 December 2001

A Hazara girl holds a child in a cave in Bamiyan, Afghanistan, where two giant Buddha statues stood for centuries before the Taliban blew them up.

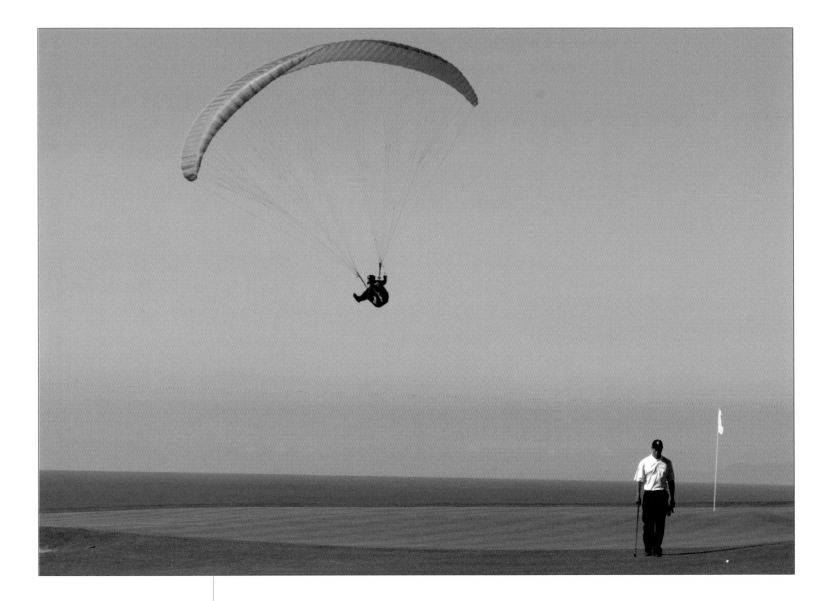

Mike Blake
14 February 2003

A paraglider sails past world number one golfer Tiger Woods as he lines up a shot during the Buick Invitational PGA event in California.

■ **Shaun Best**
31 May 2002

France's goalkeeper Fabien Barthez stands alone after Senegal beat his side in the World Cup finals in Seoul.

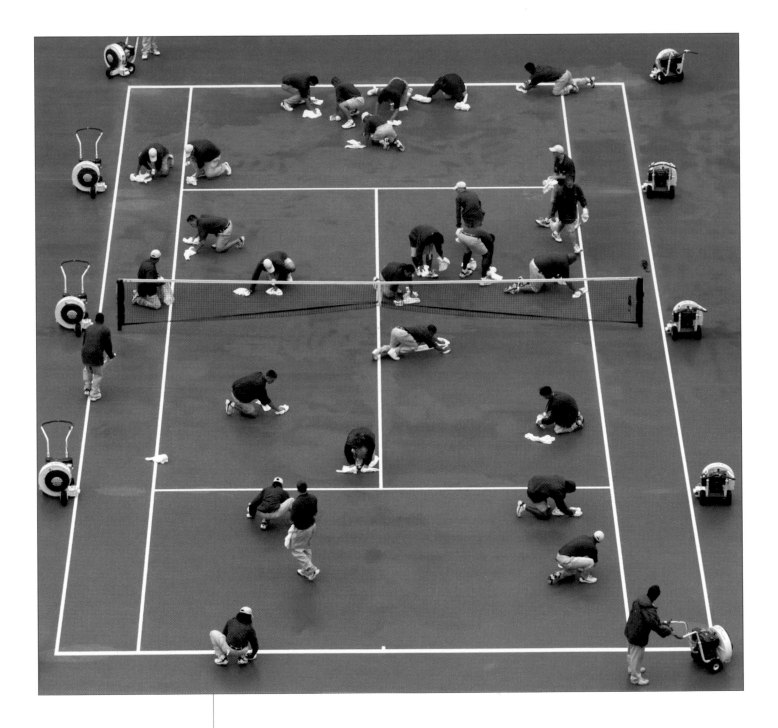

Kevin Lamarque
29 August 2002

Workers dry a tennis court after rain delayed play at the U.S. Open in Flushing Meadows, New York.

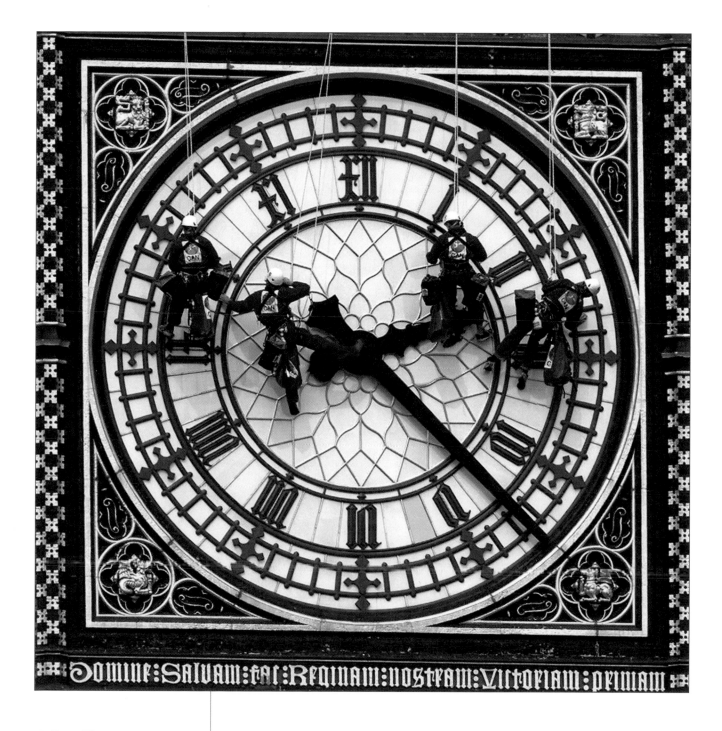

■ **Dan Chung**
20 August 2001

Abseiling cleaners tackle the face of Big Ben at the Houses of
Parliament in London.

■ **Goran Tomasevic**
9 April 2003

A U.S. soldier watches as a statue of Saddam Hussein falls in central Baghdad. In scenes reminiscent of the fall of the Berlin Wall in 1989, youths attacked the statue's marble plinth and looped a rope around its neck. A U.S. armoured vehicle helped to topple it.

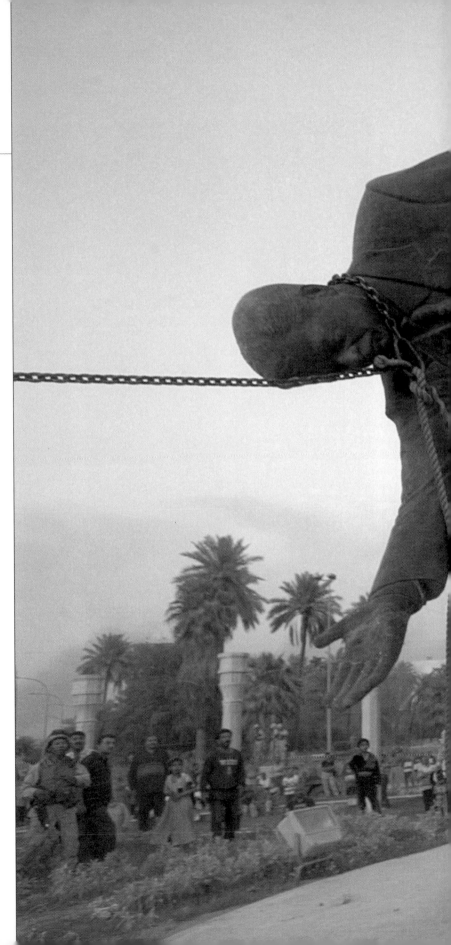

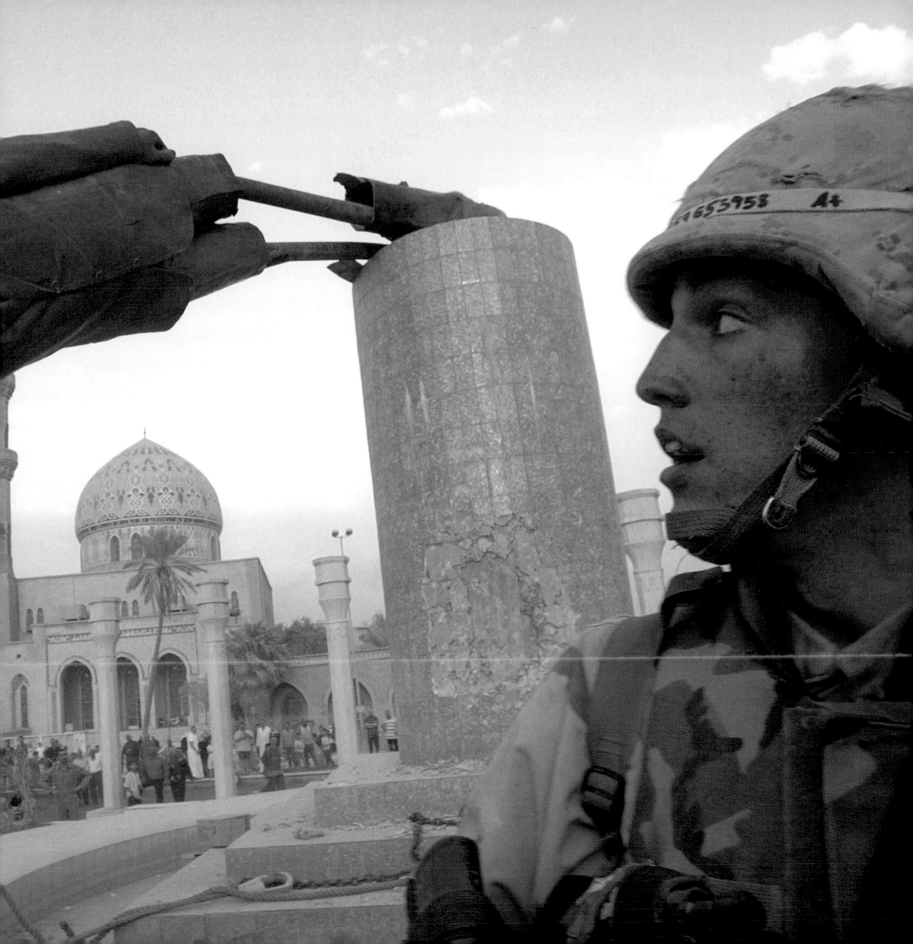

■ **David Gray**
28 September 2000

Athletes compete in the women's 20km walk final at the Sydney Olympics.

■ **Dylan Martinez**
20 November 2002

AS Roma fans protest against alleged bias by referees outside
the offices of the national football federation in central Rome.

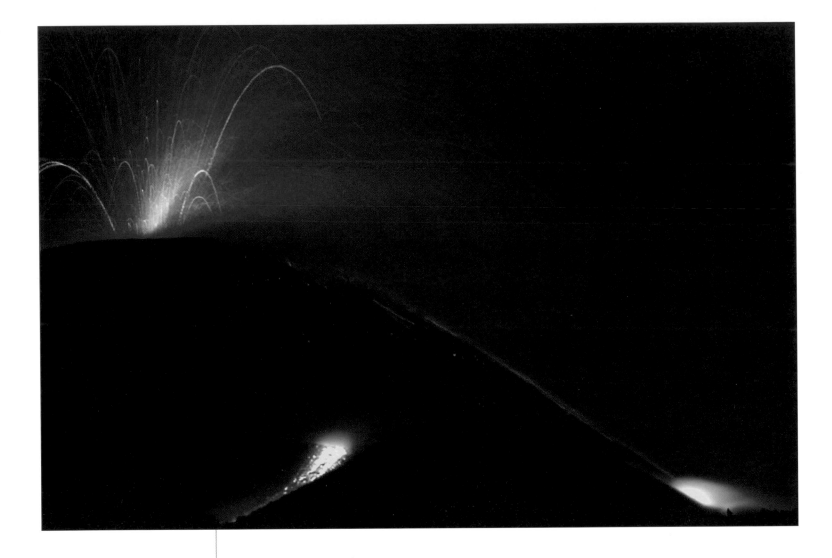

■ Tony Gentile
23 November 2002

Mount Etna spews red-hot lava during an eruption on Sicily.
The eruption, triggered by a series of earthquakes, destroyed
a few buildings and rained ash on Sicily's second-largest city
Catania, but claimed no lives.

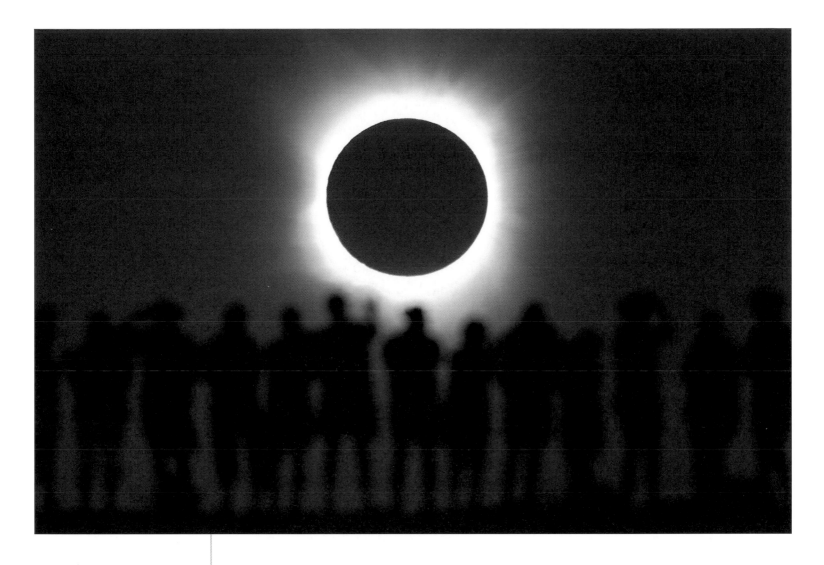

David Gray
4 December 2002

Tourists watch a solar eclipse in the Australian outback.

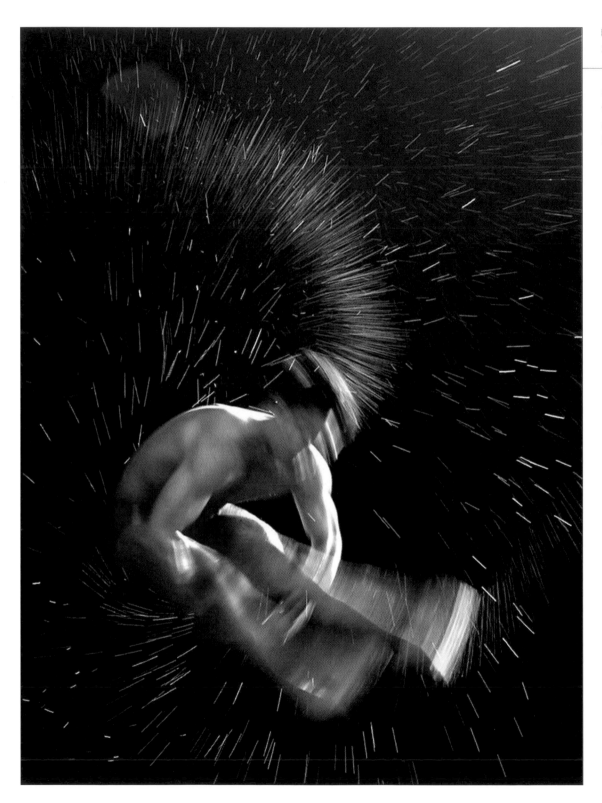

David Gray
26 July 2002

Canada's Alexandre Despatie tumbles during a practise dive at the Commonwealth Games in Manchester.

■ Dan Chung
14 September 2002

A model wears a tropical paradise-themed costume by Welsh designer Julien Macdonald at London Fashion Week.

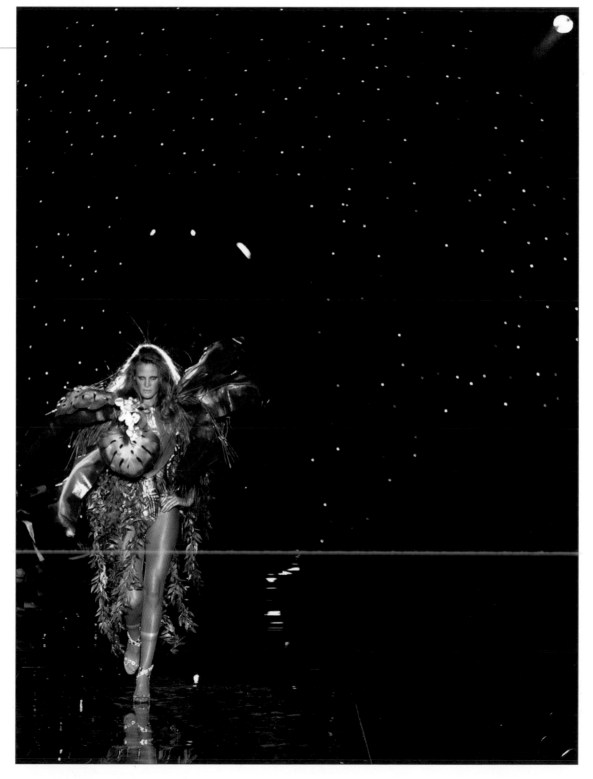

■ China Photo
August 2000

Chinese boat trackers, called 'Qian Fu', pull a vessel upstream along the Wu Jiang river, a tributary of the Yangtze River in the Sichuan province, as their ancestors have been doing for thousands of years.

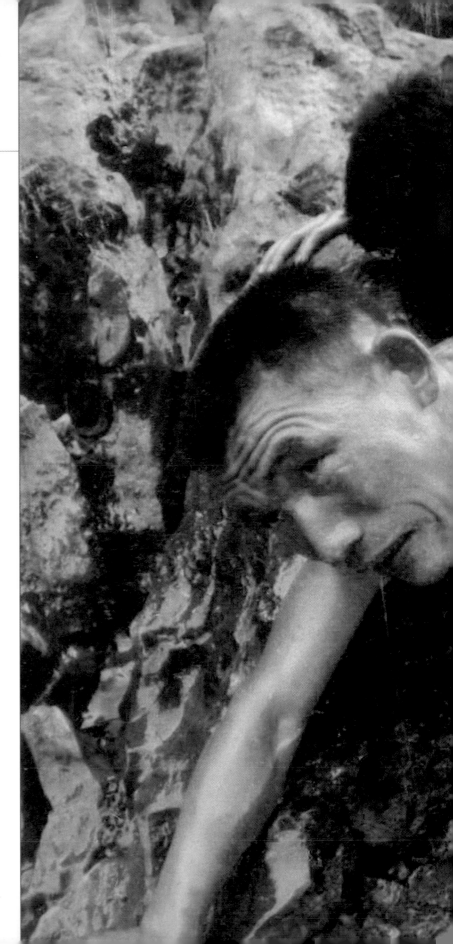

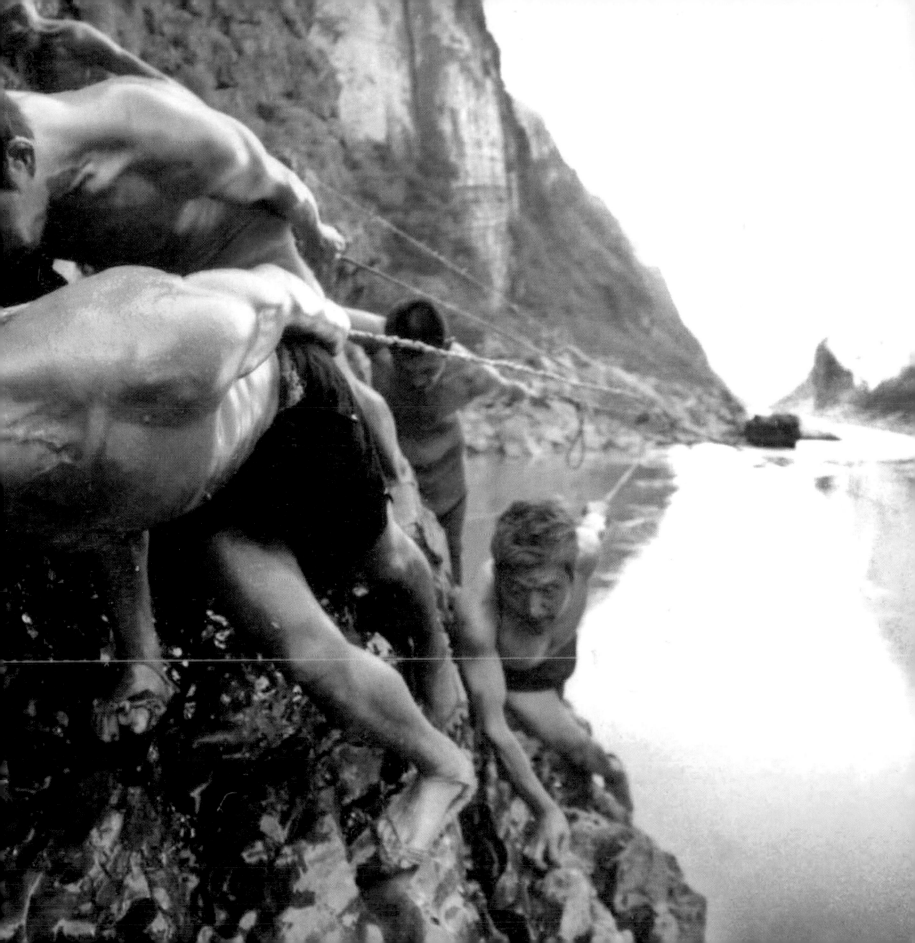

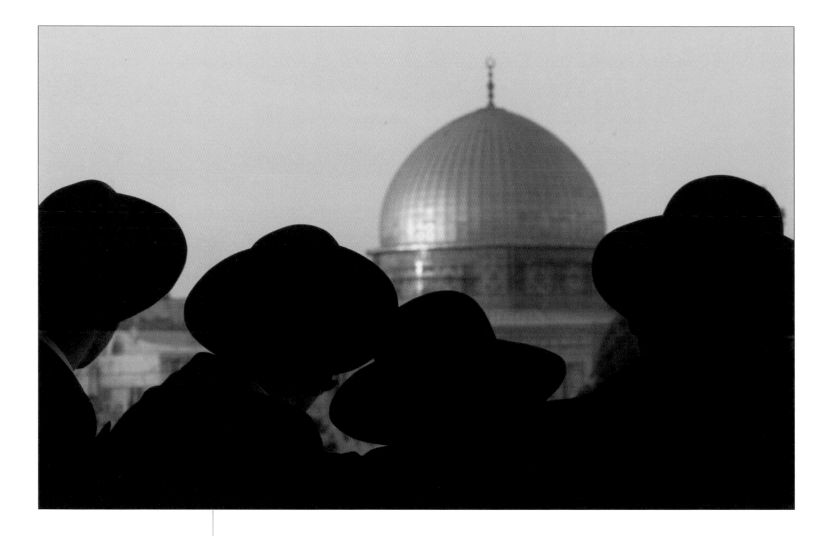

■ **Oleg Popov**
8 August 2002

Ultra-Orthodox Jews demonstrate near the Dome of the Rock mosque in Jerusalem.

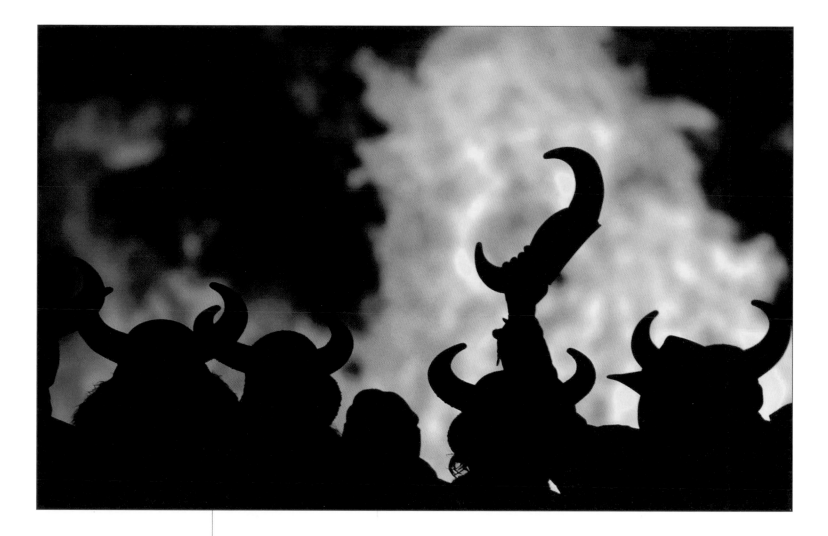

■ **Jeff J Mitchell**
28 January 2003

Locals dressed in costume are silhouetted against a burning replica Viking galley in Lerwick during the Up Helly Aa Festival on the Shetland Islands in Scotland. The festival, introduced by men returning from the Napoleonic Wars of the early 19th century, takes place annually on the last Tuesday of January. Participants drag the replica Viking galley through the streets of Lerwick to a designated point where it is ceremonially burnt.

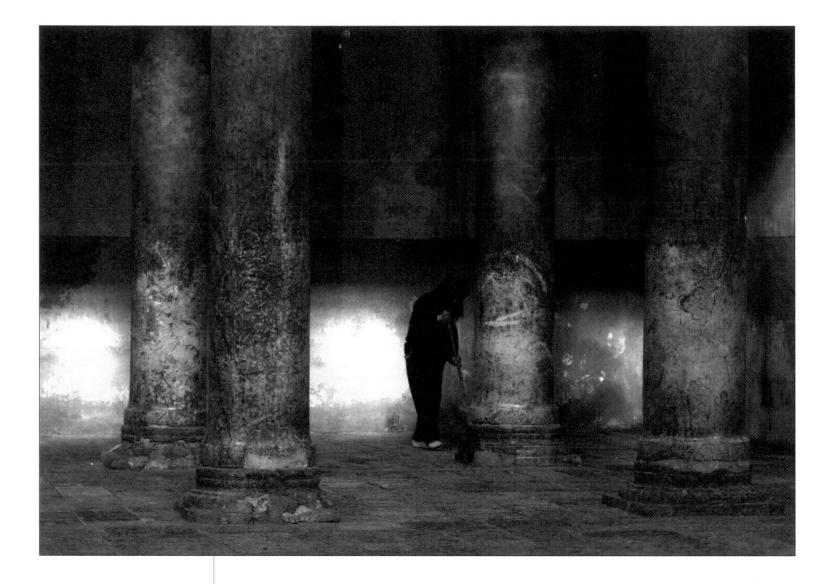

■ **Yannis Behrakis**
23 December 2002

A cleaner sweeps the floor of the Church of the Nativity, which marks one of Christianity's most sacred sites, Christ's birthplace in Bethlehem.

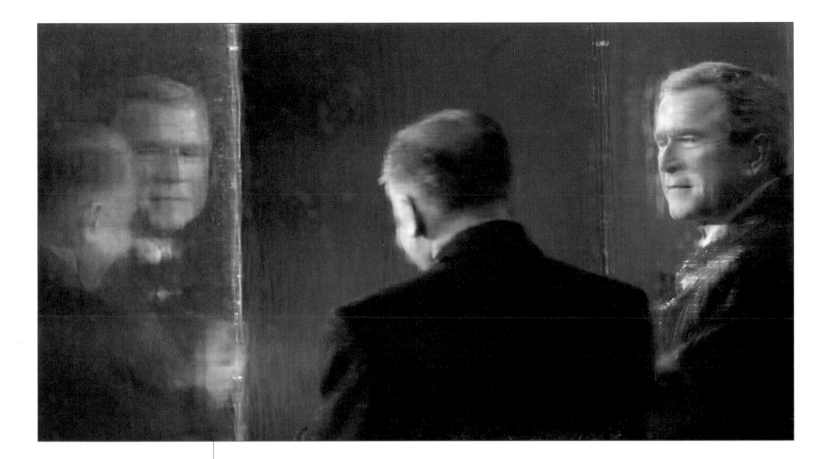

■ **Kevin Lamarque**
23 November 2002

U.S. President George W. Bush and Romanian President Ion
Iliescu are reflected in bullet-proof glass in Bucharest.

■ **Goran Tomasevic**
21 March 2003

Flame and smoke leap into the Baghdad night sky during air strikes on the Iraqi capital. U.S.-led forces invaded Iraq in March 2003, toppling President Saddam Hussein.

The Pentagon warned Iraq to brace for U.S. 'shock and awe' tactics before the beginning of the campaign that would remove Saddam. Goran Tomasevic captured the first devastating blitz on the city, in these now instantly recognizable images.

'My sources told me that Baghdad would come under very heavy bombardment in the coming nights. So at around 7 o'clock in the evening I made my way to the 12th floor of the Palestine Hotel where the media were camped out. I had to force open several locked doors to find the best position from which to shoot my pictures. A French cameraman, who had set up on the balcony I chose, tried to force me to another location. But I was resolute and set up my tripod.

'Soon after this, the bombing began. It was incredibly heavy. I could not believe what was unfolding: yellow flashes all around, the balcony shook, huge blasts lit up the night sky. Baghdad was under attack, it felt like the end of the world. Amazing images exploded in front of me and I furiously took pictures. Having secured the pictures, my problem now was getting past the Iraqi Information Ministry officials who were searching the hotel for journalists to stop them from filming the bombing. As I left the room where I had taken the pictures from, there they were on the 12th floor! I managed to slip past them with all my equipment and memory cards tucked away. It was one of the most exciting nights of my life.'

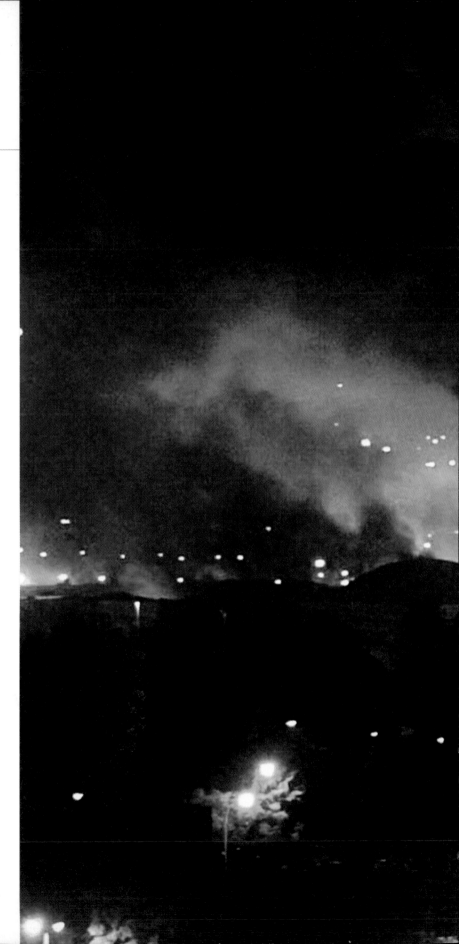

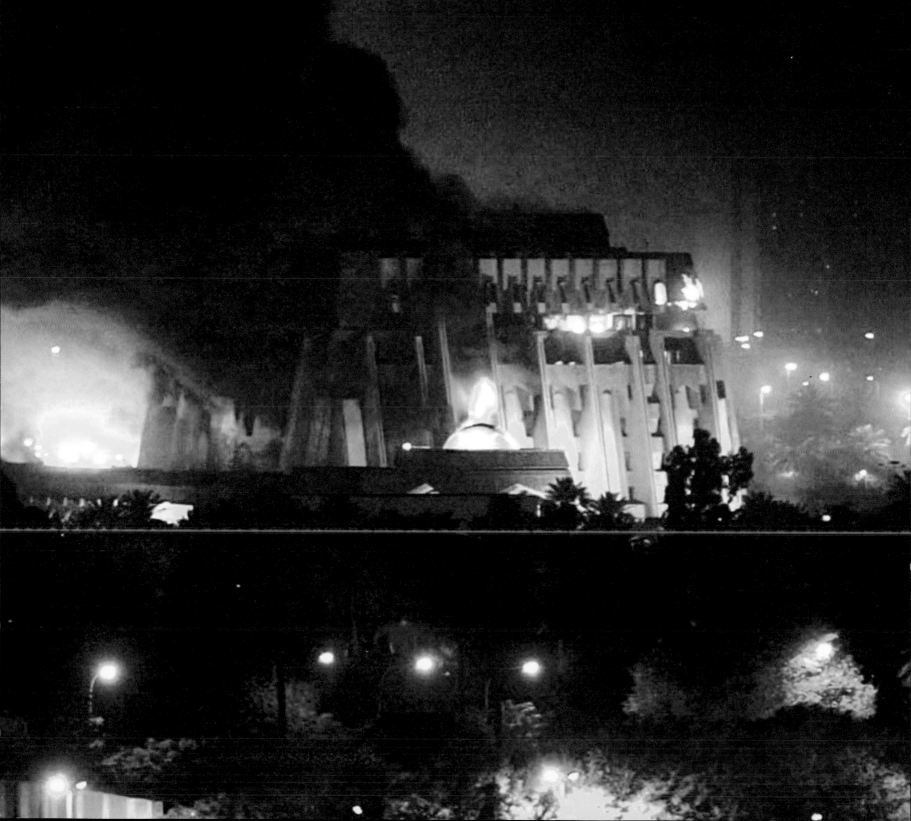

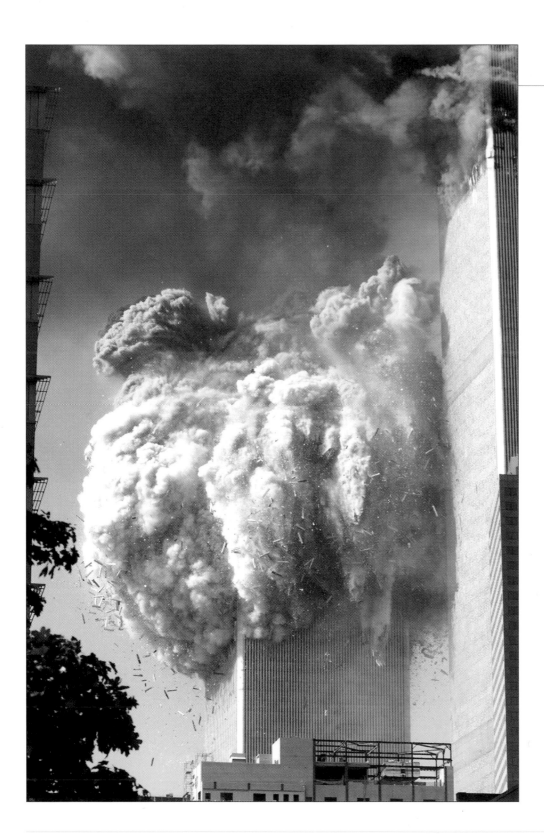

The second World Trade Center collapses in a cloud of smoke and debris after suicide hijackers flew passenger planes into the New York landmarks on September 11, 2001.

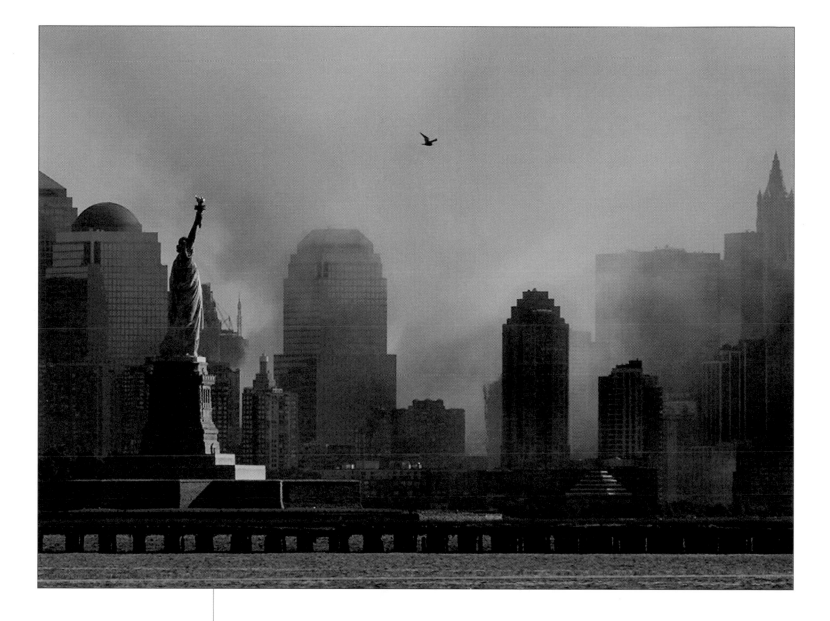

■ Ray Stubblebine
12 September 2001

Smoke from the burning debris of New York's World Trade Center shrouds lower Manhattan a day after the September 11 attacks in New York, Washington and Pennsylvania in which 3,044 people were killed.

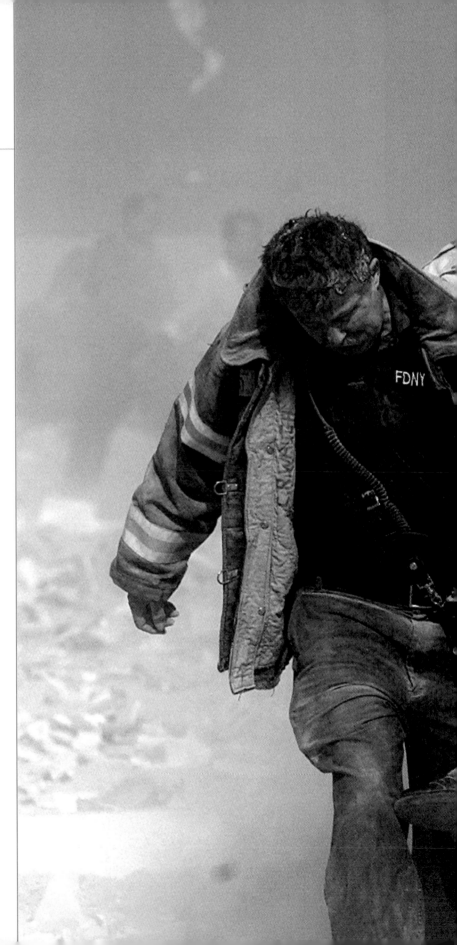

■ Shannon Stapleton
11 September 2001

Rescue workers carry New York City Fire Department chaplain, the Reverend Mychal Judge, from the devastated World Trade Center in an iconic image his friends call a 'modern Pieta'.

The 68-year-old Franciscan priest was crushed by falling debris shortly after giving the last rites to a firefighter killed when the twin towers collapsed. He was officially listed as the first of nearly 2,811 to lose their lives after suicide hijackers crashed two passenger planes into the twin towers.

'I was only four blocks away when the first tower collapsed,' Reuters photographer Shannon Stapleton told the Independent on Sunday newspaper. 'Once the dust had cleared I went nearer and got the picture of Father Judge being taken out of the wreckage. I didn't realize it was Father Judge, nor did I realize he was dead.

'This picture is the most important one I've ever taken. There's so much symbolism in the picture.

'Soon afterwards, I received a letter from the Father's niece and nephew, thanking me for taking the picture and saying how much it meant to them.'

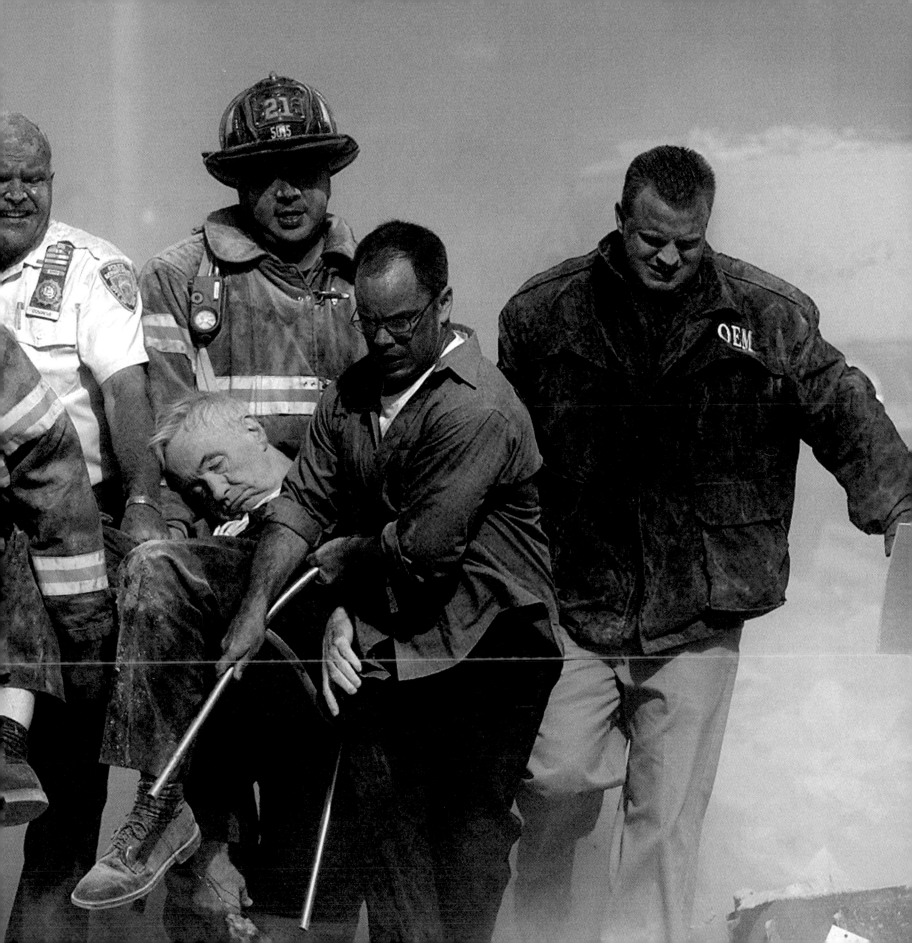

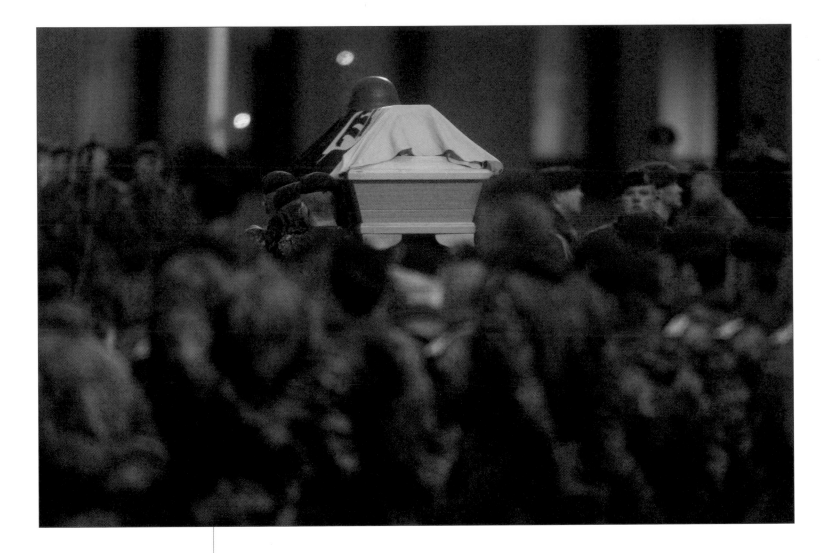

■ **Kai Pfaffenbach**
25 December 2002

German soldiers in Cologne carry the coffin of one of seven German peacekeepers killed in a helicopter crash near the Afghan capital, Kabul.

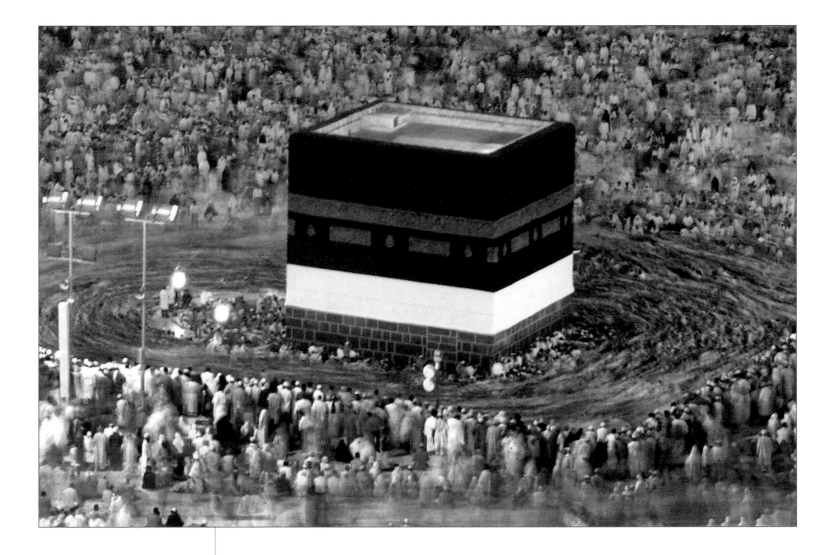

■ **Adrees Latif**
2 March 2001

Thousands of Muslim pilgrims circle the revered Kaaba, Islam's most sacred shrine, at the centre of Mecca's Grand Mosque in the final ritual of the annual haj, or pilgrimage.

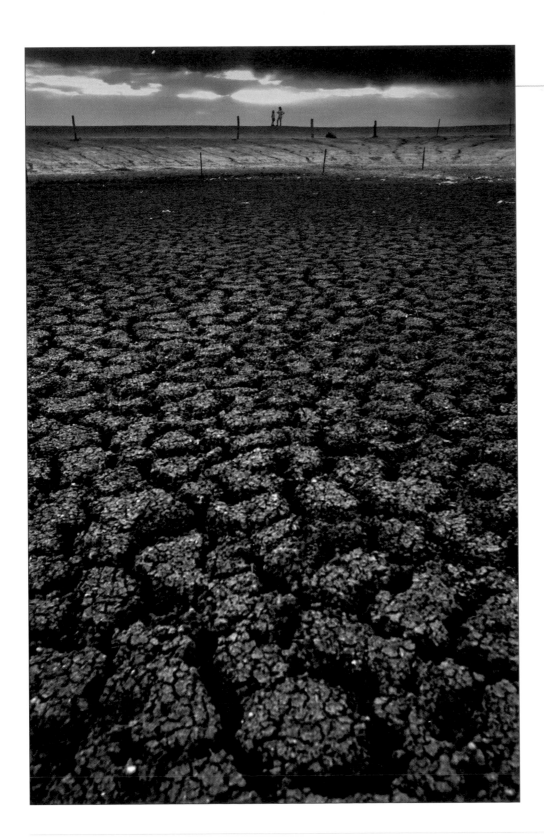

■ **David Gray**
26 September 2002

Australian farmers Cathy and Harriet Finlayson survey a sun-cracked pond on their drought-hit farm near Brewarrina in a remote part of New South Wales.

■ **Andreas Meier**
17 November 2002

A mudslide leaves a path of
devastation after slamming
through the Swiss Alpine
village of Schlans.

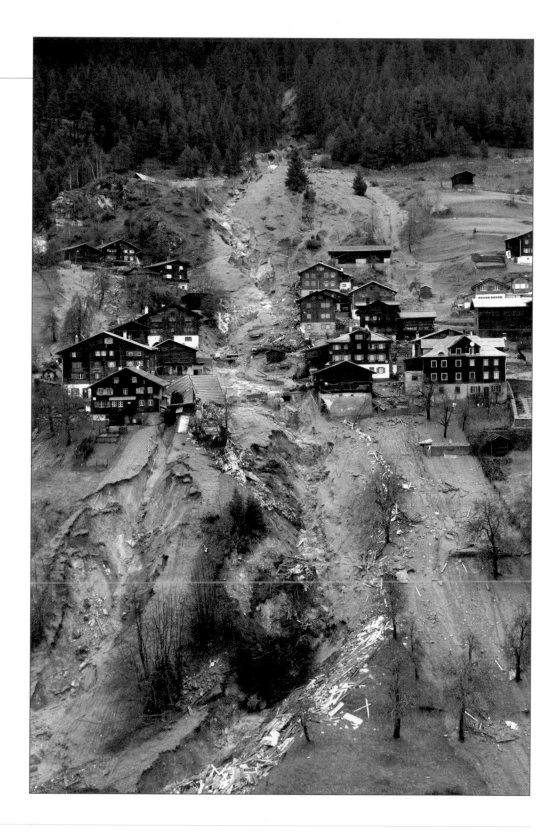

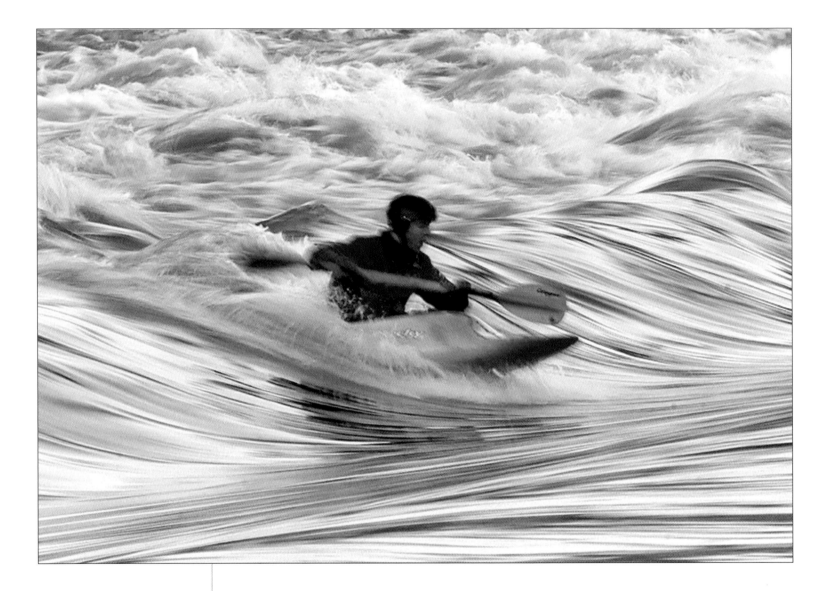

■ Petr Josek
28 March 2002

A kayaker paddles through wild water in central Prague after melting snow raised water levels.

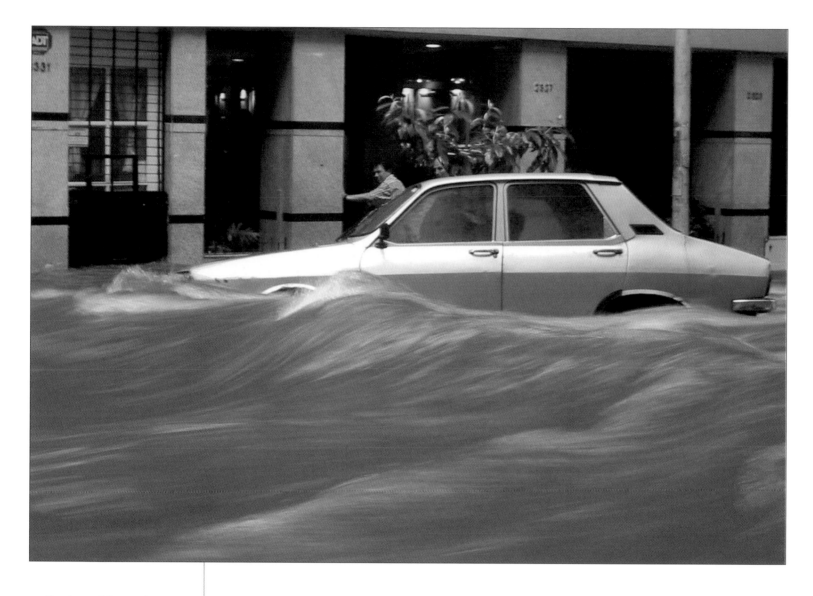

■ **Enrique Marcarian**
11 February 2003

A car is trapped in a flooded street after storms and torrential rain lashed the Argentine capital, Buenos Aires.

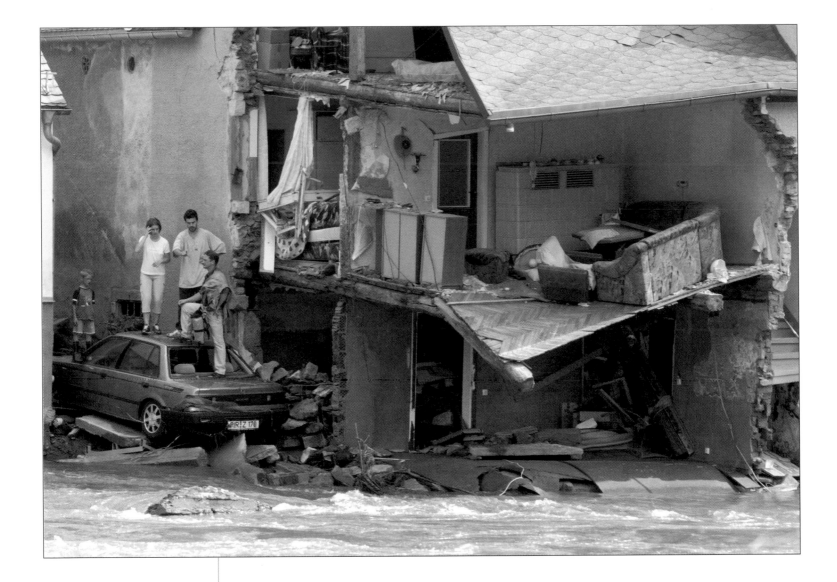

■ Fabrizio Bensch
18 August 2002

People climb onto a car next to a ruined house in the village of Weesenstein, south of Dresden, to escape floods which caused havoc across central Europe.

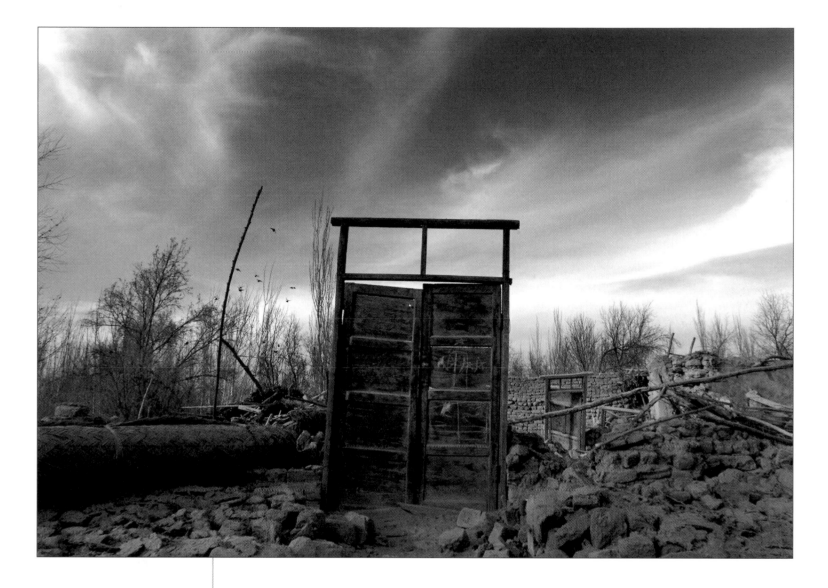

■ **Claro Cortes IV**
26 February 2003

A door is all that remains of a house flattened by an earthquake, which killed more than 260 people in China's remote Xinjiang region.

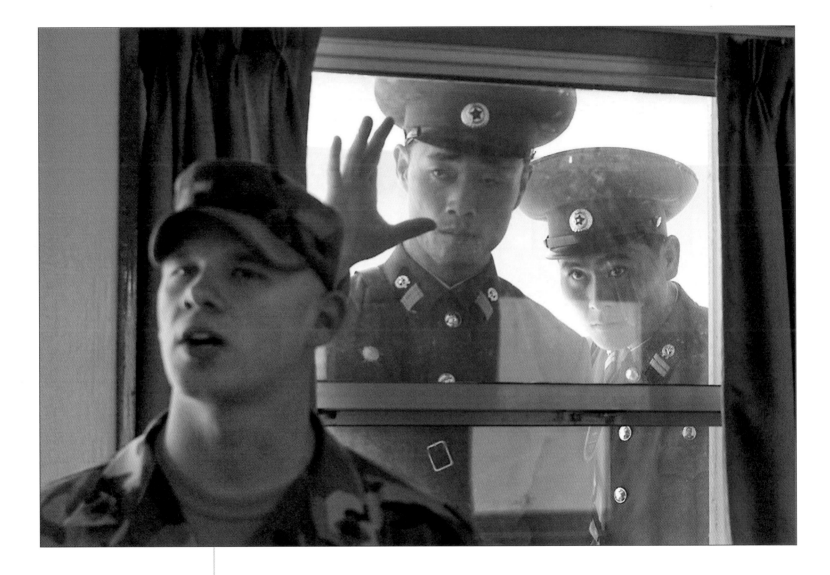

■ **Yun Suk-bong**
14 June 2001

North Korean troops watch as U.S. soldier John Cooly Reeves briefs journalists at Panmunjom, the only point of contact between the communist North and capitalist South.

mediummediummedium

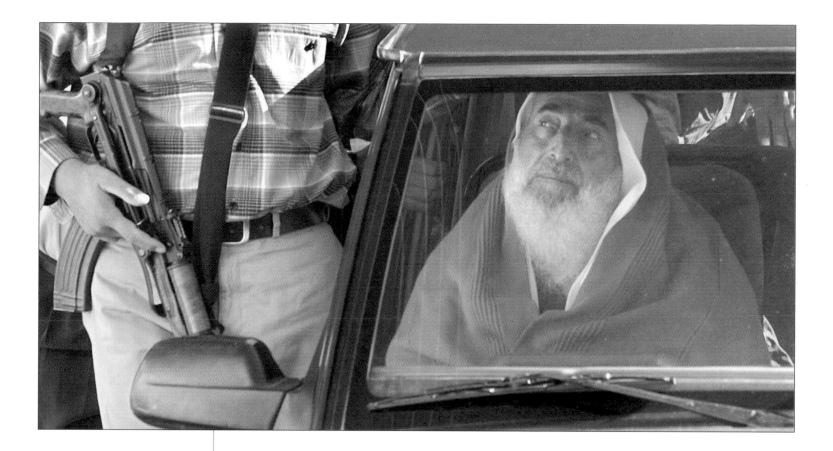

Ahmed Jadallah
7 February 2003

Hamas founder Sheikh Ahmed Yassin arrives at a pro-Iraq rally in Gaza.

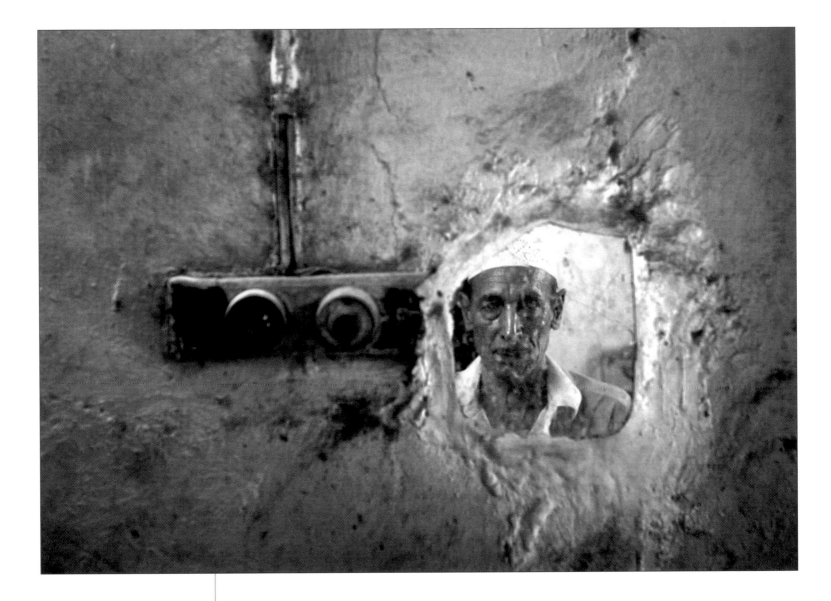

■ **Damir Sagolj**
4 September 2002

An Iraqi man is reflected in a mirror in a teahouse in central Baghdad.

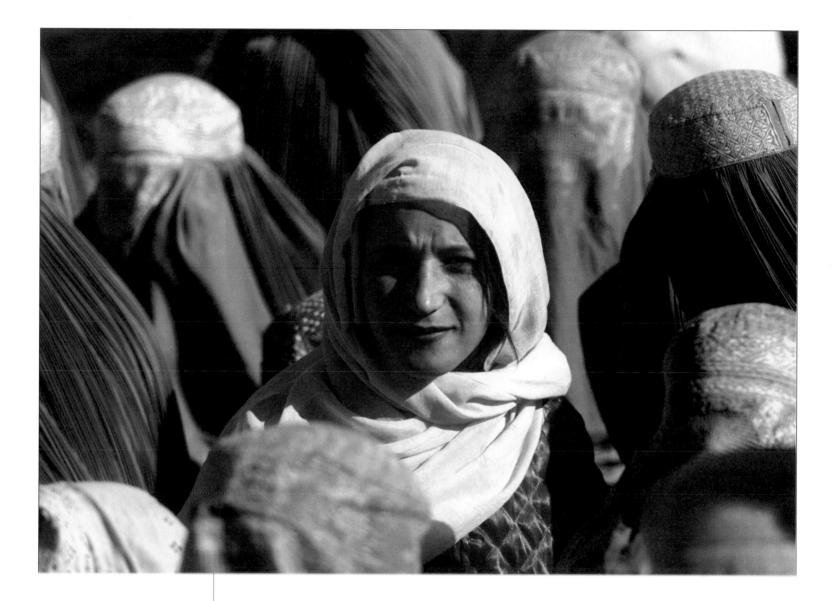

Yannis Behrakis
14 November 2001

A young Afghan woman shows her face in public for the first time after five years of strict Taliban rule in central Kabul.

■ Suhaib Salem
21 October 2002

An Iraqi man sits inside his home.

In this image Suhaib Salem has captured a domestic scene which, with the soaring arches and the shaft of light, looks like something from a sumptuous painting of a biblical subject, or a carefully designed stage set.

In fact, it is the ordinary home of an Iraqi family.

'At the end of 2002, as U.S.-led pressure to topple Saddam Hussein was growing, I was in Iraq. I was passing through the streets of Basra, 500 km south of Baghdad, when I came across this old traditional house. I knocked on the door and went in, and was met with this sight. There was a family of 10 people living in this house,' Salem said.

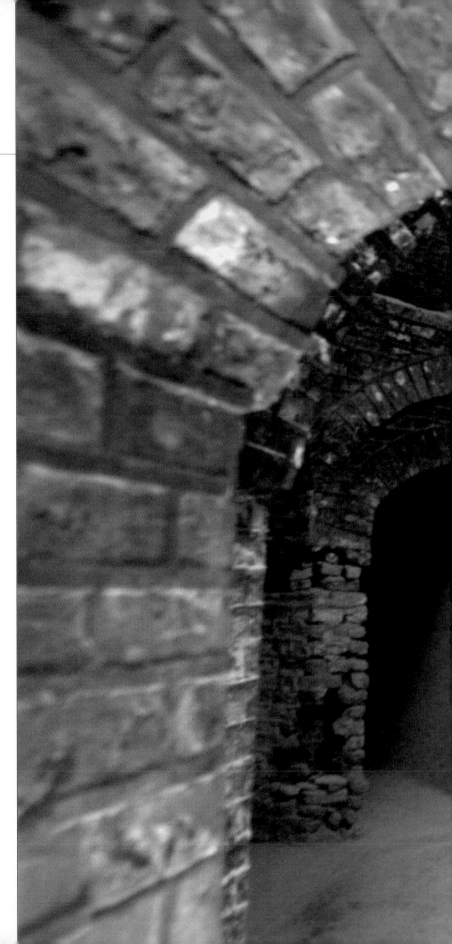

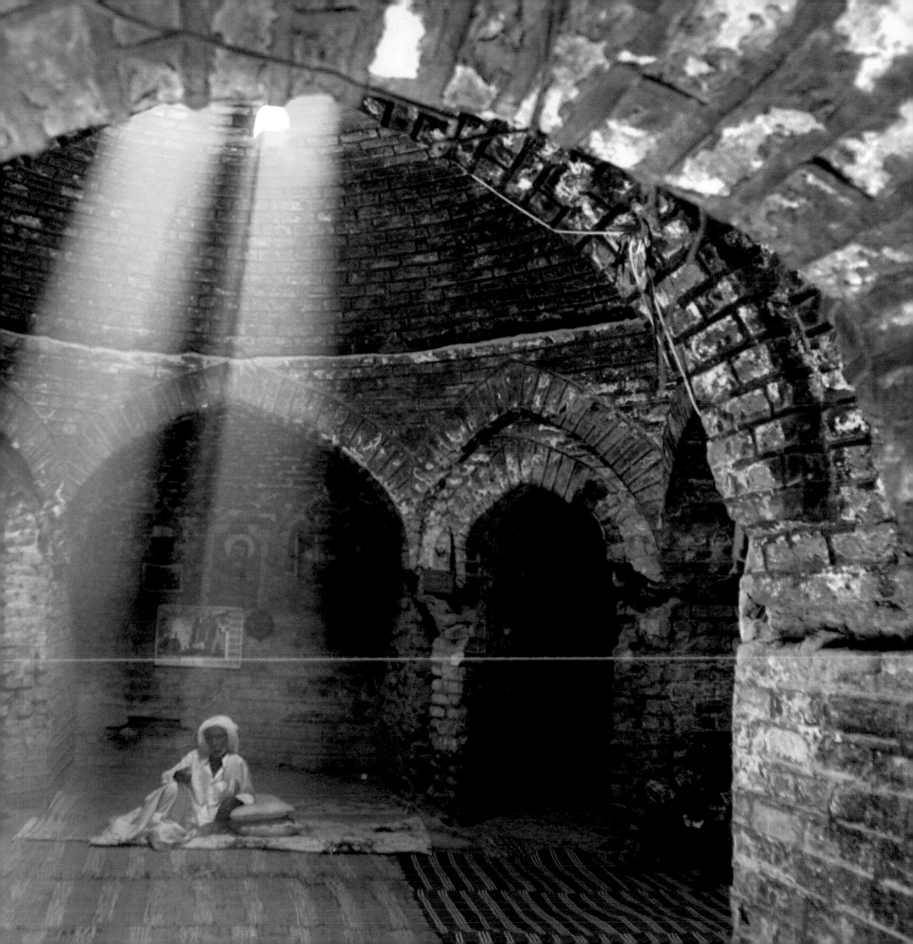

■ Guang Niu
30 December 2002

German Chancellor Gerhard Schroeder receives an honorary
degree at Tongji University in Shanghai.

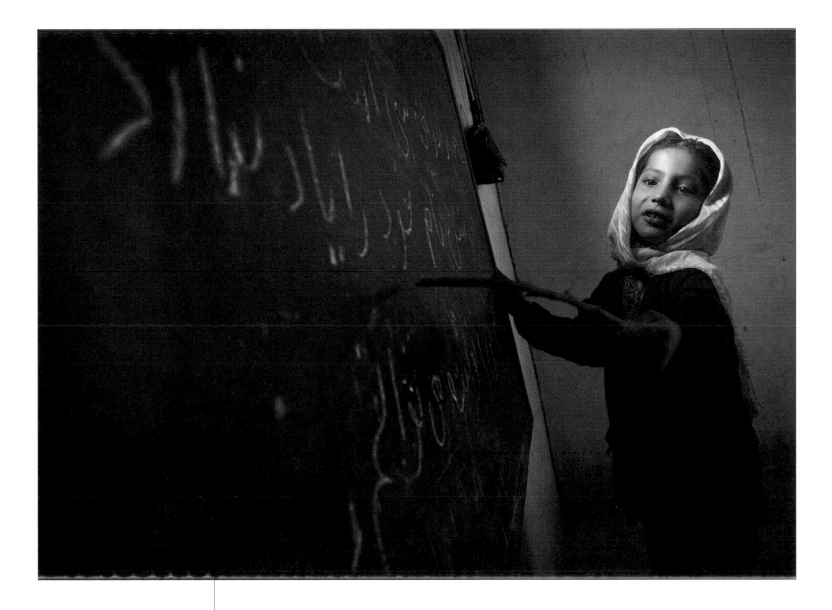

Damir Sagolj
2 December 2001

An Afghan girl teaches in a school which opened its doors to all children after operating in secret under the Taliban.

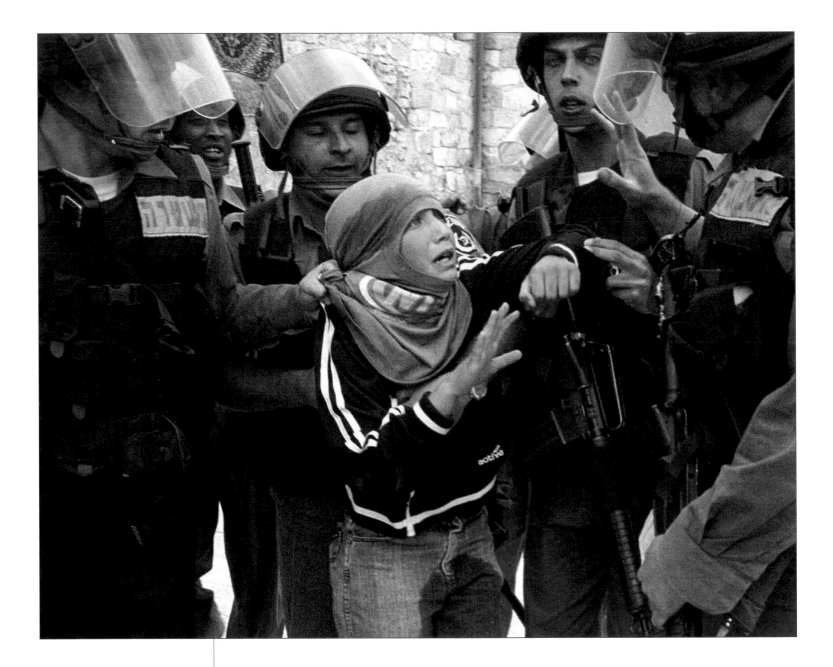

■ **Evelyn Hockstein**
6 April 2001

Israeli police in Jerusalem arrest a young Palestinian protester, his trousers stained with urine, after he threw stones following Muslim prayers.

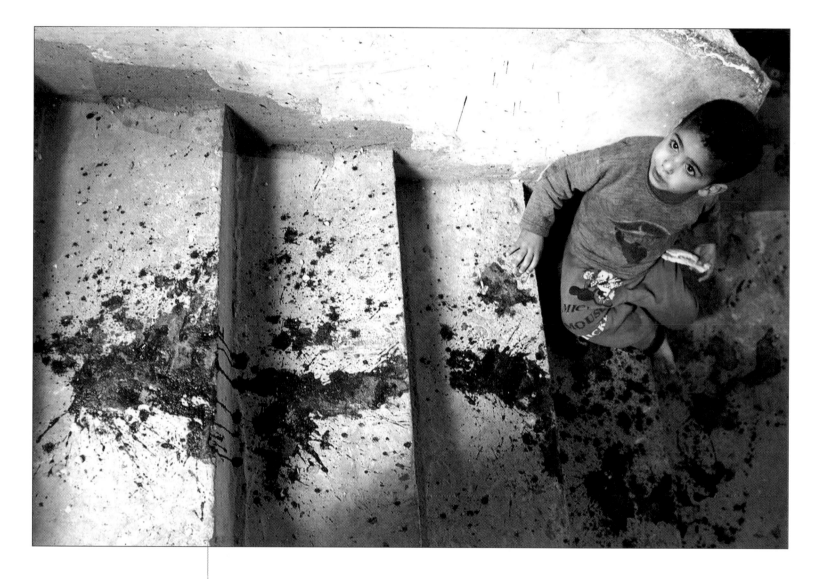

■ **Ahmed Jadallah**
12 March 2002

A Palestinian boy sits on a staircase stained with blood at a house in the Jabalya refugee camp in the Gaza Strip.

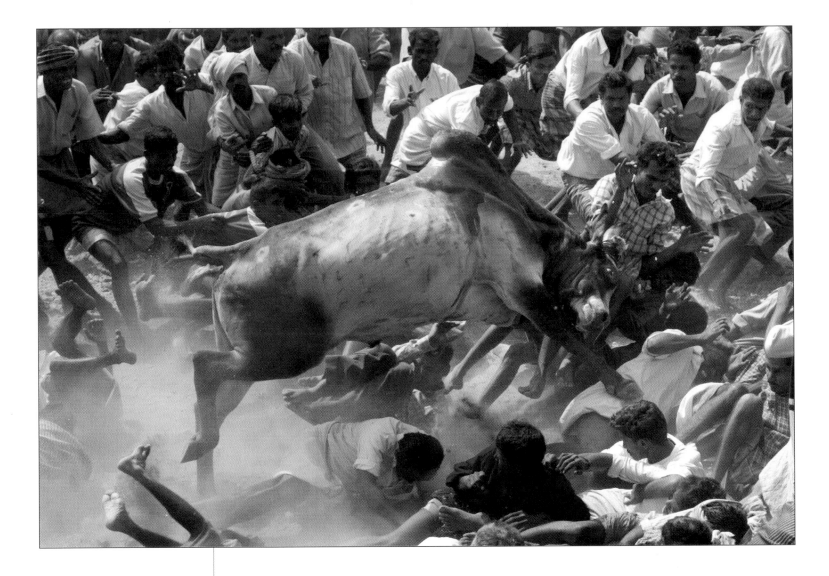

■ **Pawel Kopczynski**
16 January 2003

A painted bull stampedes during a festival in southern India as people try to grab the prize, held in a bag tied between the bull's horns.

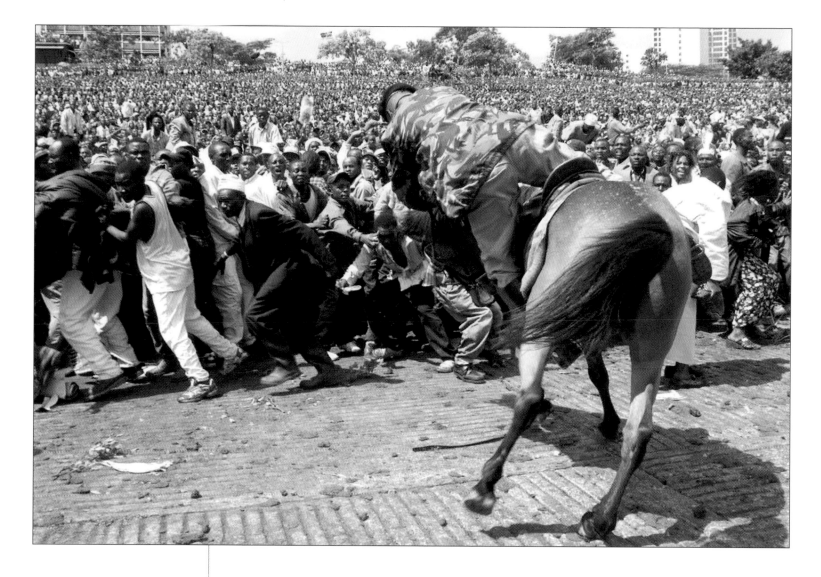

■ **Patrick Olum**
30 December 2002

A Kenyan soldier falls from his horse during the inauguration of
President Mwai Kibaki in the capital, Nairobi.

■ Reinhard Krause
20 October 2000

Palestinians run to escape, while one crawls, as Israeli soldiers fire teargas during Israeli-Palestinian clashes in the south Gaza Strip town of Khan Younis.

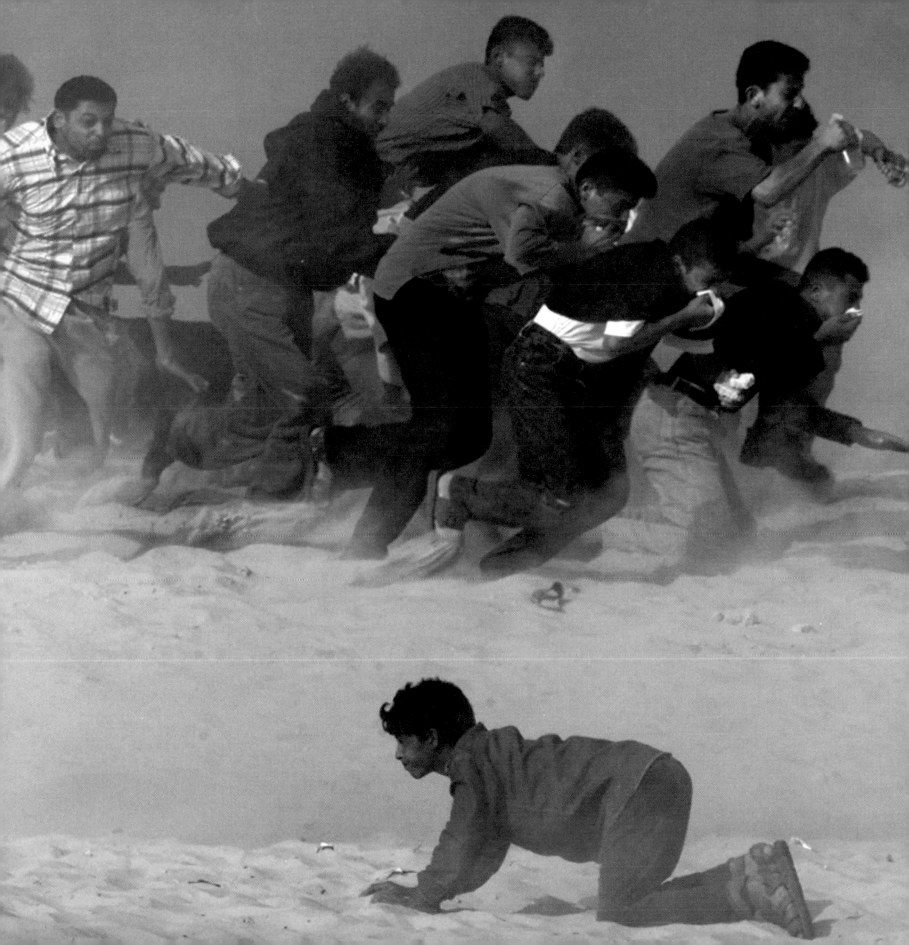

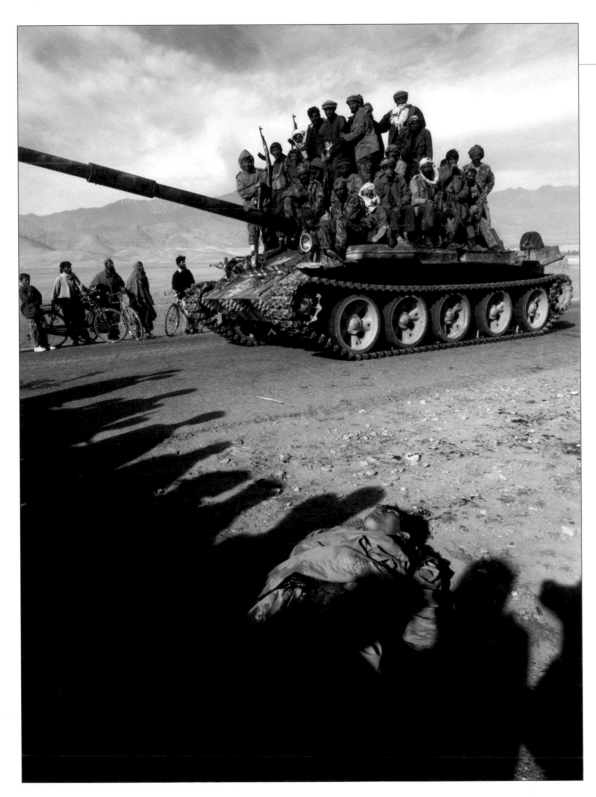

■ **Yannis Behrakis**
13 November 2001

Northern Alliance fighters pass a body on their way to Kabul after Taliban fighters fled the Afghan capital.

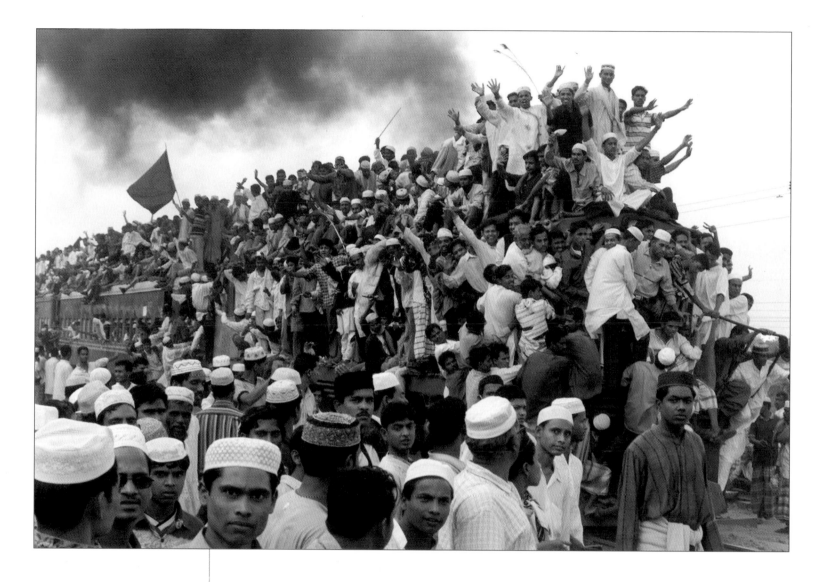

■ **Rafiqur Rahman**
15 December 2002

People swarm over a train in Bangladesh at the end of Biswa Ijtema, the biggest Muslim gathering after the annual haj pilgrimage to Mecca.

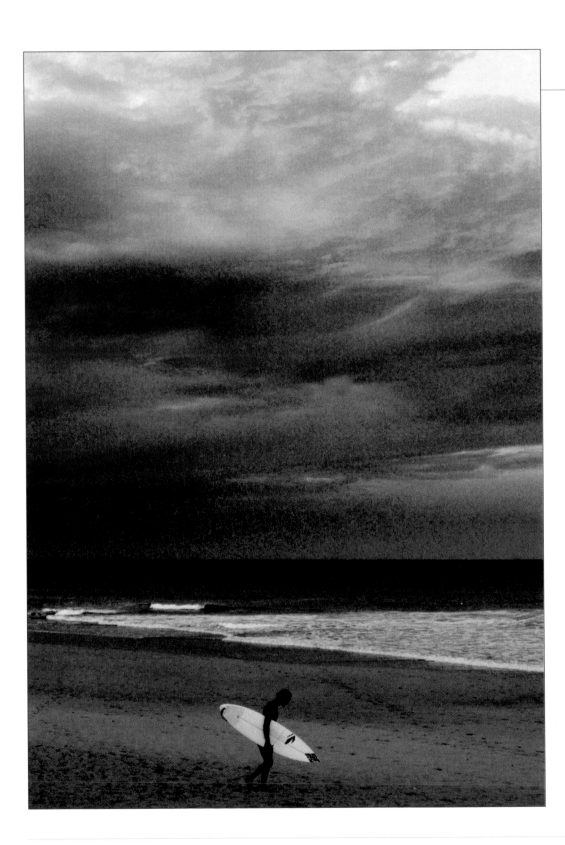

■ **David Gray**
27 June 2002

A surfer walks along Sydney's Narrabeen beach at sunset.

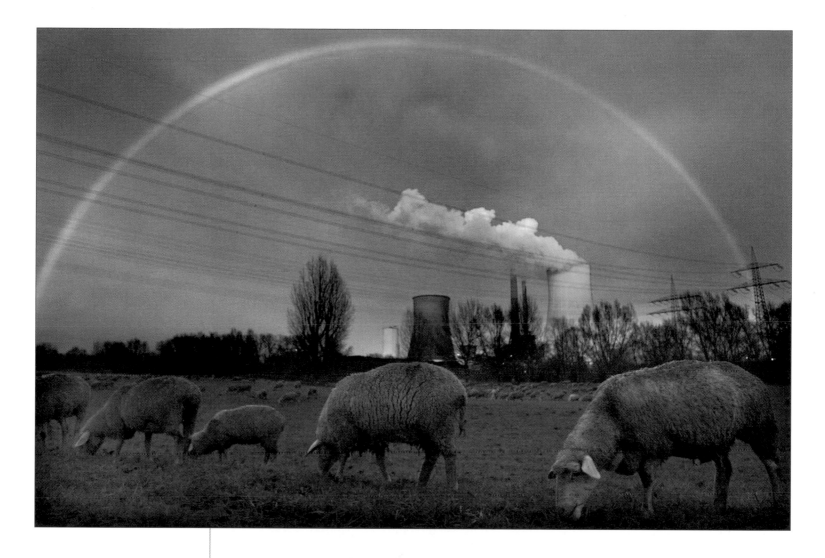

■ Kai Pfaffenbach
25 November 2002

A rainbow shines above sheep grazing in the shadow of a
power station near Frankfurt.

■ **Dylan Martinez**
20 July 2001

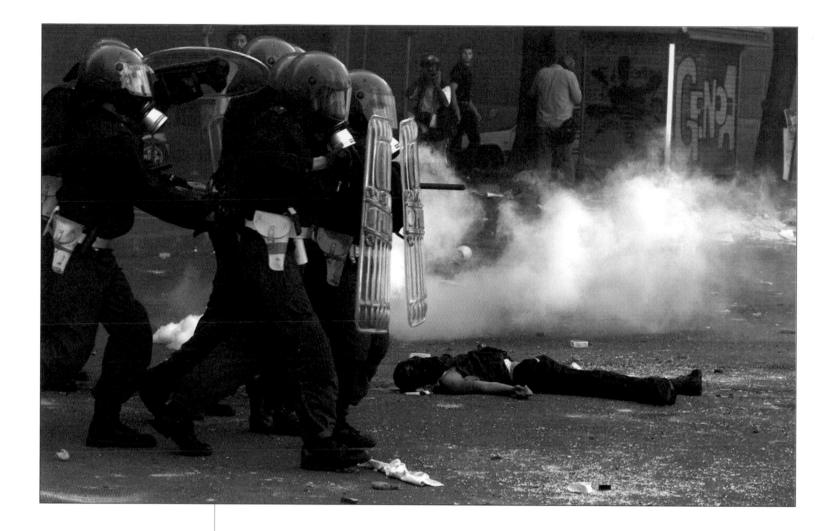

■ Dylan Martinez
20 July 2001

An Italian policeman points a gun (L) at an anti-capitalist protester during rioting in Genoa at a G8 summit of leaders from the world's industrialized powers. Officer Mario Placanica shot dead 23-year-old Carlo Giuliani as the demonstrator tried to throw a fire extinguisher into a police jeep. Minutes later, riot police (R) storm past the dead protester. Hundreds of demonstrators were injured, some seriously, in battles with police who used teargas and a water cannon to keep them away from the main G8 venue.

■ Ahmed Jadallah
6 March 2003

Blood pouring from a shrapnel wound, award-winning Reuters photographer Ahmed Jadallah kept taking pictures of an Israeli raid on a Palestinian refugee camp in the northern Gaza Strip.

'Were my pictures used?' he asked in his first words after coming round following surgery.

His Reuters colleague Shams Odeh, a television cameraman, was also wounded and underwent surgery for a fractured foot.

The pair were covering the Israeli raid a day after a suicide bombing carried out by a Palestinian militant killed 17 people in the northern Israeli city of Haifa.

Here, Jadallah's pictures show two unidentified men lying in the refugee camp.

Eleven people were killed and 140 wounded during the nine-hour raid into Jabalya, the largest refugee camp in the Gaza Strip.

Palestinian witnesses said an Israeli tank fired a shell at a crowd, but Israel's army denied firing on civilians and said most deaths were caused when Palestinian militants detonated bombs meant for Israeli forces.

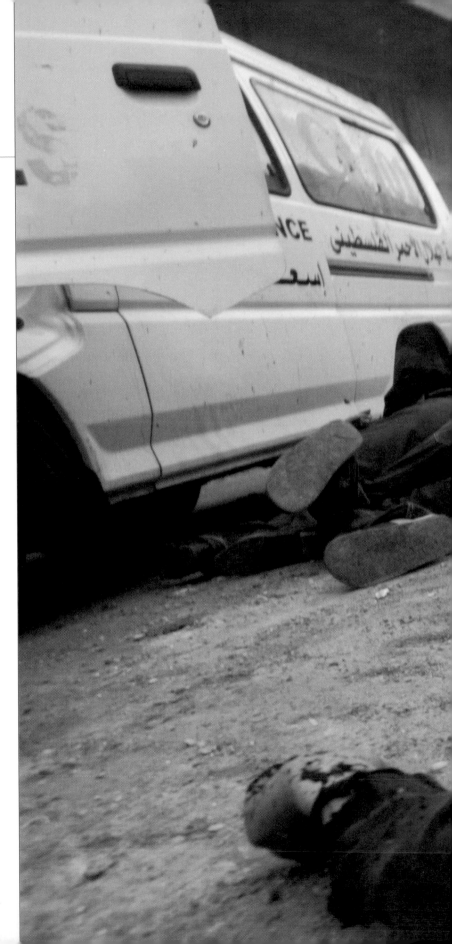

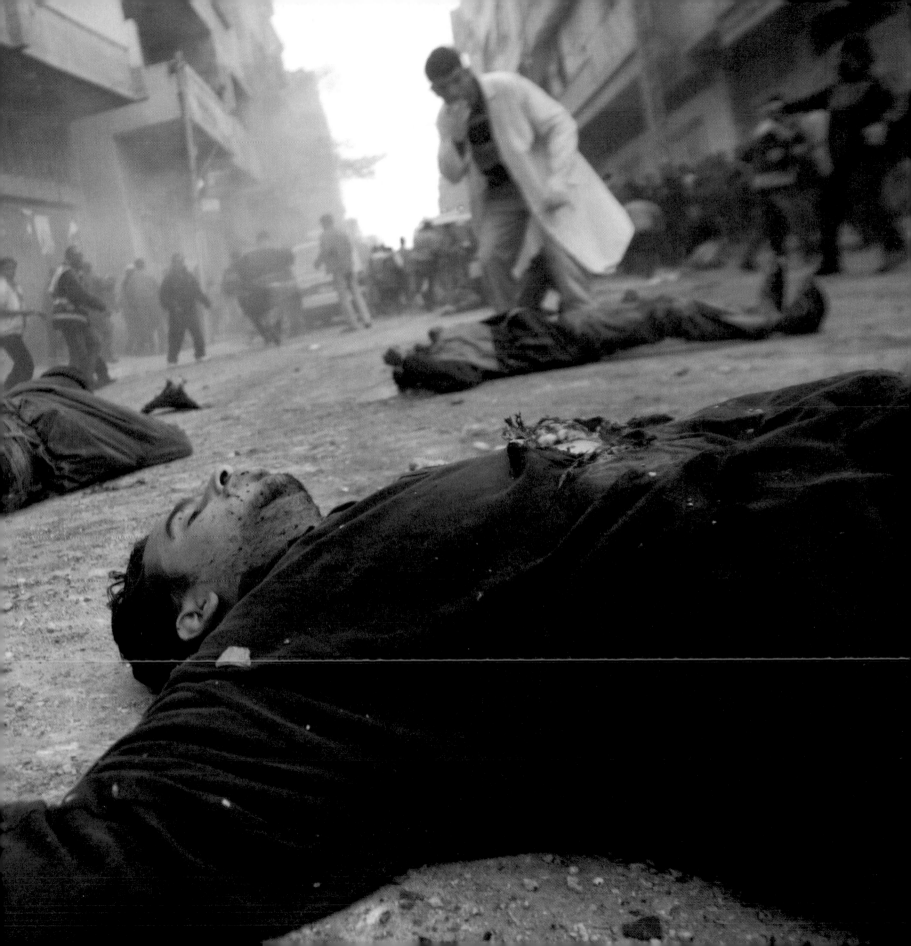

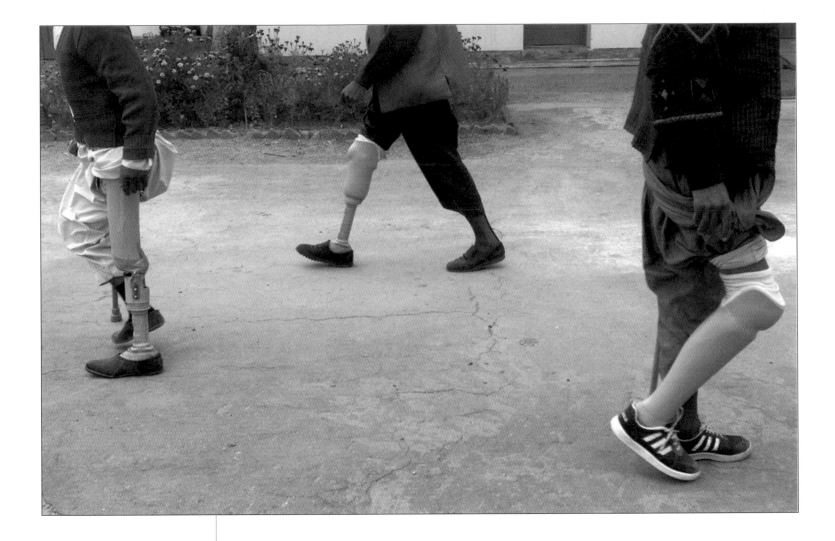

■ **Yannis Behrakis**
30 October 2001

Afghan amputees walk through a Red Cross hospital for mine victims north of Kabul.

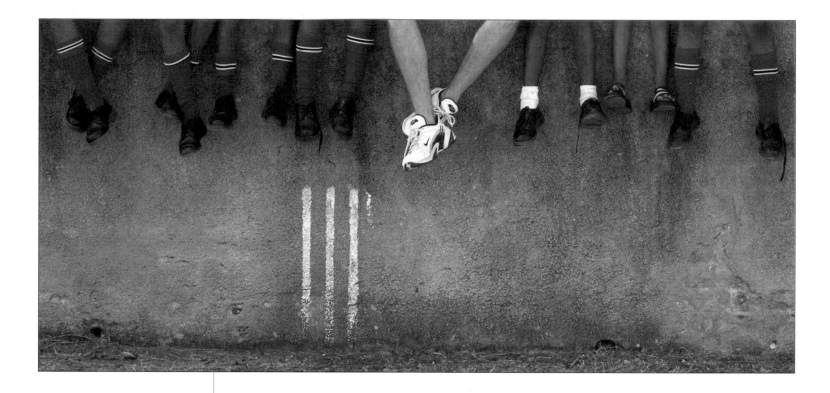

■ **Darren Staples**
3 February 2003

England's Craig White (C) sits with schoolchildren in Port Elizabeth, South Africa.

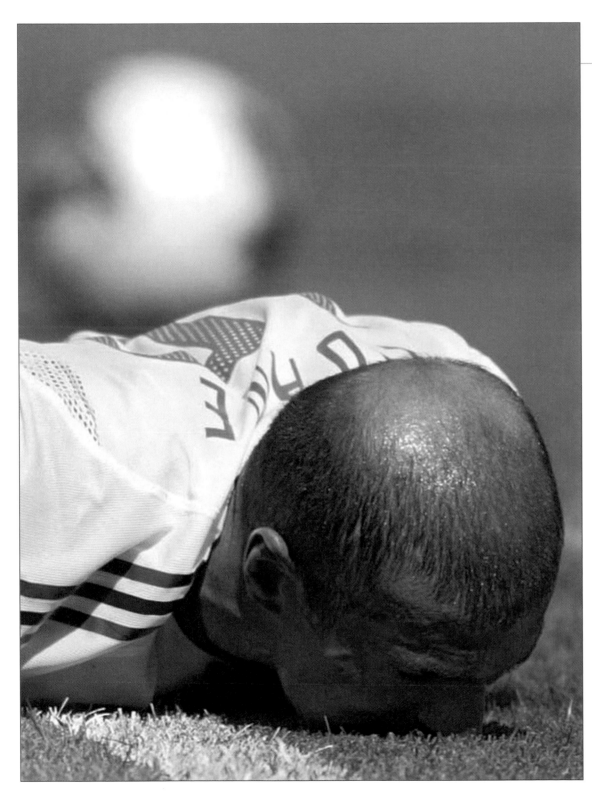

■ **Jerry Lampen**
11 June 2002

France's Zinedine Zidane lies flat out after missing a chance against Denmark in the World Cup finals in Inchon, South Korea.

Damir Sagolj
15 June 2001

An Iranian cleric reads a book
before Friday prayers at
Tehran's university campus.

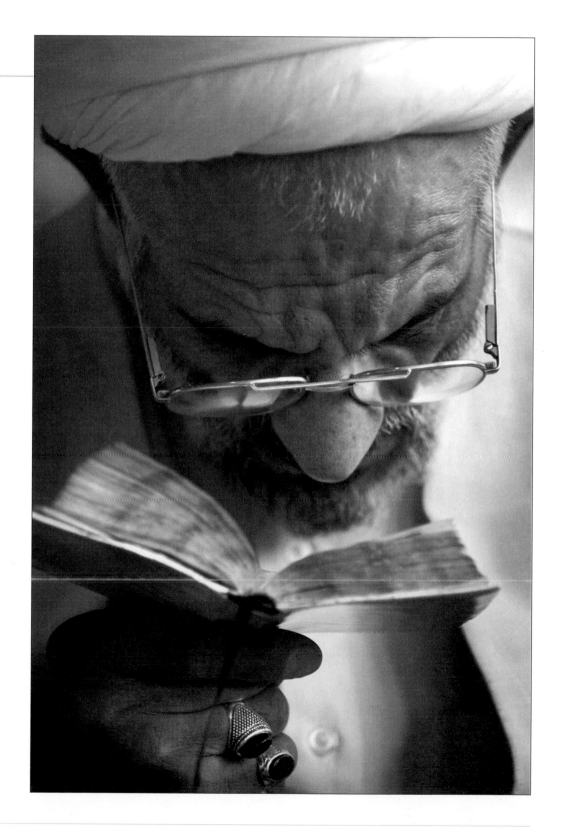

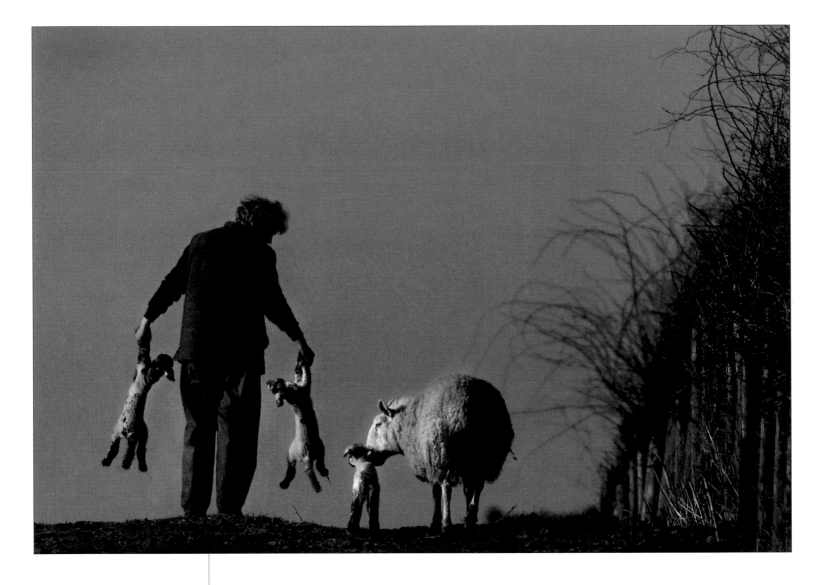

■ **Jeff J Mitchell**
19 March 2001

A farmer carries two new-born lambs during the foot-and-mouth disease crisis in Cumbria, northern England.

Previous page
■ **Albert Gea**
4 May 2003

The Ferrari German Formula 1 driver Michael Schumacher is reflected in glass over the pits during a pit stop at the Spanish Grand Prix.

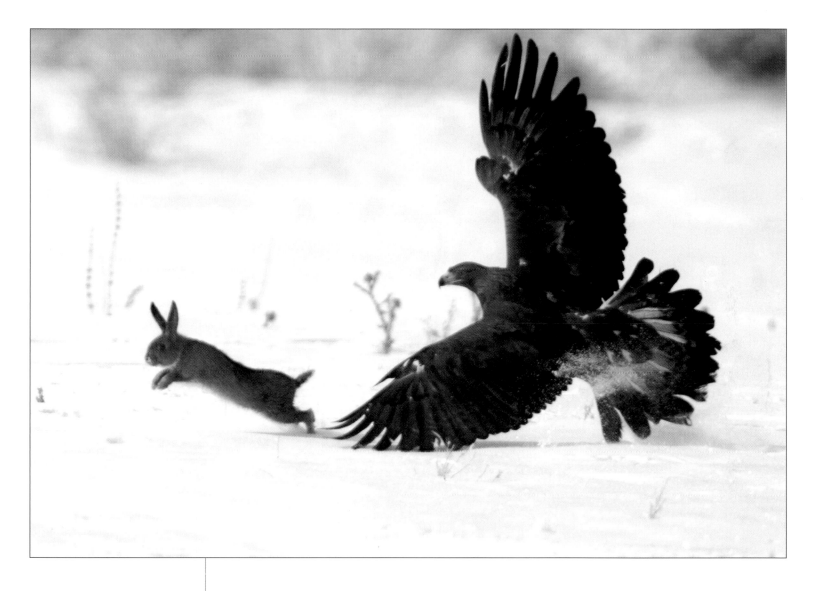

■ **Gleb Garanich**
9 February 2003

A golden eagle chases a hare during a traditional hunting contest in Kazakhstan.

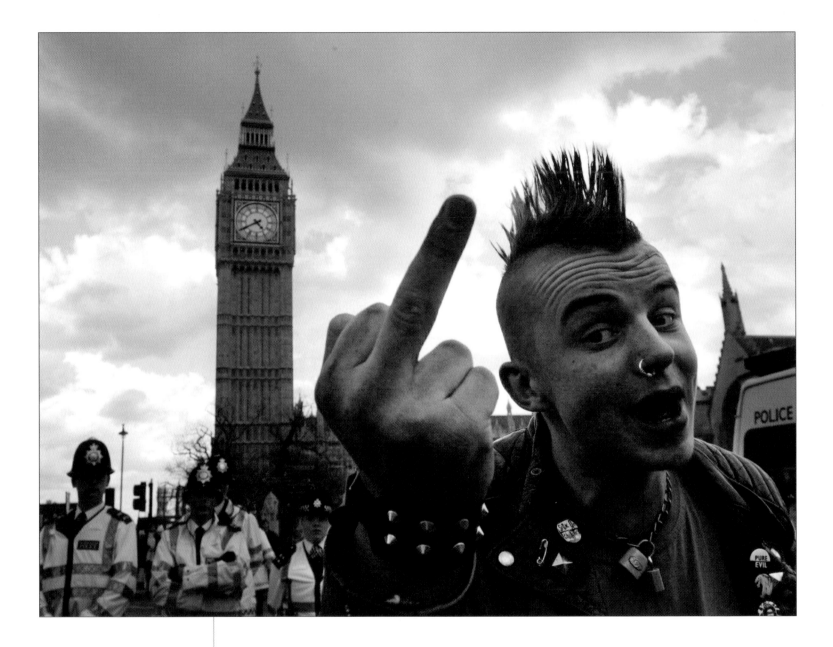

■ **Toby Melville**
1 May 2003

An anti-war demonstrator gestures during an anti-capitalist
May Day rally near the Houses of Parliament in London.

■ **Rafa Huertas**
10 October 2002

A crayfish scurries across a flooded road during heavy rains near Castelldefels in northeast Spain.

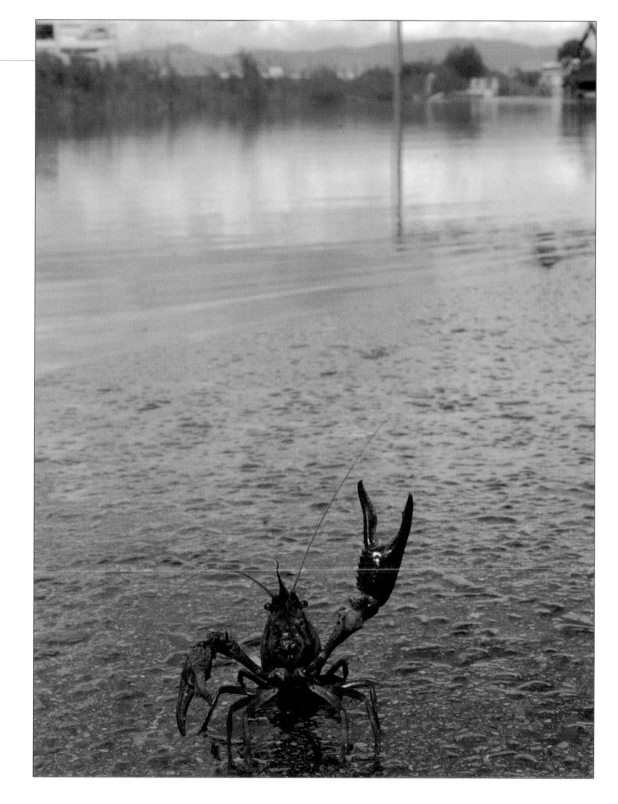

Toby Melville
19 February 2003

A model faces the press wearing a design by Spanish-born
Rafael Lopez at London Fashion Week.

THE PHOTOGRAPHERS

BIOGRAPHIES

■ Peter Andrews

Andrews was born in Kano, Nigeria, in 1961, and grew up in Poland. He emigrated to Canada in 1980 and became a photographer in 1984. In 1989 he returned to Europe and joined Reuters in 1991 during the first coup in Moscow. In 1996 he became Chief Photographer for Southern Africa based in Johannesburg and in 1999 moved to become Chief Photographer for Eastern and Southern Africa, based in Nairobi.

■ Ammar Jamil Awad

Awad was born in Jerusalem in 1980 and began working with Agence France-Presse (AFP) as a photographer in 1999. He joined Reuters in 2000 to cover breaking news events in Jerusalem and the West Bank. In 2001 he was recognised at the 11th Baghdad International Festival for Photographic Pictures.

■ Laszlo Balogh

Balogh was born in Budapest in 1958 and still lives there. He started working as a photographer with a Hungarian daily paper in Budapest in 1976 and joined the Reuters team in 1990.

■ Yannis Behrakis

Behrakis was born in Athens in 1960. After school and military duty in the Greek Air Force, he began studying photography. Behrakis started with Reuters as a stringer based in Athens in 1987 and became a fulltime staff photographer in 1989. Four days later he took his first assignment outside Greece on the breaking story of the Libyan chemical warfare factories. Since then he has covered major news stories in the Middle East (Iraq, Iran, Jordan, Israel, the West Bank and Gaza Strip, Turkey and Egypt); in Somalia and Northern Africa; and in Spain and Italy. He also has worked in Albania, Bulgaria, Romania and Hungary and covered wars in Croatia, Bosnia, Kosovo and Chechnya.

■ Fabrizio Bensch

Bensch was born in 1969 in Berlin and has been working with Reuters since 1992.

■ Shaun Best

Best was born in 1968 in Canada. He has been a Reuters staff photographer based in Montreal since February 2001. He previously worked for Reuters for six years as a contract photographer. Prior to that, he was a staff photographer at the Winnipeg Sun.

■ Mike Blake

Blake has worked with Reuters for 14 years, based in Vancouver, Canada. He spends a large portion of the year on the road covering everything from hockey to football, basketball, skiing and golf. Blake has covered five Summer Olympic Games, including Atlanta and Barcelona, and three Winter Olympics.

■ Russell Boyce

Boyce joined Reuters in 1988 and has travelled the world covering both news and sports stories. His assignments have ranged from covering sporting events such as the Olympics, soccer, cricket and rugby world cups to working in war zones and covering international politics. Besides working as a photographer based in the United Kingdom, he now spends part of his time editing major international news and sporting events.

■ Desmond Boylan

Boylan was born in 1964 in London and joined Reuters after a three-year stint with the Associated Press. He has been based in Madrid for the past six years.

■ Colin Braley

Braley was born in 1962. He began his career freelancing for UPI while attending college. After working for several years at a Midwestern U.S. newspaper, Braley joined Reuters as a contract photographer in 1989. Based in Miami, he covers international news and major sporting events throughout the United States and the Caribbean.

■ Nadezhda Breshkoskaya

Breshkoskaya was born in 1975 in the Bryanskaya region and has been living in Archangelsk since 1976, working as a journalist since 1993. She graduated from the journalism faculty of St Petersburg University in 2001 and thinks of herself as a writer who takes her camera with her wherever she travels. She began working with Reuters in 2001.

■ Natasha-Marie Brown

Brown was born in London and studied music and economics at university. She lived in Japan for two years, then travelled extensively in Asia before returning to London to study photography in 2000. She began her career as a freelancer, working in the Balkans, Russia and Israel on feature assignments for magazines. Brown is based in London.

■ Howard Burditt

Burditt was born in Harare, Zimbabwe, in 1958 and has lived in Britain, Australia and South Africa. He began his career in 1983 as a corporate and advertising photographer in Harare and joined Reuters as a southern Africa stringer in 1987.

■ Christian Charisius

Charisius was born in 1966 in Freuburg, Germany, and has worked as a freelance photographer since 1989. From 1989 to 1995 he was based in Munich, working in reportage and portrait for several magazines as well as the advertising industry. In 1996 he travelled through Spain, France and Belgium and later moved to Hamburg where he started his work as a stringer for Reuters.

■ Kin Cheung

Cheung was born in Hong Kong in 1973 and studied Fine Art Photography in the UK before starting work as a photographer for **Cyber Daily** online newspaper. Cheung later joined the Reuters Hong Kong bureau as a stringer and was awarded the annual best sports photograph by the Hong Kong Press Photographers Association.

■ Jeff Christensen

Christensen was born in Duluth, Minnesota, in 1958. His first job as a photographer was for UPI in Minneapolis. He started working for Reuters as a contract photographer in 1989. In 1991 he moved to New York City, where he still lives.

■ Dan Chung

Chung was born in Britain in 1971. He began freelance photojournalism while still at college, then worked for a local newspaper in 1994. Chung joined Reuters in 1996 and covered general and sports news, including the European Champions, the Winter Olympics in Salt Lake City and the 2002 Soccer World Cup. In 2002, Chung won the Nikon UK Press Photographer award. He now works for a leading UK daily newspaper.

■ Andrea Comas

Comas was born in Konstanz, Germany, in 1972 and was educated in Bonn and Madrid. After completing a degree in biochemistry, he started his career as a photographer with a Spanish national newspaper. Since 1999 he has worked with Reuters as a stringer based in Madrid.

■ Claro Cortes IV

Cortes was born in 1960 in Manila and is based in the Reuters Singapore bureau. He joined Reuters in 1988 in Manila, moving to Hanoi in 1992 to help establish the Reuters pictures and television operations in Vietnam. He has covered events in Pakistan, Malaysia, Indonesia, the Philippines, South Korea, Brunei, Hong Kong, China, Vietnam and Singapore and was the first recipient of the Willie Vicoy-Reuter Fellowship at the University of Missouri in Columbia, Missouri, in 1987.

■ Sucheta Das

Das is 26 and based in Calcutta. Her passion for photography began in childhood when she took pictures of nature. She had had photographic freelance roles with India's leading newspapers and magazines and joined Reuters as a stringer in Calcutta in 2001. In 2003 Das was awarded second prize in the Nikon-sponsored photo contest organized by the **Times of India**.

■ Amit Dave

Dave is a freelance photographer based in New Delhi.

■ Marcelo del Pozo

del Pozo was born in Seville, Spain, in 1970. He studied photography and television camera operation before starting work as a photojournalist for a national newspaper in Spain. He has worked for Reuters in Spain and Portugal as a stringer since 1997.

■ Larry Downing

Downing worked for newspapers and a major news agency before starting a 15-year stint with **Newsweek** magazine, as a White House photographer. He joined Reuters in 2002 and remains based in Washington.

■ Caren Firouz

Firouz was born in Shiraz, Iran, in 1962 and later moved to Tehran. Before Iran's Islamic Revolution she left Iran to study abroad. After graduation Firouz worked for a weekly newspaper in Washington before relocating to Iran. She covered the first Gulf War and the Kurdish uprising in northern Iraq. In Africa, she covered the arrival of U.S. forces in Somalia and elections in Kenya. In 1998, Firouz joined Reuters in Iran. She is now the Tehran bureau photo editor and a photographer outside Iran.

■ Victor Fraile

Fraile was born in Santander in 1977 and lives there between his travels as a freelance surfing photographer. For five years he has been touring the Canary Islands, Indonesia, Hawaii and Maldives for his work. He joined the Reuters team in 1999.

■ Robert Galbraith

Galbraith joined Reuters as a contract photographer in Los Angeles in 2002 and covers news, sports and entertainment. Previously he spent 15 years with the Associated Press in Los Angeles and northern California. He is a graduate of Marshall University and a native of West Virginia.

■ Gleb Garanich

Garanich was born on Sakhalin Island, Russia, in 1969. He went to school in Ukraine and studied at the Kharkiv Aviation Institute. His career in photography began in 1990 at a national news agency. In 1995 he joined Reuters as a photographer based in Kiev.

■ Albert Julian Gea

Gea was born in 1977 in Barcelona. After university he took his first steps into professional photography with the motorcycle magazine **Piloto**. He began working with Reuters as a stringer in July 2000.

■ Tony Gentile

Gentile was born in Palermo in 1964 and began his career in 1989 as a photographer with a local newspaper in Sicily. He went on to work with many other national and international newspapers and magazines in Italy. In 1992, Gentile began working as a stringer for Reuters before joining the Reuters team in Rome.

■ David Gray

Gray started his training as a cadet with News Limited Australia. In 1993 he joined **The Australian** as a sports photographer before starting with Reuters in 1996. Gray has covered events in Australia, Papua New Guinea and New Zealand, as well as the 1996 Cricket World Cup in India, political unrest in Indonesia and East Timor, the 1997 Hong Kong handover, the 1998 Commonwealth and Asian Games and the 1999 West Indies cricket tour. He won the 1998 Australian Walkey Award for best sports photograph and the 1999 Australian Photojournalist Award for best news photograph. He was the 1999 Australian Photojournalist Award winner.

■ Zainal Halim

Halim was born in Malaysia in 1957 and began a career as a photographer in the early 1980s with a local newspaper before joining Reuters in Kuala Lumpur.

■ Paul Hanna

Hanna used to follow his father to photo assignments and started studying photojournalism in high school. After settling in Madrid in 1987, he started working for Reuters as a stringer in 1989, covering Spain, Portugal and a few foreign assignments. In 1992 he was hired as a photographer and desk sub-editor in London and in 1996 moved to Rome as Chief Photographer, Italy. He is now back in Madrid as Chief Photographer, Iberia (Spain and Portugal).

■ Chris Helgren

Helgren, 38, started his photography career in Canada and after four years moved to London to work with Reuters. He helped launch coverage of the first Gulf War. His next move was to the Balkans to cover the war in Bosnia. In 1996 he became a picture sub-editor while still shooting photo assignments around Europe and the Middle East. In 2002, Helgren again went to the Gulf to organize the Reuters photographic coverage of the war in Iraq. Starting from Kuwait, he was the first photographer into the southern city of Basra, made it into Baghdad while the tea was still warm and later moved on to the northern stronghold of Tikrit the day it fell to the U.S. Marines. He is starting a new post as Chief Photographer in Iraq and the Gulf.

■ Yves Herman

Herman was born in Brussels in 1968 and lives in Belgium. After studying cookery for six years, he also learned photography and began working for a local newspaper in Brussels. In 1997 he joined Reuters. Herman remains based in Brussels and is now pictures editor for Belgium and Luxembourg. He has covered several major international events, including the World Cup and the Olympic Games.

■ Joachim Herrmann

Herrmann was born in 1963 in Zell am Harmersbach, Germany. He attended photo school in Freiburg and became a freelance photographer. He worked as a staff photographer at the Offenburger Tageblatt in 1987-1988 and as a stringer at the DPA Hamburg office in 1988-1989. In 1990, Joachim started working for Reuters at the Frankfurt office. He moved to Bonn for a while and has been based in the Berlin bureau since 1999.

■ Gary Hershorn

Hershorn was born in London, Ontario, in April 1955. He started freelancing for a local paper in Toronto in 1978. He began working at United Press Canada in 1979. In 1985 Reuters News Pictures, which had just begun its worldwide picture service, hired him as Chief Photographer for Canada. He was transferred in 1990 to Washington, where he is now News Picture Editor.

■ **Stephen Hird**

Hird was born in the United Kingdom in 1969 and began his career in 1992 when he moved to Hong Kong. He lived there for five years and then travelled throughout Asia. He worked as a photographer's assistant, then as a commercial photographer, before getting his editorial break at the **South China Morning Post**. Returning to Britain in 1997, Hird worked for the **Daily Telegraph** before joining Reuters in 2000. He is based in London.

■ **Evelyn Hockstein**

Hockstein, an American freelance photojournalist, has covered the Israeli-Palestinian conflict for Reuters, the **Philadelphia Inquirer** and **Knight Ridder/Tribune**. She has been a Pew Fellow in international journalism at the Johns Hopkins School of Advanced International Studies in Washington.

■ **Rafa Huertas**

Huertas is a Reuters stringer, normally based in Spain.

■ **Ahmed Jadallah**

Jadallah joined Reuters in 1992 and is now senior photographer in Gaza. He was born in 1970 in Gaza and has worked in the region as a reporter, camera operator and photojournalist. In 2001 Jadallah was awarded the best photographic picture by the **Dubai Journalism Press**. He has also exhibited his work in Norway, France, Gaza and Egypt.

■ **Ali Jarekji**

Jarekji was born in Beirut in 1954 and started his photographic career with international news agencies at the beginning of the war in Lebanon in 1975. He joined Reuters as a staff photographer in 1985 in Lebanon before moving to Syria. Jarekji is based in Jordan.

■ **Petr Josek**

Josek was born in 1952 in Brno, but moved to Prague while he was still at school. After working with several Czech media companies, he was hired by the Czechoslovak News Agency as a photographer. He joined Reuters in 2000 and is now responsible for coverage in the Czech Republic and Slovakia.

■ **Kim Kyung-hoon**

Kim lives in Seoul and began his career in 1999 as a photographer with a South Korean sports newspaper. In 2002 he joined Reuters as staff photographer with the Seoul bureau.

■ **Michael Kooren**

Kooren was born on Curacao, a Dutch Caribbean island, in 1953. He moved when he was eight years old to the Netherlands, where he still lives in the city of Utrecht. Kooren has worked for several Dutch newspapers, including Algemeen Dagblad. In 2000 he joined the Reuters team as a freelancer.

■ **Pawel Kopczynski**

Kopczynski was born in 1971 in Warsaw and graduated from college with a diploma in news photography. He began working as a news photographer in 1987, first for daily newspapers, then for the Polish Press Agency, and finally for Reuters, which he joined in 1995. Kopczynski has covered a variety of major world events, including the war in the former Yugoslavia, the Kosovo refugee crisis, the Soccer World Cup, the Winter Olympics and rising tensions between India and Pakistan. He is now Chief Photographer, India and Pakistan.

■ **Reinhard Krause**

Krause was born in Essen, Germany, in 1959 and studied design. He later worked as a freelance photographer for several German magazines and papers and joined Reuters in 1989 as the Berlin Wall came down. He is Chief Photographer, Israel and the Palestinian Territories.

■ **Kevin Lamarque**

Lamarque has been a staff photographer with Reuters for 15 years. Beginning in Hong Kong, Lamarque later transferred to London where he covered major sporting events, politics, royalty and more. Now based in Washington in his native United States, Lamarque spends the bulk of his time covering news from the White House for Reuters.

■ **Jerry Lampen**

Born in Rotterdam in 1961, Lampen began work as a photographer in 1981, covering local news and sports. In 1985 he joined United Photos in Haarlem, returning in 1997 to Rotterdam where he worked with picture agencies and began his career with Reuters, covering sports and general news.

■ **Adrees Latif**

Latif was born in 1973 in Lahore, Pakistan, and was a staff photographer at the **Houston Post** from 1993 to 1996. Latif freelanced for Reuters in Houston, Texas, starting in 1996 and later in Los Angeles. In 2003 he accepted a staff position with Reuters as Senior Photographer, Thailand, based in Bangkok.

■ **Lee Jae-won**

Lee was born in Seoul in 1971 and still lives there. He joined Reuters in 1999 after two years as a freelance photographer. He is currently Chief Photographer at the Reuters Korea bureau.

■ **Anuruddha Lokuhapuarachchi**

Lokuhapuarachchi was born in Colombo, Sri Lanka, in 1964. After working for various local media organizations, he began covering the island's civil war in 1989 for the local **Sunday Times** newspaper. He joined Reuters in 1992 and since then has covered a full range of events from military campaigns and an assassination attempt on the president to cricket and feature assignments. He lives in Colombo with his wife and two children.

■ **Enrique Marcarian**

Marcarian was born in 1950 in Rosario, Argentina. He began working in photojournalism for a local newspaper before joining the Reuters team in 1992, initially as a stringer and, five years later, as a staff photographer.

■ **Dylan Martinez**

Martinez was born to Argentine parents in Barcelona and raised in Britain. At 18, he started freelancing in London for music magazines, national newspapers and small news agencies. Martinez began working with Reuters three years later, first in the United Kingdom and later from Hanoi. In 1998 he returned to London and in 2001 moved to Rome in his current post of Chief Photographer, Italy.

■ **Win McNamee**

McNamee was born in 1963 in Washington, D.C. He majored in journalism and graduated from the University of South Carolina in 1985. After working as a freelancer, he joined Reuters as a staff photographer in Washington in 1990. McNamee has covered four U.S. presidents, three presidential campaigns and the Gulf War as well as conflicts in the Philippines, South Korea and Afghanistan.

■ **Andreas Meier**

Meier was born in 1952 in Pfeffikon near Lucerne and has lived in Bern and Zurich. He began his career in 1986 as a photographer with Keystone in Switzerland where he worked for four years before joining a sports magazine. He then became picture editor at a news magazine, before joining Reuters as a freelance photographer in 1998.

■ **Toby Melville**

Melville was born in Britain in 1970. He began studying history at university, but left to become a staff photographer. He worked with regional and evening newspapers before joining the Press Association in 1998. Melville joined Reuters, in London, as a staff photographer in 2003.

■ **David Mercado**

Mercado was born in Cochabamba, Bolivia, in 1957, and later lived and went to school in La Paz. Before beginning his career in photography he was a professional musician playing Andean folk music. He began as a photographer with the Bolivian magazine **Epoca** in 1989, continuing with **La Razon** newspaper and then the national picture agency JathaFotos. He also worked for the Associated Press before joining Reuters in 1997.

■ **Anton Meres**

Meres was born in Badajoz, Spain, in 1960, and has lived in the north and south of Spain. He began his career in 1984, working as a photojournalist for several local and European publications throughout Spain and the north of Africa. His career highlights include work on the illicit traffic of tobacco and drugs in the area of the Strait of Gibraltar and the illegal immigration between Africa and Spain. Meres joined Reuters in 1999.

■ **Jeff J Mitchell**

Mitchell was born near Glasgow in 1970. His first fulltime job was as a photographer with the **Helensburgh Advertiser** in 1989 before moving to the **Edinburgh Evening News** in 1992 and the **Herald newspaper** in 1994. He has worked for Reuters since 1996 and is now based in Glasgow. Mitchell has been awarded several prizes from the Nikon Awards, the British Picture Editors Guild, Scottish Press Photography Awards, and first prize in the World Press Awards for his coverage of Britain's foot-and-mouth outbreak.

■ **Bazuki Muhammad**

Muhammad was born in Kuala Lumpur, Malaysia, in 1965. He graduated with a Bachelor of Architecture from Louisiana State University in the United States. He has photographed American sports since he was 17. In 1998, he joined Reuters, based in Kuala Lumpur, and he photographs politics, features, sports and economic news stories.

■ **Jacky Naegelen**

Naegelen was born in Colmar, France, in 1956. After studying photography in Paris, Naegelen worked as a freelance photographer in the east of France and joined Reuters in 1985.

■ Morteza Nikoubazl

Nikoubazl was born in Tehran in 1974 and studied art and photography there. Nikoubazl started work as a freelancer for Iranian daily and weekly newspapers then moved to the United Arab Emirates newspaper **Gulf News**. In 1999 Nikoubazl began working with the Reuters team as a stringer and now works exclusively with the Reuters Tehran picture team.

■ Guang Niu

Niu was born in Japan in 1963 and has lived in Japan, Canada and the United States. Niu went to university in Beijing and began his career in 1997 as a stringer in Beijing with the Associated Press, where he worked for three years before taking his current job with Reuters in June 2000.

■ Noh Soon-Taek

Noh was born in Seoul in 1971 and began a career as a photographer at the **Kyosu Newspaper** in South Korea, then Seoul's Internet newspaper Ohmynews. Noh joined Reuters as a stringer photographer just in time to cover the 2002 World Cup in Korea and Japan.

■ Patrick Olum

Olum was born in Nairobi in 1969 and has lived in Nairobi and Kampala. He began his career in 1996 as a photographer with the **Daily Nation** in Nairobi where he worked for five years before taking up a job at Reuters as a photographer for East Africa.

■ Kai Pfaffenbach

Pfaffenbach was born in 1970 and studied history and journalism before beginning his news photography career in Frankfurt as a freelancer for the German newspaper **Frankfurter Allgemeine Zeitung**. He began working for Reuters as a freelance photographer in 1996 before becoming a staff photographer in 2001. He is currently based in Frankfurt and was part of the Reuters team that covered the Iraq war in 2003.

■ Vincenzo Pinto

Pinto is a Reuters stringer based in Rome.

■ Vladimir Pirogov

Pirogov was born in 1958 in Novosibirsk, Russia. He was educated in Kazakhstan and after graduation served with the military in Germany. He later joined the police service and became interested in photography. He worked as a photographer in advertising then at several newspapers before joining Reuters in 2002.

■ Charles Platiau

Platiau was born in 1959 in Saint-Omer, France. He was a freelance sports photographer from 1979 to 1983, then joined Agence France-Presse (AFP) and UPI in 1984 as a stringer. In 1985, Platiau joined the Reuters team and is based in Paris.

■ Oleg Popov

Popov was born in 1956 in Sofia and studied photography and journalism there. He joined Reuters in 1990 as a stringer after working for a local agency, daily newspaper and magazine. Popov is currently chief photographer in Bulgaria and has covered the wars in Slovenia, Croatia and Bosnia, the siege of Sarajevo, the wars in Chechnya and Kosovo, as well as the 1994 and 1998 World Soccer Championships, Atlanta Olympic Games and the World Athletics Championship in Sweden.

■ Rafiqur Rahman

Rahman was born in 1950 in Dhaka, Bangladesh, and continues to live there. He started his career as a press photographer in 1970, working with local newspapers. In 1982, he began working as a camera operator with Reuters Television and in 1986 he started also taking still pictures for the Reuters News Pictures service.

■ Hazir Reka

Reka was born in 1961 in Ferizaj, Kosovo, and began his career in 1984 working for a student magazine. Throughout the 1980s and 1990s, Reka collaborated with several newspapers and magazines in the former Yugoslavia, including in Slovenia, Croatia, Bosnia and Serbia. He joined Reuters in 1998.

■ Stefano Rellandini

Rellandini was born in Milan in 1963 and studied graphic design. While working as a designer, he developed his photography skills and by 1987 was working for an agency at the Alpine ski World Cup. In 1997 Rellandini began his career with Reuters, taking now famous pictures of mourners, including Princess Diana, at fashion designer Gianni Versace's funeral. He remains based in Milan.

■ Damir Sagolj

Sagolj was born in Sarajevo and moved with his family to Moscow in 1985. A few months before the war started in Bosnia, Sagolj returned to Sarajevo where he worked in a small photo studio as a photographer's assistant. He then joined the Bosnian army and began taking pictures again just as the war was coming to an end. After years of freelance work for Reuters, he joined the team as Reuters Bosnia photographer in 1997. Sagolj remains based in Sarajevo and covers major news stories and sports events in Europe and the Middle East.

■ Suhaib Salem

Salem was born in Gaza in 1979 and went to a refugee school in Gaza. He began his career in 1997 as a cameraman with a local TV organization. He later joined Reuters as a photographer.

Tobias Schwarz

Schwarz was born in Munich in 1977. Schwarz started working as a photographer in early 2000 for a local newspaper in his hometown after an internship at the Mauritius picture agency. In 2001 he worked for the DDP news agency in Germany and joined Reuters in Munich six months later. He has been based in Berlin since 2002.

Mike Segar

Segar was born in 1961. He received his Bachelor of Arts degree in American Studies in 1985 from Boston University and received his Masters in photojournalism in 1989 from the International Center of Photography. Segar worked as a staff photographer for the Beacon Newspaper chain in Massachusetts and later joined the Black Star Photo Agency as an associate news picture editor. He joined Reuters in 1991 and has since covered a full range of news, sports and political and feature assignments throughout the United States.

Amit Shabi

Shabi is an independent photographer based in the Middle East.

Andres Stapff

Stapff was born in Montevideo in 1972. During the Uruguayan dictatorship period (1973-1985) he lived in Mexico, Cuba and Bolivia, returning in 1985 to Uruguay where he finished school. In 1992 he started working as a cameraman with an advertising agency and in 1995 began work as a press photographer with Uruguayan magazine Posdata. Since 1999 Stapff has worked for Reuters in Montevideo.

Darren Staples

Staples was born in Britain in 1970 and started his career in the darkroom of his local newspaper. He was one of the first photographers on the scene after the Kegworth plane disaster, capturing scenes of devastation for which he was awarded the Ilford Young Photographer of the Year in 1989. He joined Reuters in 2001 as a stringer covering news and sports and has spent the last two winters touring India and South Africa with the British cricket team.

Shannon Stapleton

Stapleton was born in Fort Benning, Georgia, in 1968. He later moved to Ohio where he attended university and later travelled the world before settling in Colorado. Stapleton joined Reuters as a contract photographer in 2000 and has since covered many major international news events, including the Kosovo crisis, the war in Sierra Leone and the September 11 attacks in New York.

Ray Stubblebine

An AP staff photographer from 1971-87, Stubblebine covered sports and news events and the Guyana Jonestown Massacre. For New York Newsday he covered part of the 'Iranscam' hearing. Since 1988, as a Reuters contract photographer, he has covered many New York sporting and political events.

Goran Tomasevic

Tomasevic was born in Belgrade in 1969. He began working as a photographer in 1991 for the daily newspaper Politika, based first in Belgrade and then – during the wars in Slovenia, Croatia and Bosnia – throughout the former Yugoslavia. He started working for Reuters as a freelance photographer in 1996 during the anti-Milosevic demonstrations. During the recent Iraq conflict, Tomasevic was in Baghdad and is now based in Jerusalem.

Miguel Vidal

Vidal was born in Pontevedra, Spain, in 1968 and has lived there all his life. Vidal began photography by chance in 1992 and in 1994 started work with a local newspaper. He joined Reuters in 1999 and, although based in Spain throughout, has covered stories in Cuba, Kosovo and London.

Ian Waldie

Waldie was born in Nambour, Australia, in 1970, and started his career as a cadet photographer with a regional newspaper in Queensland. In 1992 he relocated to the United Kingdom and started working with several British newspapers and magazines. Waldie became a Reuters stringer in 1993, based in Scotland, and in 1996 he moved to London as a Reuters staff photographer. He has won many awards including 1994 Young Photographer of the Year, News Photographer of the Year and Photographer of the Year (British Picture Editors awards); 1997 Photographer of the Year (Nikon UK press photography awards), and 2000 and 2002 Photographer of the Year (British Picture Editors awards).

Paulo Whitaker

Whitaker was born in Sao Paulo, Brazil, on January 27, 1960. He graduated in journalism in Sao Paulo at Faculdades Integradas Alcantara Machado in 1986 and was a staff photographer for one of the biggest newspapers in Brazil, Folha de Sao Paulo from 1984 to 1988. From 1990-1996 Whitaker worked for AFP as stringer and has been a staff photographer for Reuters since 1997.

THE ART OF SEEING

■ Darren Whiteside

Whiteside was born in 1965 in Toronto. Since joining Reuters in 1995 he has been based in Phnom Penh. Whiteside's work has taken him to news stories in places as diverse as Somalia, Japan, Afghanistan and East Timor.

■ Alexandra Winkler

Winkler was born in Nuremberg, Germany, in 1976. In 1999 she started working for a German newspaper before taking her current job at Reuters in 2000. Winkler is normally based in Munich but has worked also in Frankfurt and Berlin.

■ Philippe Wojazer

Wojazer was born in 1959 and has always lived in Paris. He began working as a sports photographer before joining Agence France-Presse (AFP) in 1981. He started work with the Reuters team in Paris in 1985.

■ Bobby Yip

Yip was born in Hong Kong in 1962 and began his career in 1984 as a photographer for local newspapers and magazines. In 1990 he started working for Reuters Asia as a photographer and sub-editor before taking up his current job as Reuters photographer, Hong Kong, in 1997.

■ Yun Suk-Bong

Yun was born in Kongju, South Korea, in 1941 and lives in Seoul. Yun began work as a photographer in 1967 with Seoul's Dong-A daily newspaper before joining Reuters 10 years later.

The Art of Sport offers a fascinating selection of sports pictures taken by Reuters photographers who have had the vision and ability to see and capture extraordinary sporting moments. This collection comprises a sporting story with many threads: victory and defeat, natural skill, ability and hard work, beauty, strength and courage, joy and crushing disappointment – and offers some of the most clever and beautiful sporting photographs that you will ever see.

The Art of Sport sets each photograph in context, outlining the circumstances behind the image: how the photographers came to be there at that moment and how they managed to document them. It showcases the two essential characteristics of the top photojournalist – a nose for a sporting story and an eye for a beautiful photograph.

THE ART OF SPORT
The best of Reuters sports photography

ISBN 1 903 68412 9

£19.99

REUTERS
KNOW. NOW.

www.reuters.com